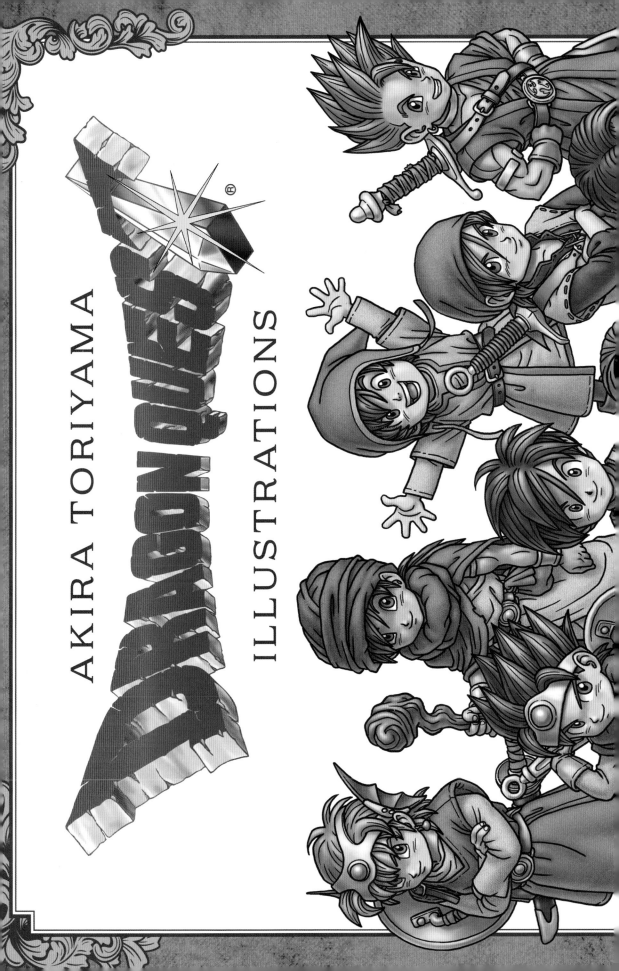

DRAGON QUEST®

AKIRA TORIYAMA

ILLUSTRATIONS

1998.9.25 GB

1993.12.18 SFC

DQ I

1986.5.27 FC

DRAGON QUEST MONSTERS:
Terry no Wandaarando

EST MONSTERS 1+2:
usha to
kamatachi

1999.9.23 GB

DRAGON QUES

DQ II **1987**.1.26 FC

DRAGON QUEST I • II

DQ VI **1995**.12.9 SFC

DRAGON QUEST I • II

2001.3.9/4.12 GB

DRAGON QUEST II: *Luminaries of the Legendary Li*

DQ III **1988**.2.10 FC

GBA

RAGON
opo Dan

DRAGON QUEST MONSTERS 2:
Maruta no Fushigi na Kagi: Ruka no Tabidachi/
Maruta no Fushigi na Kagi: Iru no Bouken

DRAGON QUEST VI: Realms of Revelation

DRAGON QUEST III: The Seeds of Salvatio

2002 2001 2000 1999 1998 1996 1995 1993 1992 1990 1988 1987 1986

2003.9.19

KENSHIN DRAGON QUEST:
Yomigaerishi Densetsu no Tsurugi

1999.9.15 PS

DQ IV **1990**.2.11 FC

1996.12.6 SFC

Torneko: Last Hope

DRAGON QUEST III:
The Seeds of Salvation

DRAGON QUEST IV: Chapters of the Chose

1992.9.27 SFC

DRAGON QUEST V:
Hand of the Heavenly Bride

DQ VII

2000.8.26

PS

DRAGON
QUEST VII:
Fragments of the
Forgotten Past

2001.11.22 PS

30

years of
DRAGON QUEST

PACKAGE
HISTORY

Here's the package art for
all of the games featured in
this book! Looking at those
release years, you can really
feel the history!

DRAGON QUEST IV: Chapters of the Chosen

2000.12.8 GB

DRAGON QUEST III:
The Seeds of Salvation

1993.9.19 SFC

Torneko no Daibouken:
Fushigi no Danjon

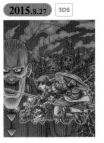

2015.8.27 [3DS]

DRAGON QUEST VIII:
Journey of the Cursed King

DQ X

2012.8.2 [Wii]

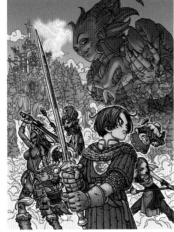

DRAGON QUEST X:
Mezameshi Itsutsu no Shuzoku Onrain

2011.11.2 [3DS]

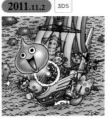

SURAIMU MORIMORI
DRAGON QUEST 3:
Daikaizoku to Shippo Dan

2011.3.31
[DS]

DRAGON QUEST
MONSTERS: Joker 2

2012.5.31
[3DS]

DRAGON QUEST
MONSTERS:
Terry no Wandaarando 3D

2015.4.30

[Wii] [Wii U] [PC]

DRAGON QUEST X:
Inishie no Ryuu no Denshou Onrain

2015.2.26 [PS3] [PS4]

DRAGON QUEST HEROES:
The World Tree's Woe and the Blight Below

2013.2.7 [3DS]

DRAGON QUEST VII: Fragments of the Forgotten Past

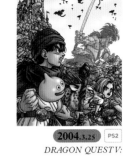

2002.5.30

2004.3.25 [PS2]

DRAGON QUEST V:
Hand of the Heavenly Bride

DRAGON QU
Hoshifuri no Yu
Bokujou no Na

2002.10.31

[PS2]

DRAGON QUEST
CHARACTERS:
Torneko no Daibouken 3:
Fushigi no Danjon

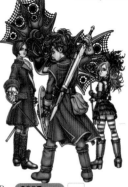

2007.7.12 [Wii]

DRAGON QUEST SWORDS:
The Masked Queen and
the Tower of Mirrors

2003.11.1

SURAIMU MORIMORI DI
QUEST: Shougeki no Shi

2016 2015 2014 2013 2012 2011 2010 2009 2007 2006 2005 2004 200

2013.12.5 [Wii] [Wii U] [PC]

DRAGON QUEST X:
Nemureru Yuusha to
Michibiki no Meiyuu Onrain

2016.1.28

[PS3] [PS4] [Vita]

DRAGON QUEST
BUILDERS

2014.2.6 [3DS]

DRAGON QUEST MONSTERS 2:
Iru to Ruka no Fushigi na Fushigi na Kagi

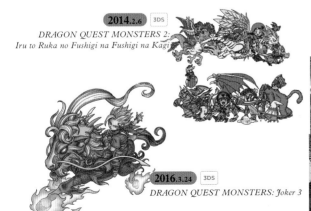

2016.3.24 [3DS]

DRAGON QUEST MONSTERS: Joker 3

2016.5.27 [PS3] [PS4] [Vita]

DRAGON QUEST HEROES II

2010.4.28 [DS]

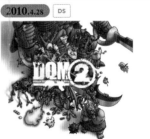

DRAGON QUEST
MONSTERS: Joker 2

2010.1.28 [DS]

DRAGON QUEST VI:
Realms of Revelation

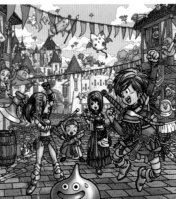

DQ IX

2009.7.11

[DS]

DRAGON
QUEST IX:
Sentinels of the
Starry Skies

2006.4.20 [PS2]

DRAGON QUEST:
Shounen Yangus to Fushigi no Danjon

2006.12.28 [DS]

DRAGON QUEST
MONSTERS: Joker

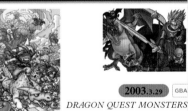

2003.3.29 [GBA]

DRAGON QUEST MONSTERS
Kyaraban Hate

DQ VIII

2004.11.27

[PS2]

DRAGON
QUEST VIII:
Journey of the
Cursed King

2005.12.1 [DS]

DRAGON QUEST HEROES:
Rocket Slime

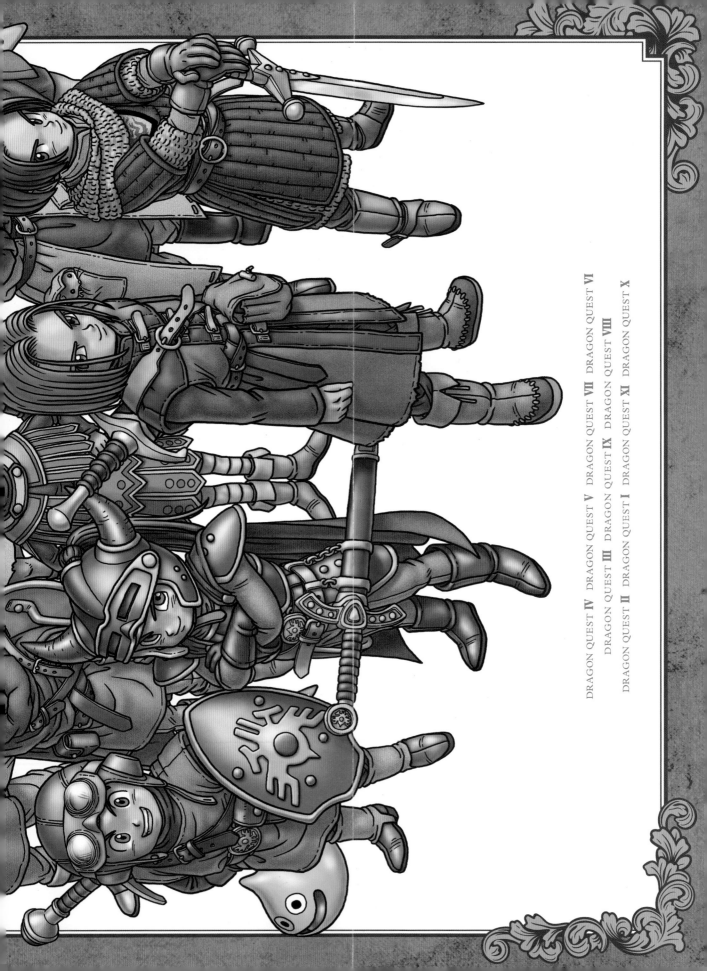

DRAGON QUEST IV DRAGON QUEST V DRAGON QUEST VII DRAGON QUEST VI
DRAGON QUEST III DRAGON QUEST IX DRAGON QUEST VIII
DRAGON QUEST II DRAGON QUEST I DRAGON QUEST XI DRAGON QUEST X

AKIRA TORIYAMA

DRAGON QUEST

ILLUSTRATIONS

Message from
AKIRA TORIYAMA

AKIRA TORIYAMA

Akira Toriyama was born on April 5, 1955 in Aichi Prefecture, Japan. He made his manga debut in 1978 with the one-shot *Wonder Island*. 1980 saw the start of the megahit *Dr. Slump*, serialized in *Weekly Shonen Jump*. *Dragon Ball* began in 1984 and experienced worldwide popularity that continues to this day. Toriyama was responsible for the package art and monster designs for 1986's *DRAGON QUEST*. In the decades since, he's continued to create the package art and character designs for the series.

Thirty years back, I was already familiar with Horii-san, as he was a writer for *Shonen Jump*. One day, my editor at the time—Torishima-san—passed along a message from the man. Horii-san was apparently making a game for the Famicom, and he told me, "You should do the character designs."

I remember hearing it was an RPG and thinking, "Role-playing? Really?" Because back then, the RPG was much more of a niche genre that generally only appeared on PC. Even when they explained the concept to me, I still didn't get it.

In those days, I was already busy enough with my serializations and barely getting any sleep as it was, so my instinct was to refuse, but Torishima-san (always alert to new trends) kept nagging and eventually convinced me. I accepted the offer casually, seeing it as a potentially interesting little project that would earn me some cash on the side.

Turned out there were a ton of characters I had to draw! Monsters too. It was my job to do every single design, starting practically from scratch, so it ended up being quite the task. Not to mention, I wasn't all that knowledgeable about fantasy worlds in the first place. Horii-san had to send me simple, rough sketches, like of the gloopy slime monster that basically looked like a puddle.

Despite my initial puzzlement, though, I came to realize that basically anything goes in fantasy, so I had a lot of freedom in designing these characters.

The game was a smash hit, and once I got a chance to play it myself, I finally understood what all the fuss was about. It was incredibly fun, and I took a lot of pride in my involvement in the project.

Naturally, I thought that was the end of it. I couldn't have been more wrong…!

In truth, I've never been that interested in the main characters and big, bad final-boss types; the minor characters and monsters are much more fun. Sadly, I don't get to draw as many as I'd like, due to time constraints.

But has it really been thirty whole years?

Now that the series is as big as it is, I don't quite have that same freedom as in years earlier, but my own design sensibilities have been informed and broadened by my experience with these games. Plus, when I see my son enjoying the finished games, it makes me grateful that I was given the opportunity to be a part of this incredible series.

After thirty years, there are bound to be some characters I've forgotten. That's why art books like this are great for old coots like me whose memories aren't what they used to be.

A lot of the old drawings and designs seem crude in retrospect, but I also made some bold choices when I was younger. Hopefully that adds to the fun factor.

Maybe it was worth losing all that sleep, after all!

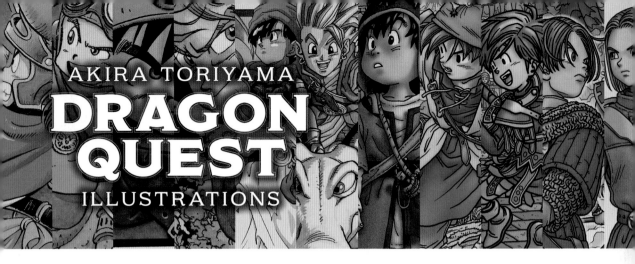

CONTENTS

Please note the following formatting as it applies to the art found in this book:

For game concept art: Character name (corresponding game release year)
Example: The Dragonlord, Pre-Transformation (1986)

For package illustrations: Game System • *Title* • Package Art (release year)
Example: Famicom • *DRAGON QUEST* • Package Art (1986)

For art found in books or magazines: Publication title (release date) • Art location
Example: *DRAGON QUEST 25th Anniversary Book* (September 15, 2011) • Cover and poster

All names without official English equivalents have been romanized from the original Japanese.

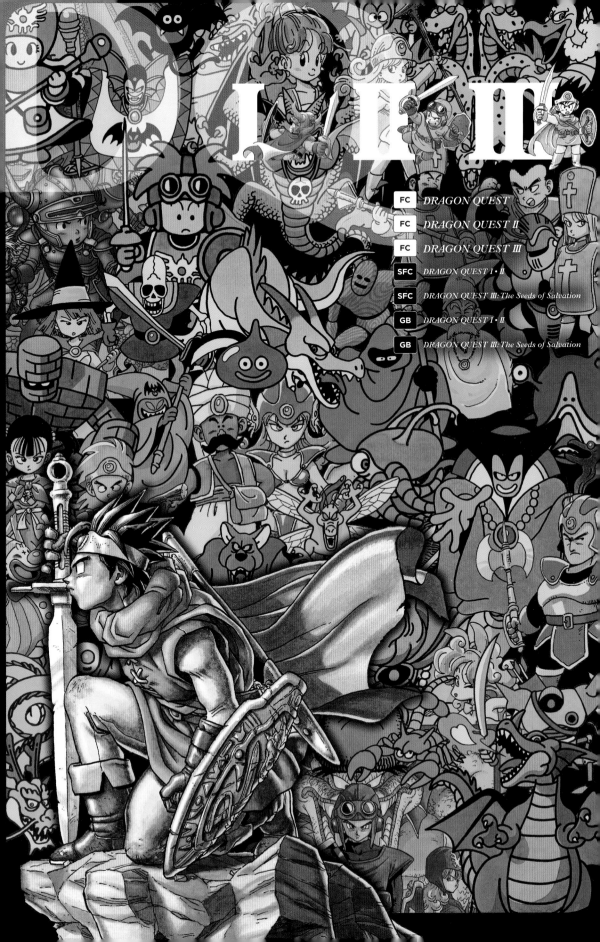

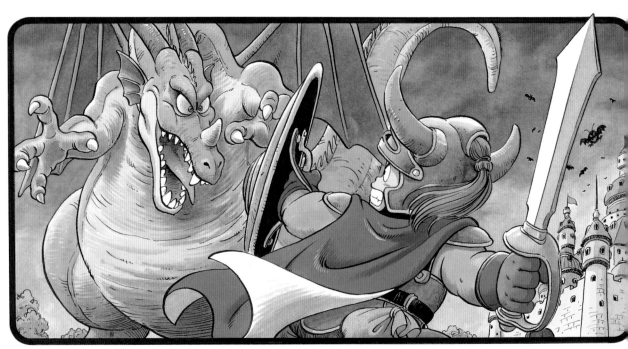

Famicom • *DRAGON QUEST* • Package Art (1986)

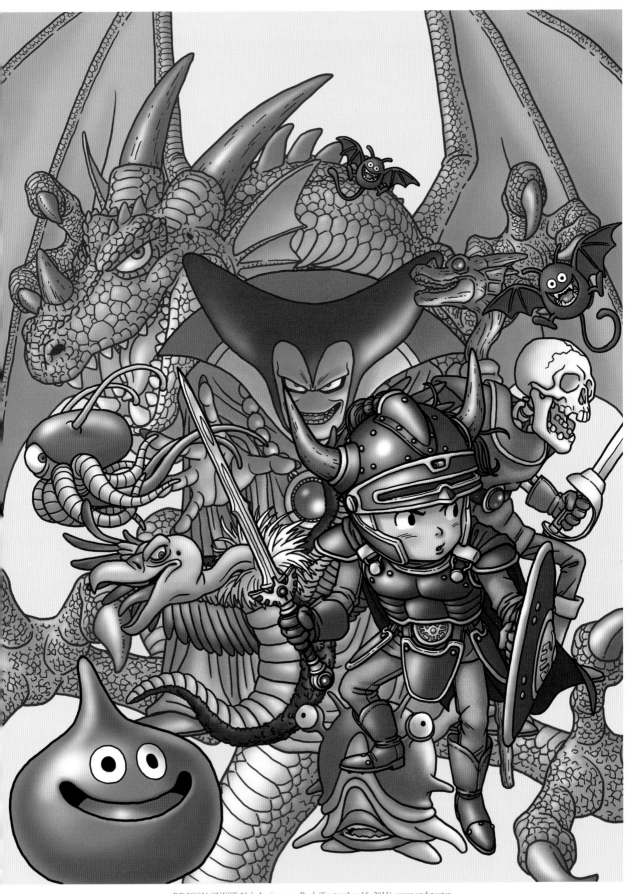

DRAGON QUEST 25th Anniversary Book (September 15, 2011) cover and poster

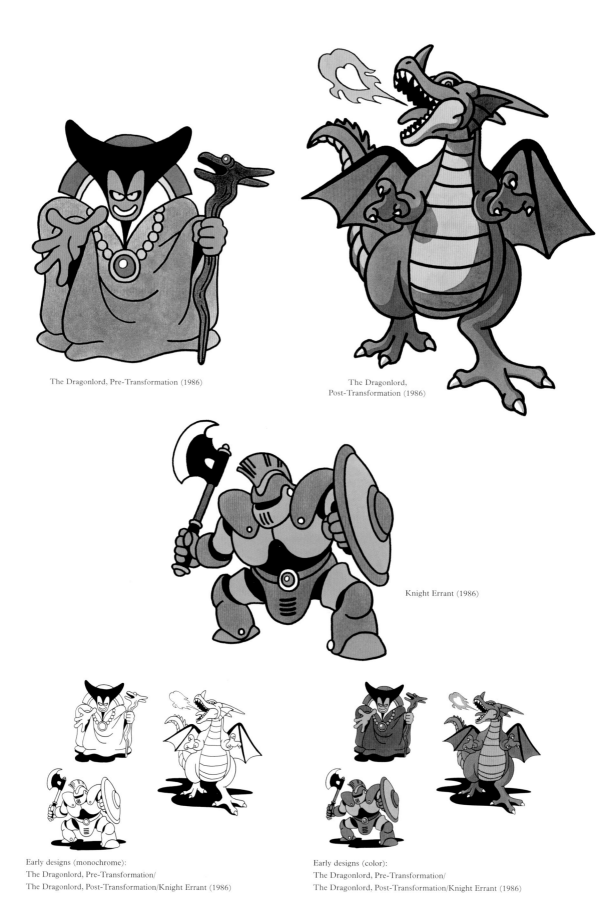

The Dragonlord, Pre-Transformation (1986)

The Dragonlord,
Post-Transformation (1986)

Knight Errant (1986)

Early designs (monochrome):
The Dragonlord, Pre-Transformation/
The Dragonlord, Post-Transformation/Knight Errant (1986)

Early designs (color):
The Dragonlord, Pre-Transformation/
The Dragonlord, Post-Transformation/Knight Errant (1986)

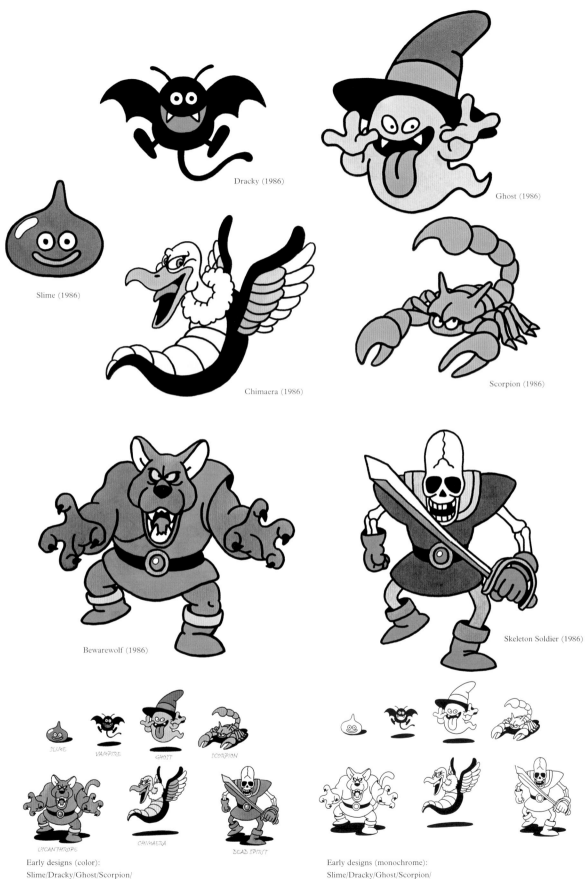

Dracky (1986)

Ghost (1986)

Slime (1986)

Chimaera (1986)

Scorpion (1986)

Bewarewolf (1986)

Skeleton Soldier (1986)

SLIME

VAMPIRE

GHOST

SCORPION

LYCANTHROPE

CHIMAERA

DEAD SPIRIT

Early designs (color):
Slime/Dracky/Ghost/Scorpion/
Bewarewolf/Chimaera/Skeleton Soldier (1986)

Early designs (monochrome):
Slime/Dracky/Ghost/Scorpion/
Bewarewolf/Chimaera/Skeleton Soldier (1986)

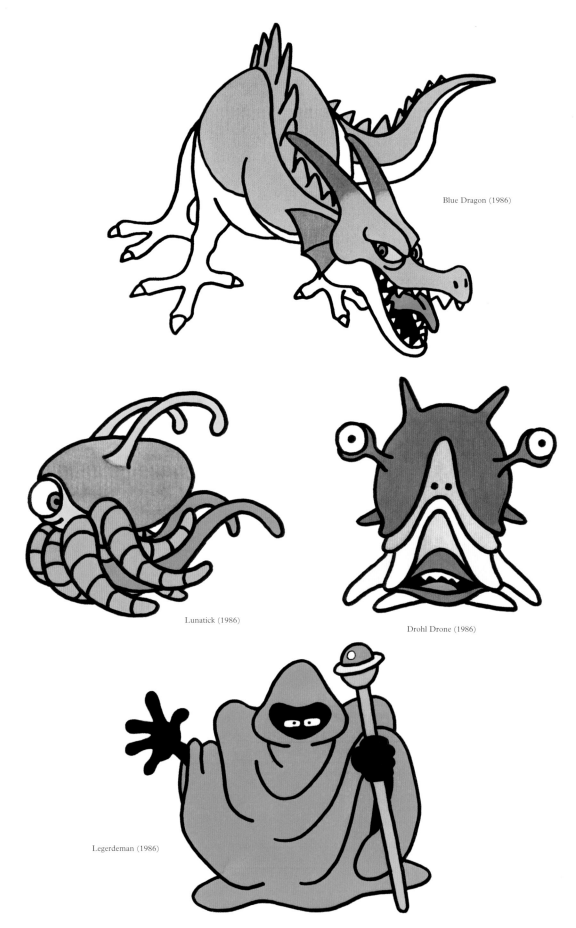

Blue Dragon (1986)

Lunatick (1986)

Drohl Drone (1986)

Legerdeman (1986)

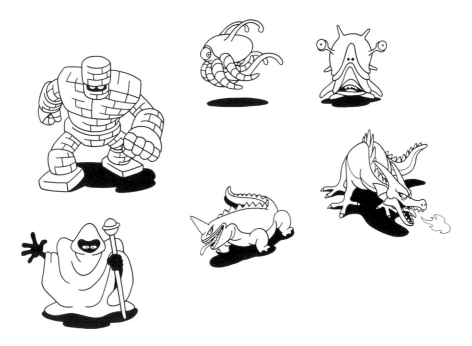

Early designs (monochrome):
Golem/Lunatick/Drohl Drone/
Legerdeman/Unused monster/Blue Dragon (1986)

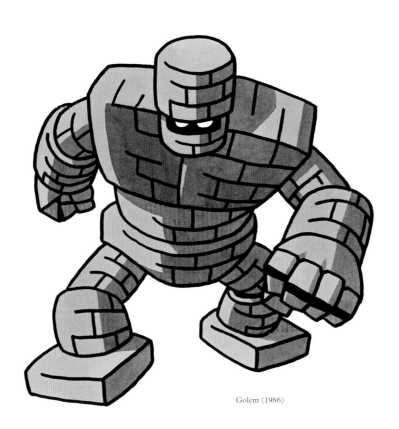

Golem (1986)

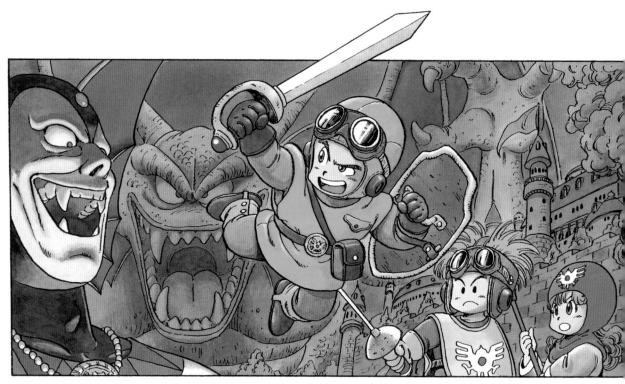

Famicom • *DRAGON QUEST II: Luminaries of the Legendary Line* • Package Art (1987)

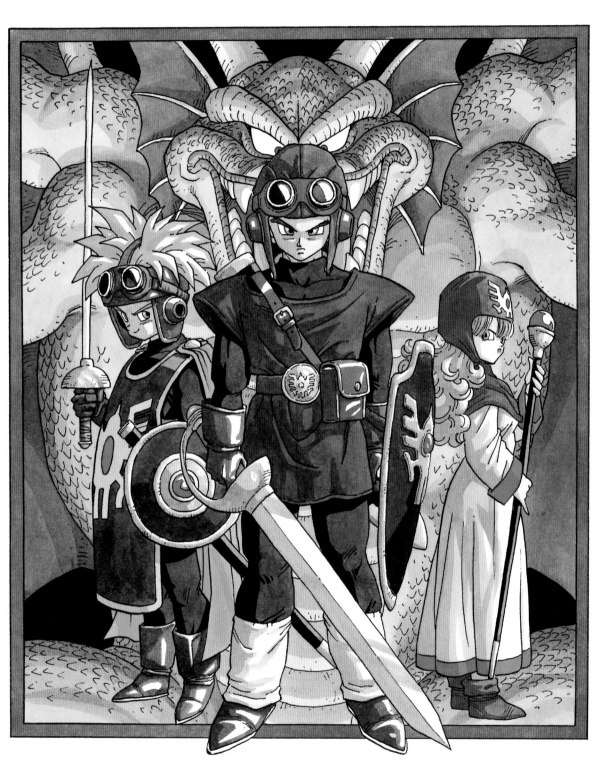

Super Famicom • *DRAGON QUEST I/II* • Package Art (1993)

Game Boy • *DRAGON QUEST I/II* • Package Art (1999)

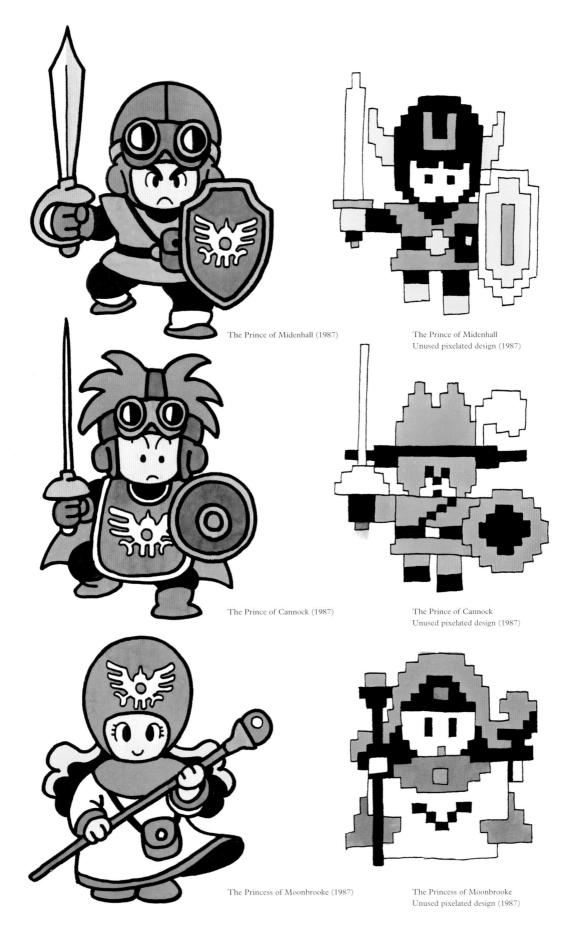

The Prince of Midenhall (1987)

The Prince of Midenhall
Unused pixelated design (1987)

The Prince of Cannock (1987)

The Prince of Cannock
Unused pixelated design (1987)

The Princess of Moonbrooke (1987)

The Princess of Moonbrooke
Unused pixelated design (1987)

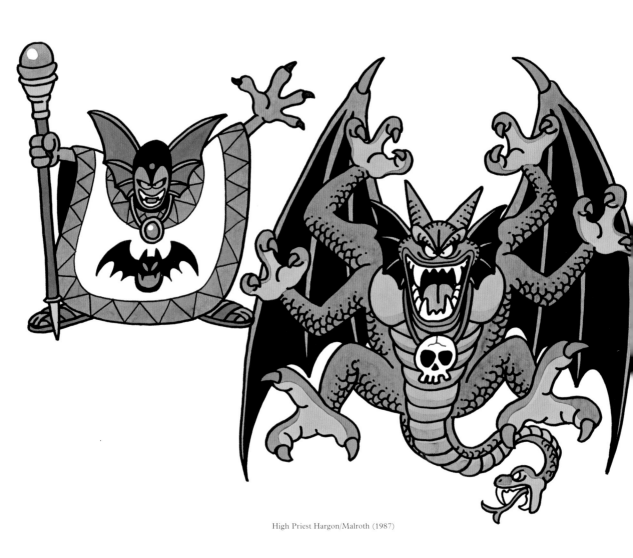

High Priest Hargon/Malroth (1987)

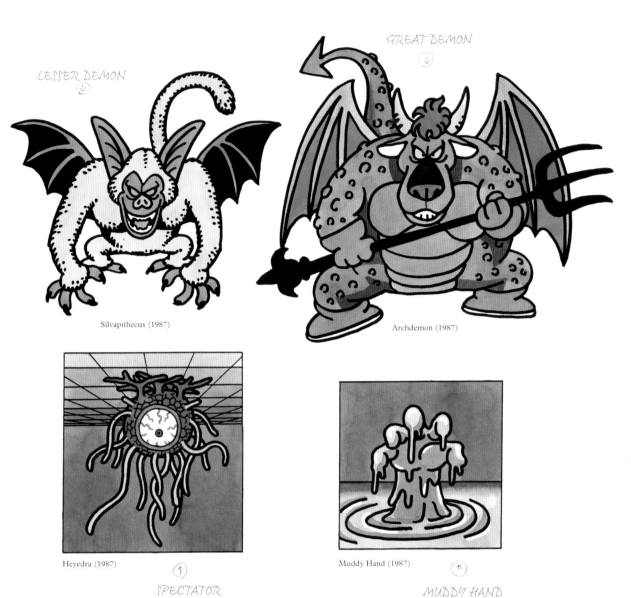

LESSER DEMON ↓

GREAT DEMON ↓

Silvapithecus (1987)

Archdemon (1987)

Heyedra (1987) ↑

SPECTATOR

Muddy Hand (1987) ↑

MUDDY HAND

WOODY SPAWN →

Treeface (1987)

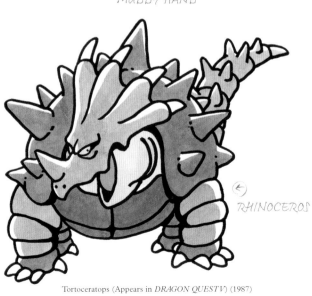

← RHINOCEROS

Tortoceratops (Appears in *DRAGON QUEST V*) (1987)

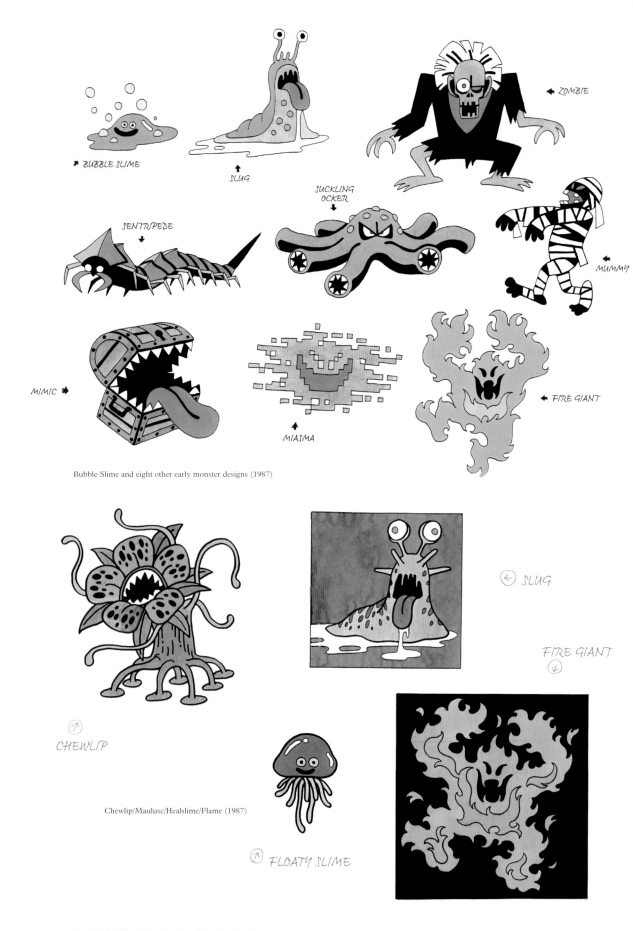

BUBBLE SLIME

SLUG

ZOMBIE

SENTRIPEDE

SUCKLING OCKER

MUMMY

MIMIC

MIASMA

FIRE GIANT

Bubble Slime and eight other early monster designs (1987)

CHEWLIP

SLUG

FIRE GIANT

Chewlip/Maulusc/Healslime/Flame (1987)

FLOATY SLIME

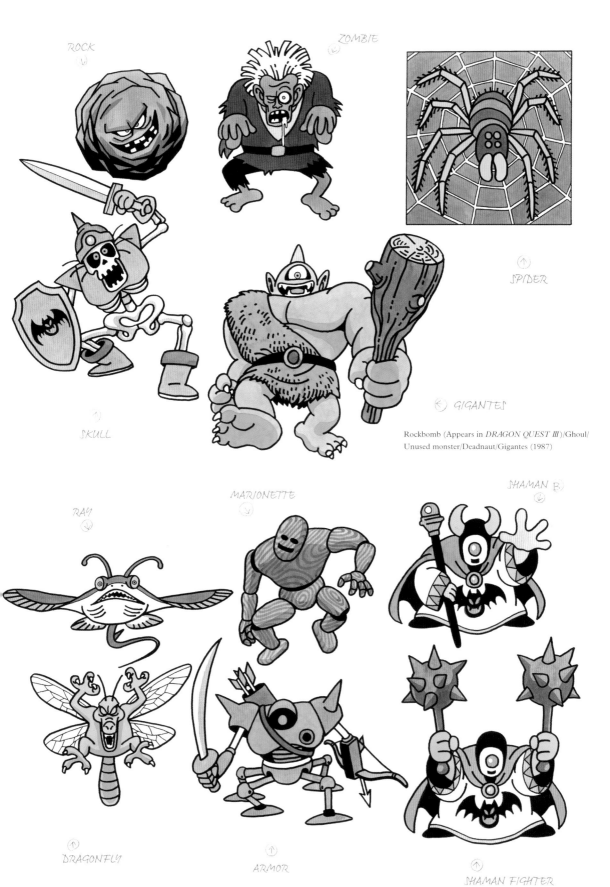

ROCK (↓)

ZOMBIE (↓)

SKULL (↑)

GIGANTES (←)

SPIDER (↑)

Rockbomb (Appears in *DRAGON QUEST III*)/Ghoul/
Unused monster/Deadnaut/Gigantes (1987)

RAY (↓)

MARIONETTE (↓)

SHAMAN B (↓)

DRAGONFLY (↑)

ARMOR (↑)

SHAMAN FIGHTER (↑)

Unused monster/Mud Mannequin/Wrecktor (Appears in *DRAGON QUEST MONSTERS: Kyaraban Hato*)/
Dragonfry/Killing Machine/Wrecktor (Appears in *DRAGON QUEST V*) (1987)

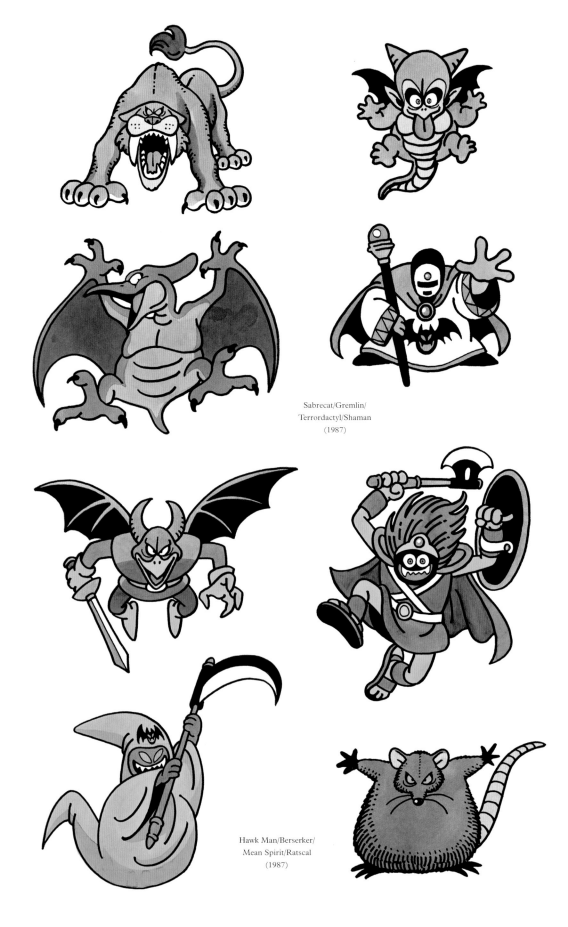

Sabrecat/Gremlin/
Terrordactyl/Shaman
(1987)

Hawk Man/Berserker/
Mean Spirit/Ratscal
(1987)

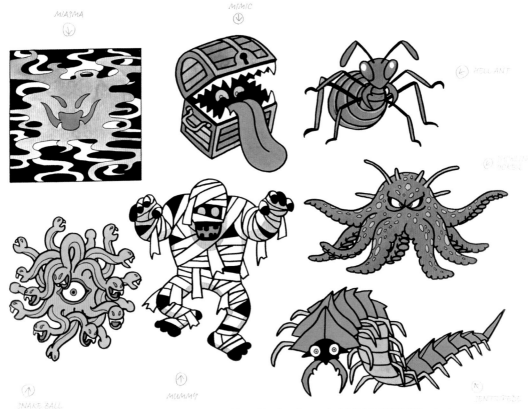

MIASMA

MIMIC

HELL ANT

SNAKE BALL

MUMMY

SENTIPEDE

Miasma/Cannibox (Appears in *DRAGON QUEST III*)/Iron Ant/
Madusa/Mummy Boy/Suckling Ocker (Appears in *DRAGON QUEST V*)/
Sentripede (1987)

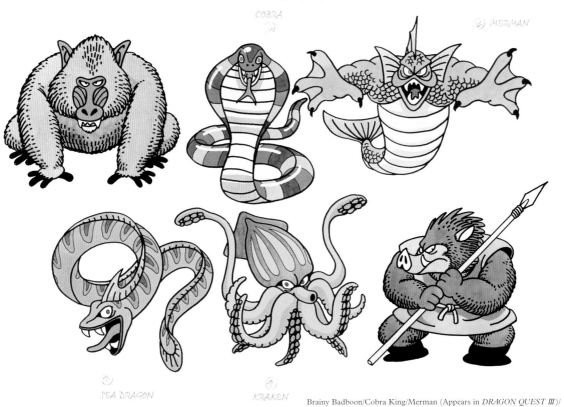

COBRA

MERMAN

SEA DRAGON

KRAKEN

Brainy Badboon/Cobra King/Merman (Appears in *DRAGON QUEST III*)/
Eveel (Appears in *DRAGON QUEST VI*)/
Tentacular (Appears in *DRAGON QUEST III*)/Orc (1987)

Famicom • *DRAGON QUEST III: The Seeds of Salvation* • Package Art (1988)

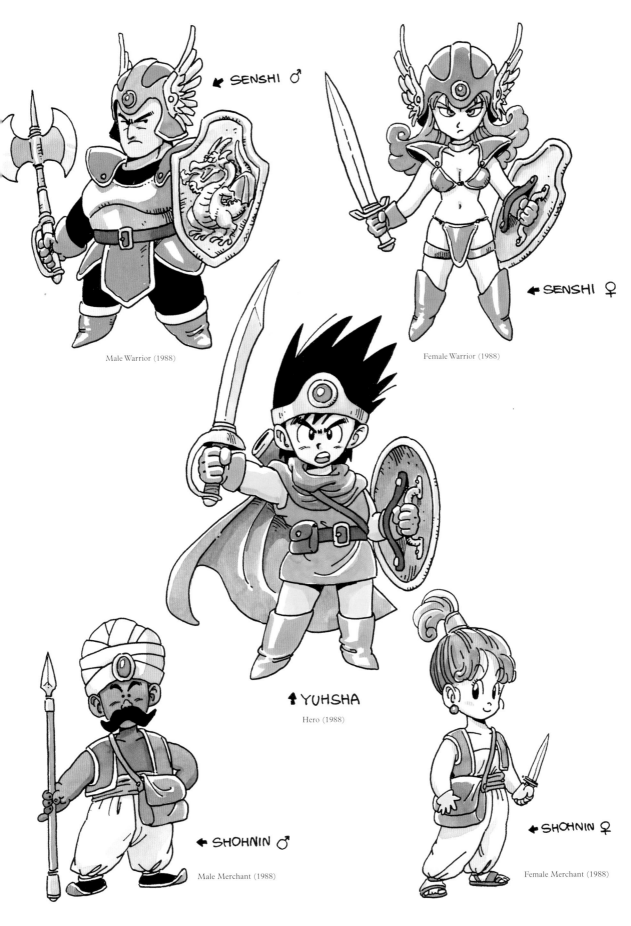

← SENSHI ♂

Male Warrior (1988)

← SENSHI ♀

Female Warrior (1988)

↑ YUHSHA

Hero (1988)

← SHOHNIN ♂

Male Merchant (1988)

← SHOHNIN ♀

Female Merchant (1988)

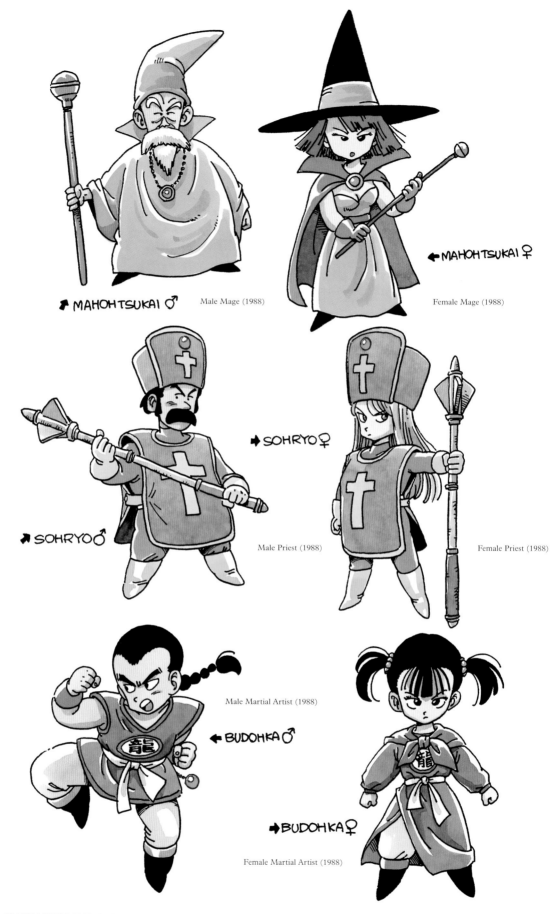

↗ MAHOHTSUKAI ♂ Male Mage (1988)

← MAHOHTSUKAI ♀ Female Mage (1988)

→ SOHRYO ♀

↗ SOHRYO ♂ Male Priest (1988)

Female Priest (1988)

Male Martial Artist (1988)

← BUDOHKA ♂

→ BUDOHKA ♀

Female Martial Artist (1988)

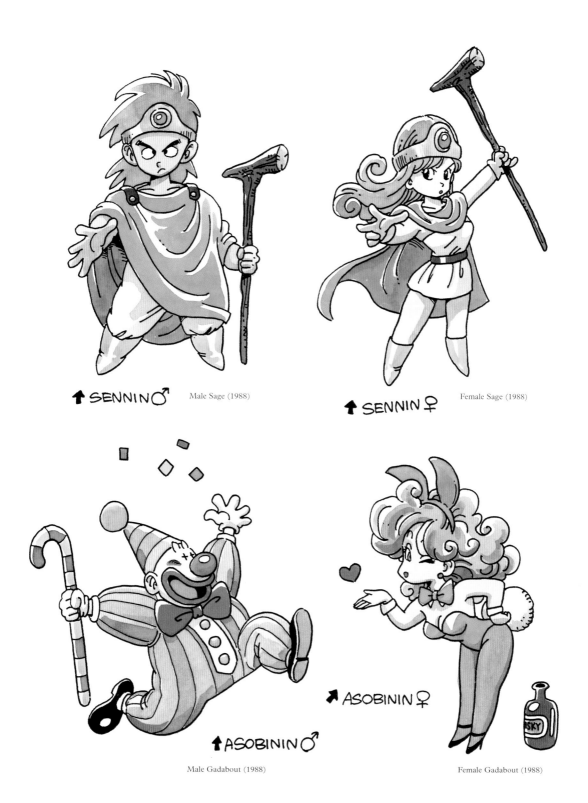

↑ SENNIN♂ Male Sage (1988)

↑ SENNIN ♀ Female Sage (1988)

↑ ASOBININ ♀

↑ ASOBININ♂

Male Gadabout (1988)

Female Gadabout (1988)

DRAGON QUEST III

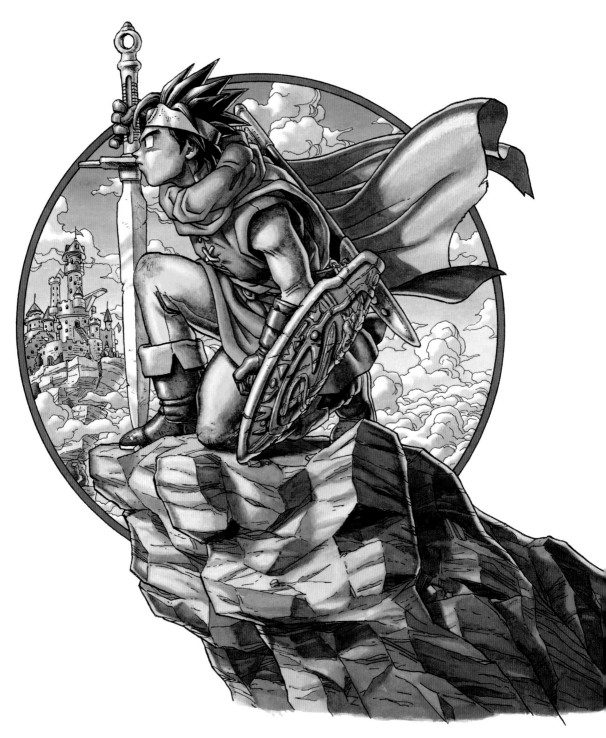

Super Famicom • *DRAGON QUEST III: The Seeds of Salvation* • Package Art (1996)

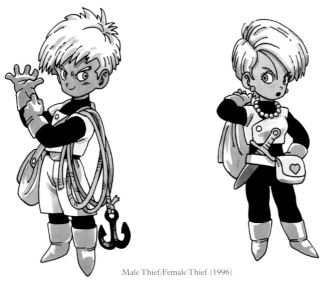

MALE THIEF
(REVISED)

FEMALE THIEF
(REVISED #1)

So sorry, but please use
these versions.
(I wasn't happy with the
size of their faces so I
revised them)

Male Thief/Female Thief (1996)

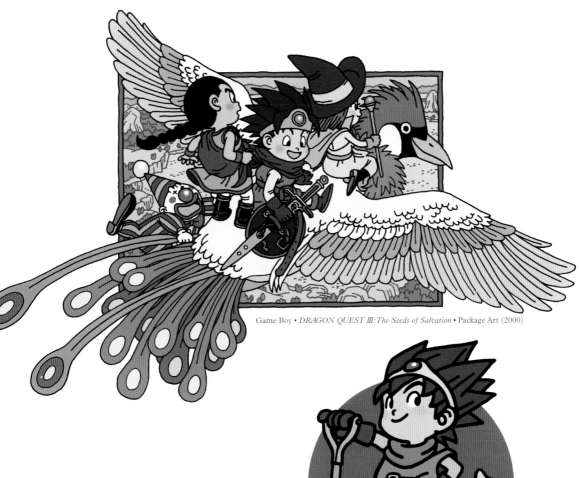

Game Boy • *DRAGON QUEST III: The Seeds of Salvation* • Package Art (2000)

V Jump, Special June 2011 Issue
(Released April 21, 2011)
Illustration supporting recovery
efforts after the Great East Japan
Earthquake Disaster

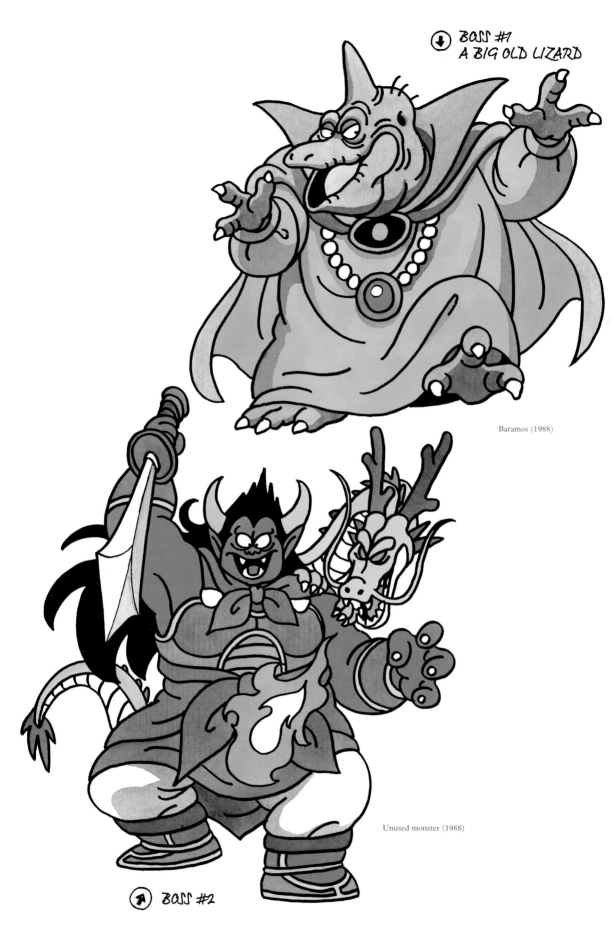

BOSS #1
A BIG OLD LIZARD

Baramos (1988)

Unused monster (1988)

BOSS #2

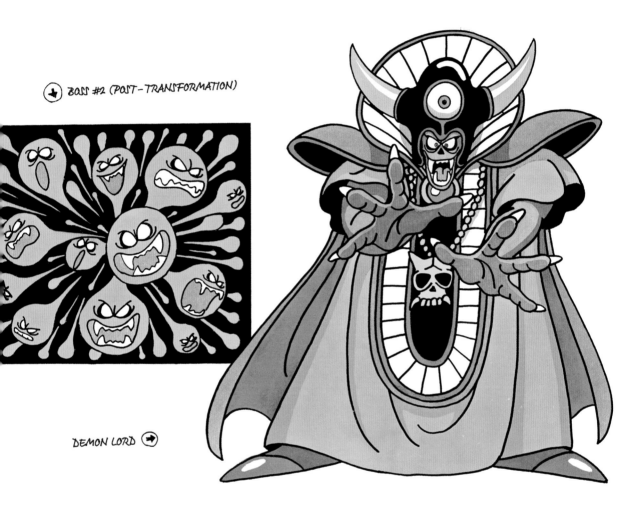

BOSS #2 (POST-TRANSFORMATION)

DEMON LORD

Zoma, Second Form (Unused)/Zoma (1988)

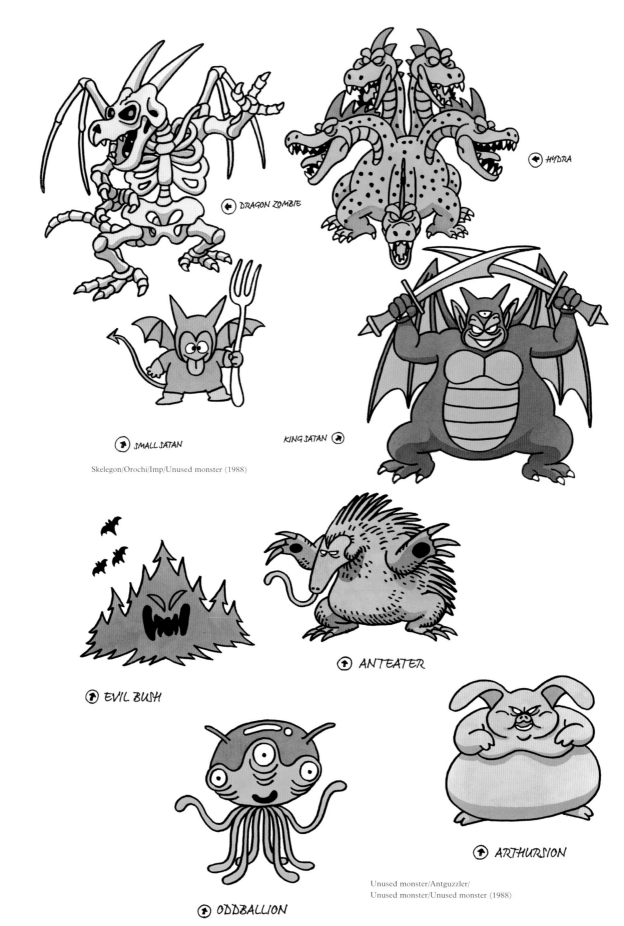

DRAGON ZOMBIE

HYDRA

SMALL SATAN

KING SATAN

Skelegon/Orochi/Imp/Unused monster (1988)

EVIL BUSH

ANTEATER

ODDBALLION

ARTHURSION

Unused monster/Antguzzler/
Unused monster/Unused monster (1988)

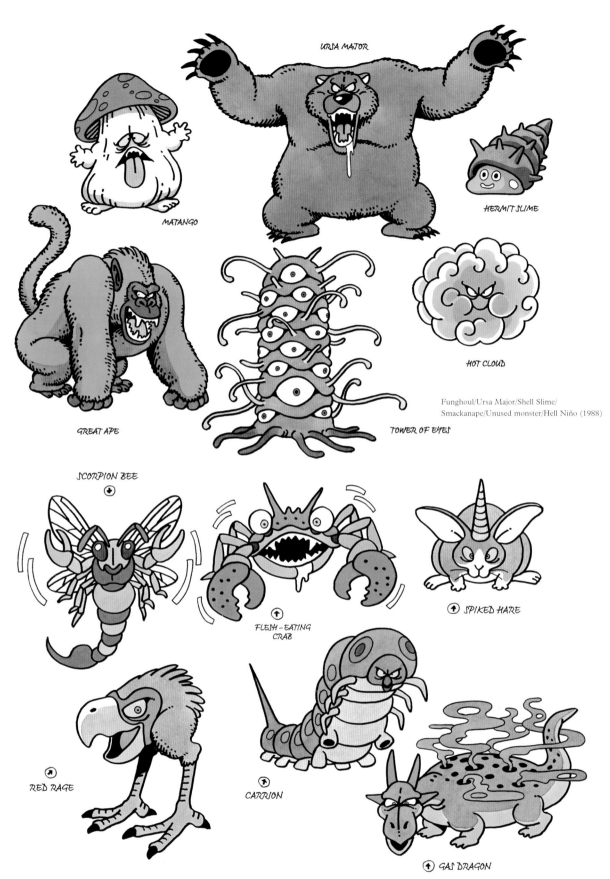

URSA MAJOR

MATANGO

HERMIT SLIME

GREAT APE

TOWER OF EYES

HOT CLOUD

Funghoul/Ursa Major/Shell Slime/
Smackanape/Unused monster/Hell Niño (1988)

SCORPION BEE

FLESH – EATING
CRAB

SPIKED HARE

RED RAGE

CARRION

GAS DRAGON

Waspion/Crabid/Spiked Hare/Weaker Beakon/Killerpillar/Unused monster (1988)

31

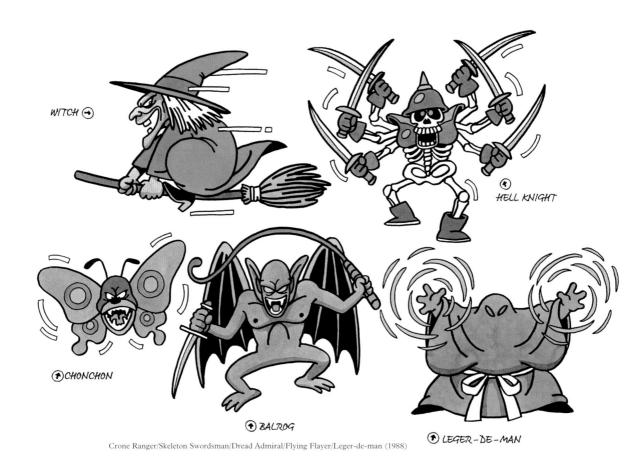

WITCH ➡

HELL KNIGHT ⬅

➡CHONCHON

⬆ BALROG

⬆ LEGER-DE-MAN

Crone Ranger/Skeleton Swordsman/Dread Admiral/Flying Flayer/Leger-de-man (1988)

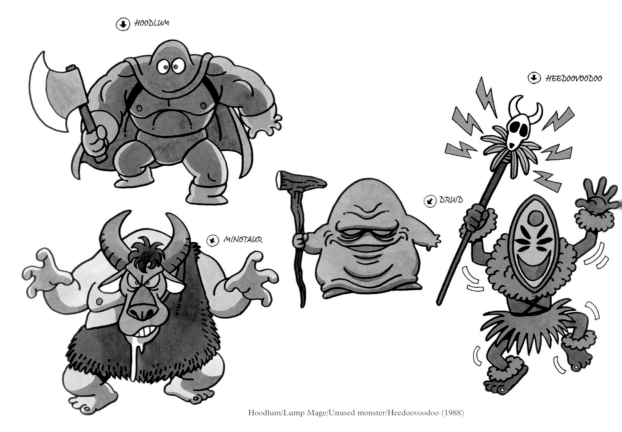

⬇ HOODLUM

⬇ HEEDOOVOODOO

⬅ DRUID

⬅ MINOTAUR

Hoodlum/Lump Mage/Unused monster/Heedoovoodoo (1988)

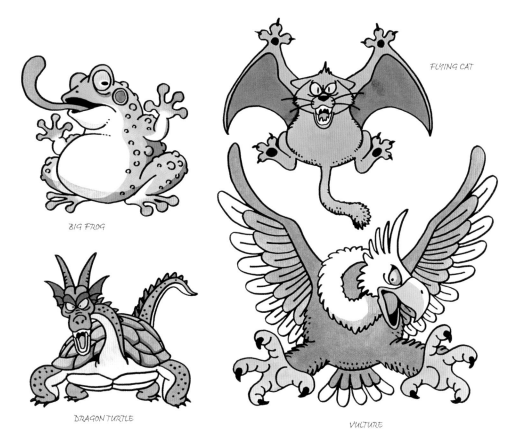

BIG FROG

FLYING CAT

DRAGON TURTLE

VULTURE

Toady/Vampire Cat/Wyrtle/Hades Condor (1988)

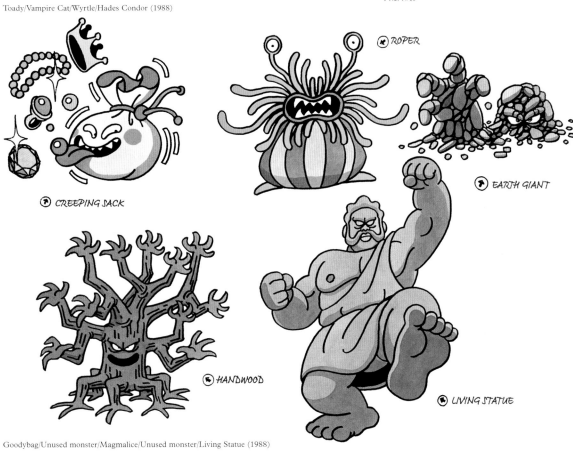

(★) ROPER

(★) CREEPING SACK

(★) EARTH GIANT

(★) HANDWOOD

(★) LIVING STATUE

Goodybag/Unused monster/Magmalice/Unused monster/Living Statue (1988)

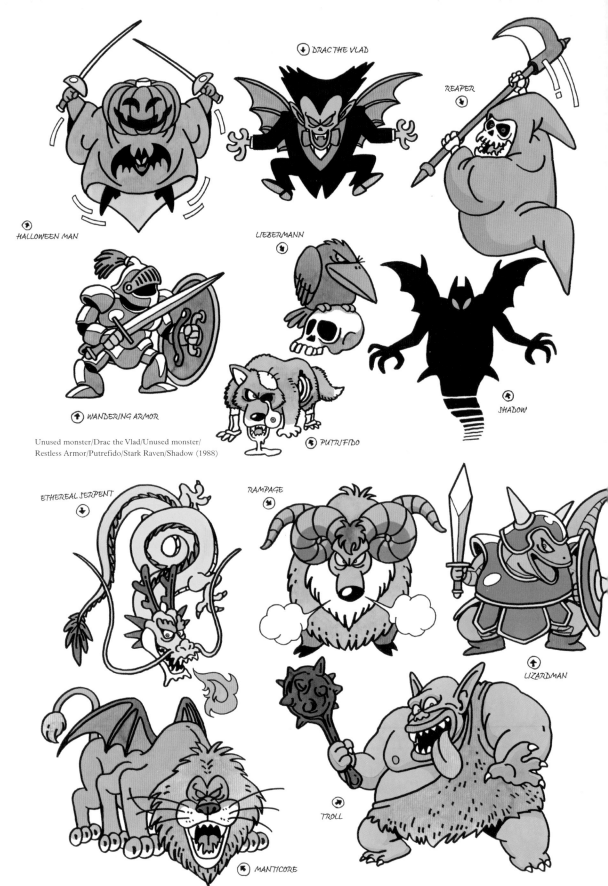

HALLOWEEN MAN

↓ DRAC THE VLAD

REAPER ↓

LIEBERMANN ↓

↑ WANDERING ARMOR

↖ PUTRIFIDO

SHADOW ↖

Unused monster/Drac the Vlad/Unused monster/
Restless Armor/Putrefido/Stark Raven/Shadow (1988)

ETHEREAL SERPENT ↓

RAMPAGE ↙

LIZARDMAN ↑

↖ MANTICORE

TROLL ↖

Ethereal Serpent/Rampage/Unused monster/Infanticore/Boss Troll (1988)

Famicom • *DRAGON QUEST IV: Chapters of the Chosen* • Package Art (1990)

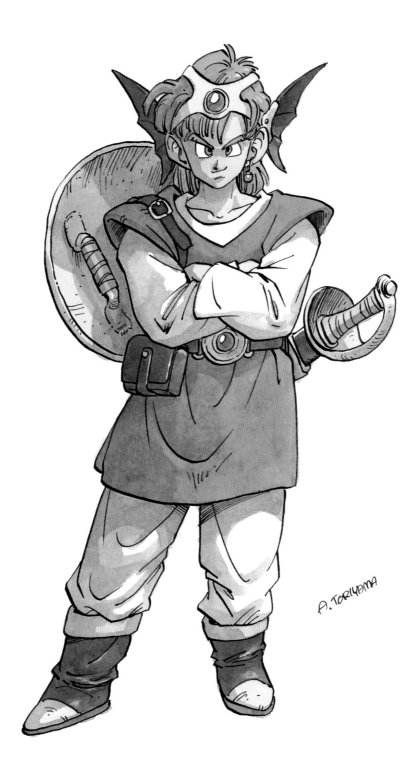

A. TORIYAMA

Male Hero (1990)

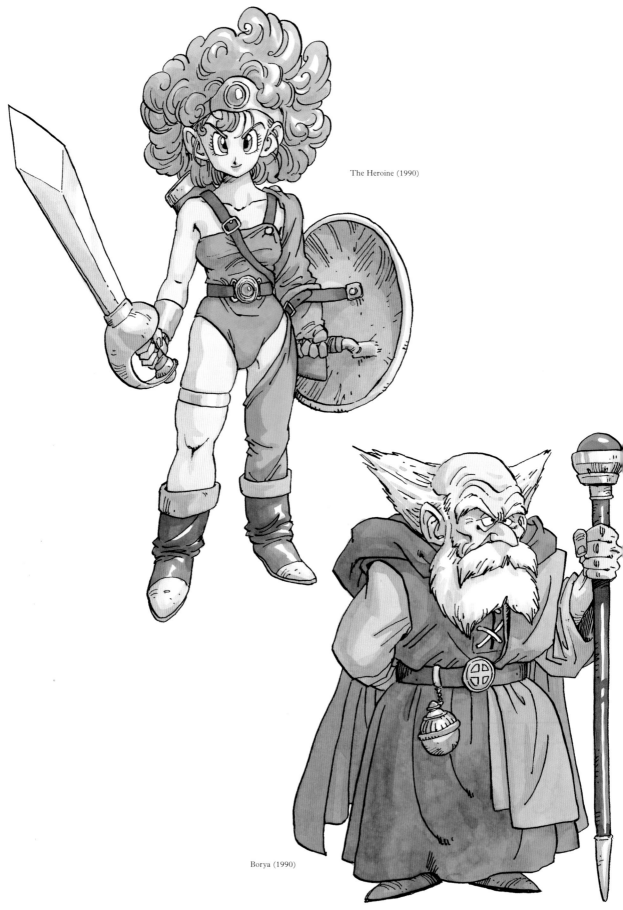

The Heroine (1990)

Borya (1990)

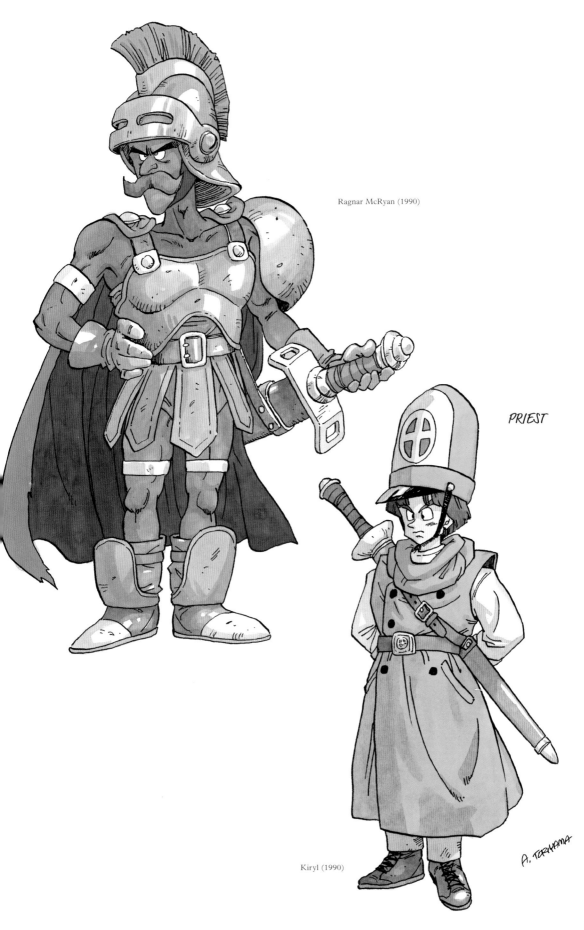

Ragnar McRyan (1990)

PRIEST

Kiryl (1990)

A. TORIYAMA

39

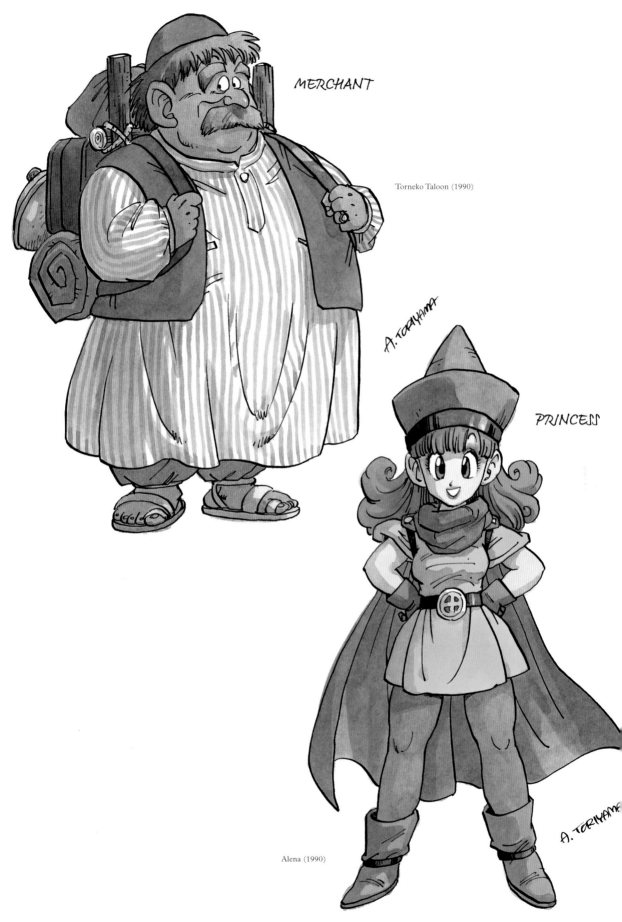

MERCHANT

Torneko Taloon (1990)

A. TORIYAMA

PRINCESS

Alena (1990)

A. TORIYAMA

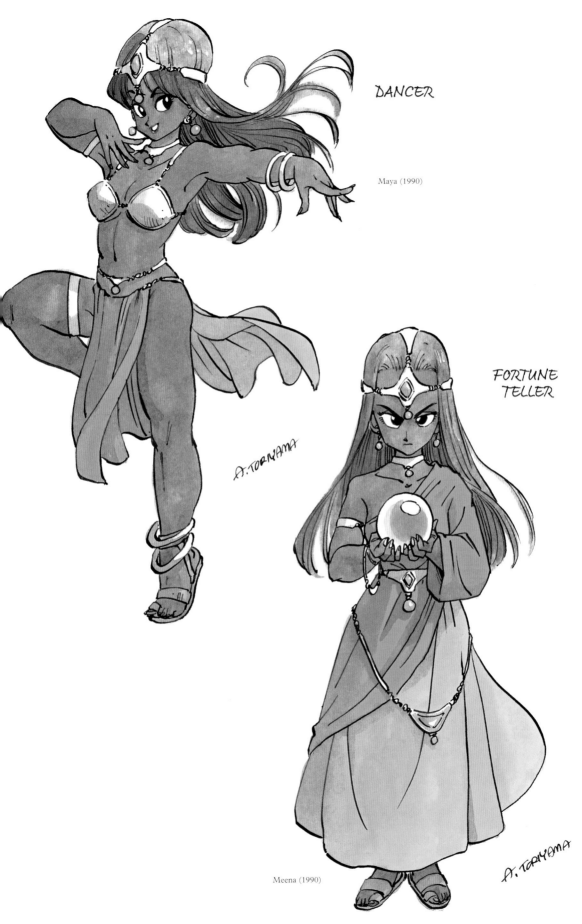

DANCER

Maya (1990)

FORTUNE
TELLER

A. TORIYAMA

Meena (1990)

A. TORIYAMA

41

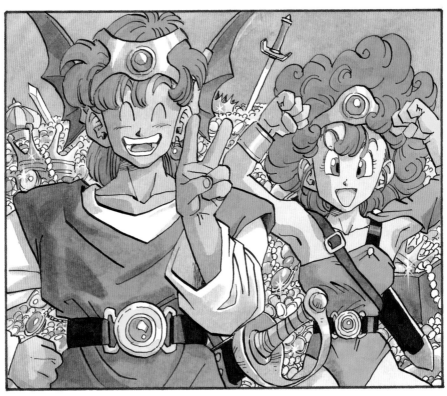

Famicom Shinken Ougi Daizensho: DRAGON QUEST IV Guide (Released February 21, 1990) Fold-Out Illustration

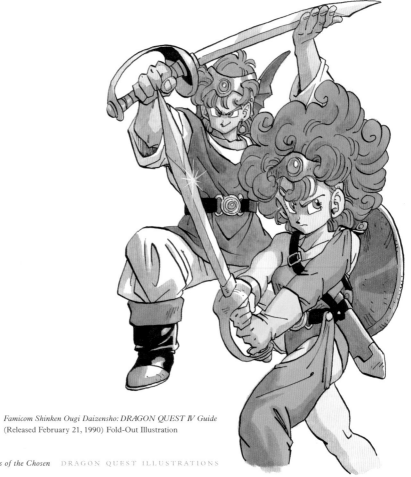

Famicom Shinken Ougi Daizensho: DRAGON QUEST IV Guide
(Released February 21, 1990) Fold-Out Illustration

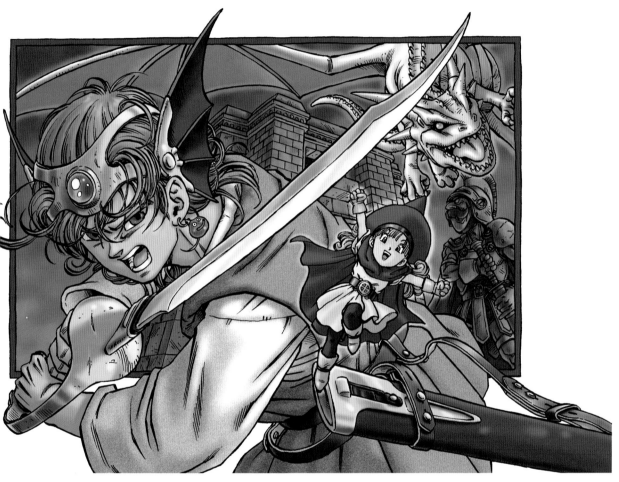

PlayStation • *DRAGON QUEST IV: Chapters of the Chosen* • Package Art (2001)

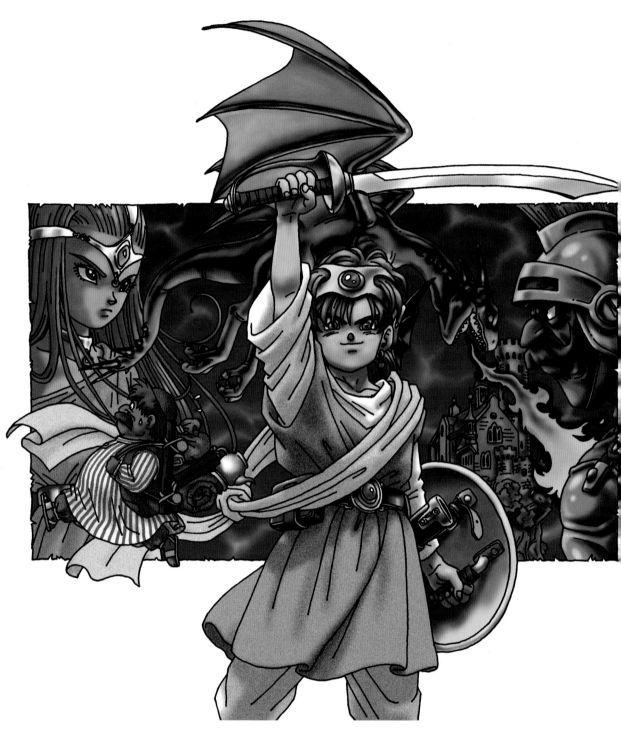

V Jump, January 2002 Issue (Released November 21, 2001) Cover Illustration

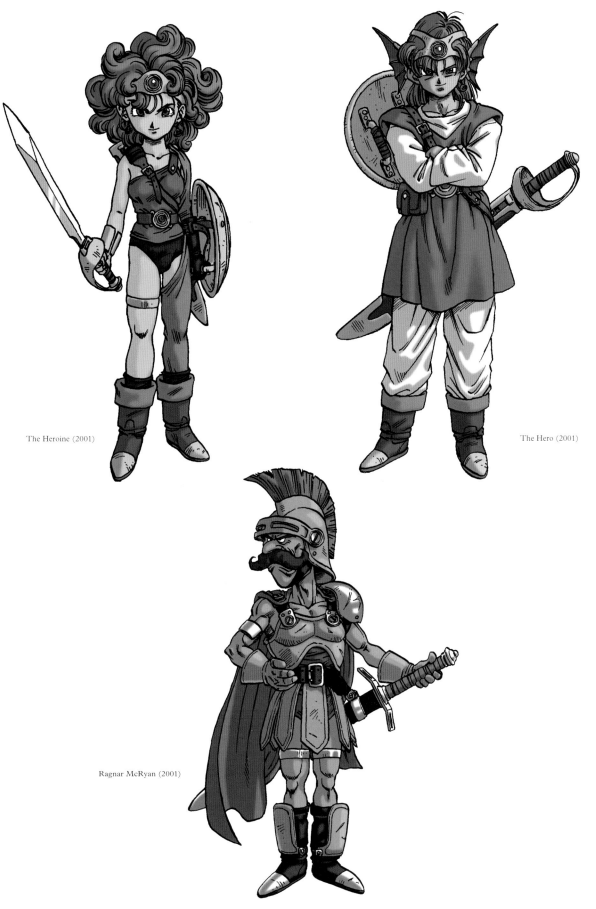

The Heroine (2001)

The Hero (2001)

Ragnar McRyan (2001)

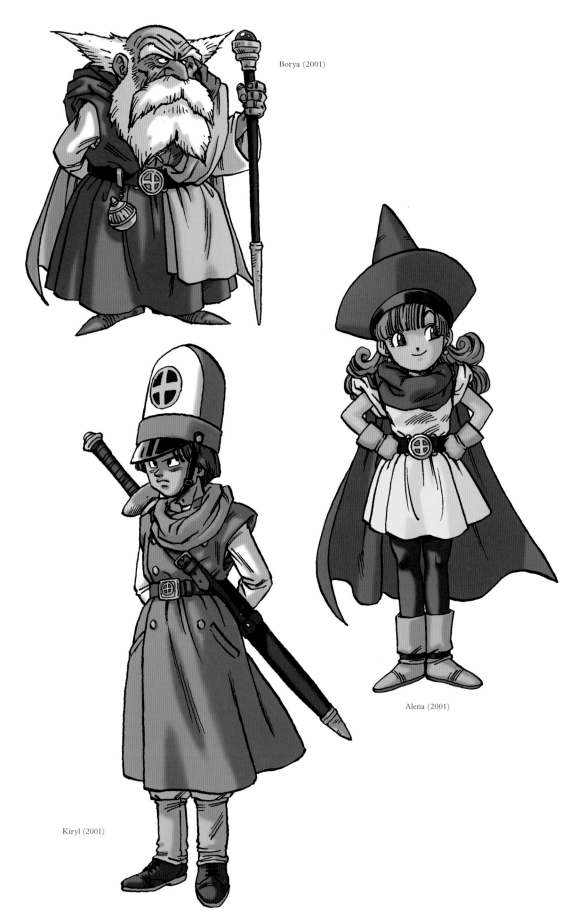

Borya (2001)

Alena (2001)

Kiryl (2001)

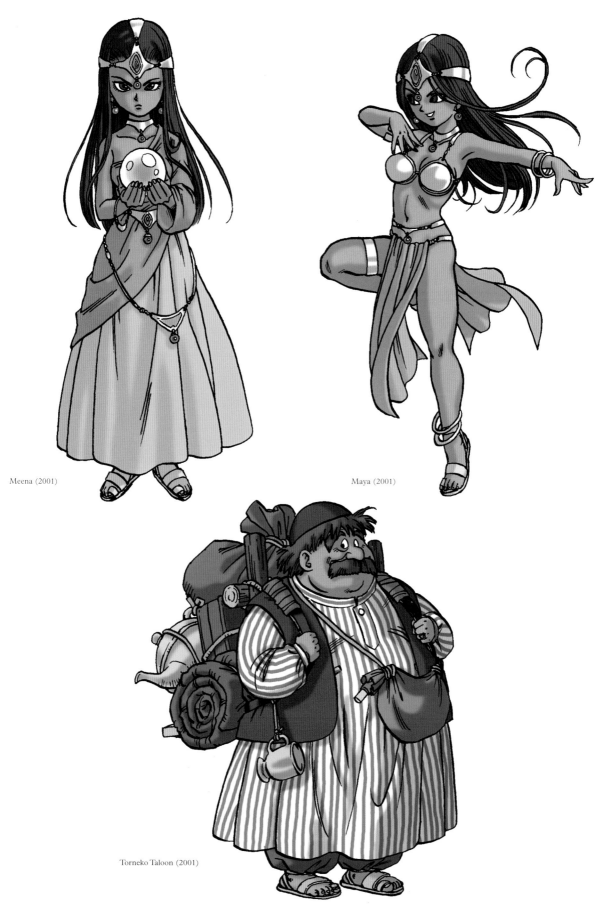

Meena (2001)

Maya (2001)

Torneko Taloon (2001)

47

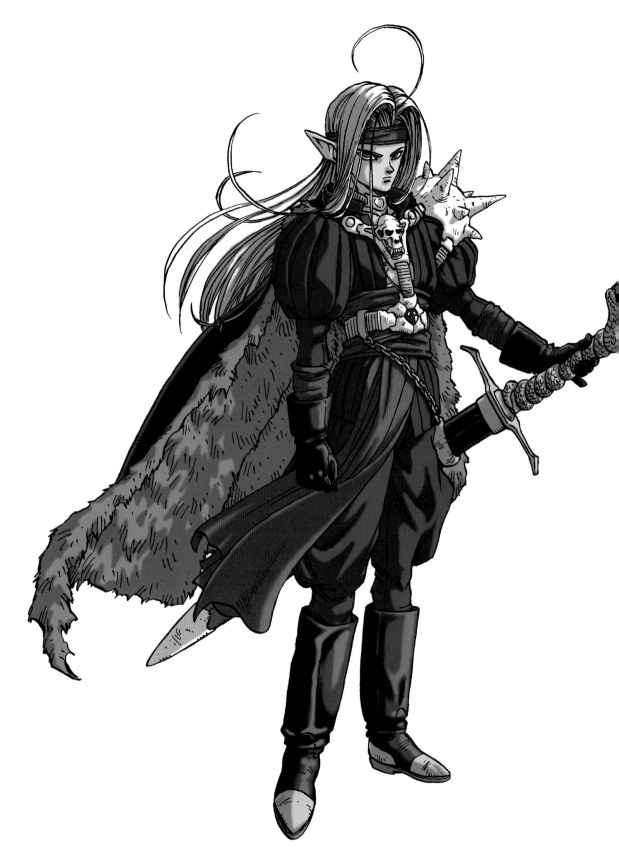

Psaro (2001)

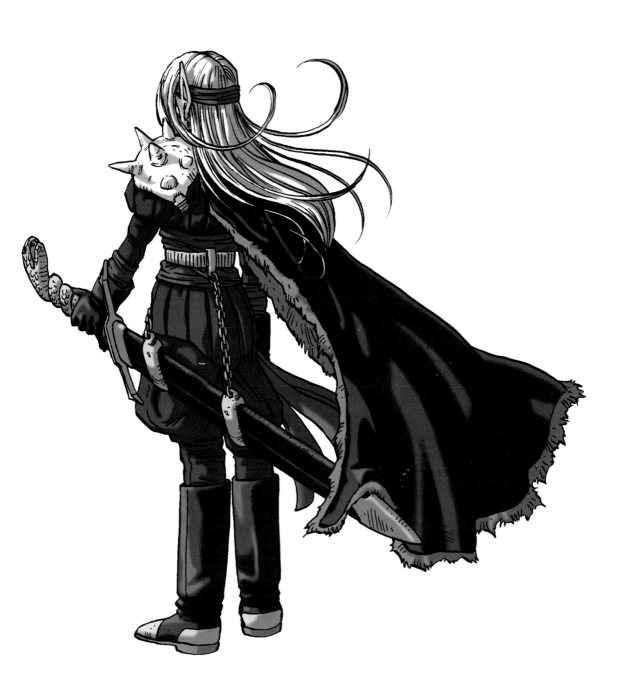

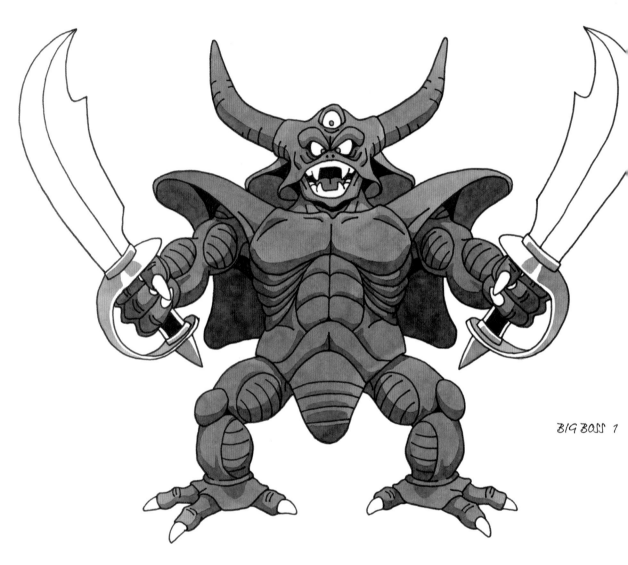

BIG BOSS 1

Psaro the Manslayer, First Form (1990)

Psaro the Manslayer, Final Form (1990)

BIG BOSS
POST-TRANSOFRMATION

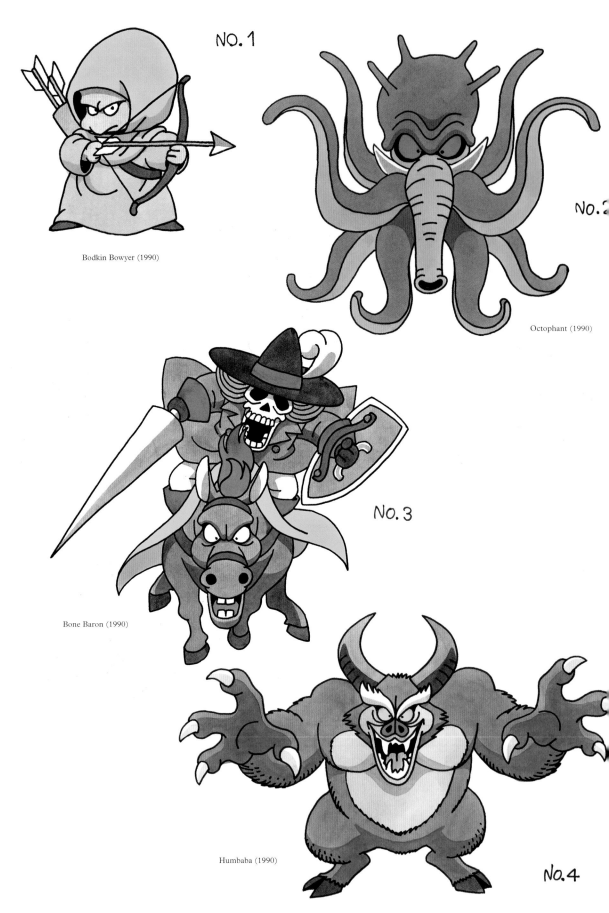

NO. 1

Bodkin Bowyer (1990)

NO. 2

Octophant (1990)

NO. 3

Bone Baron (1990)

Humbaba (1990)

NO. 4

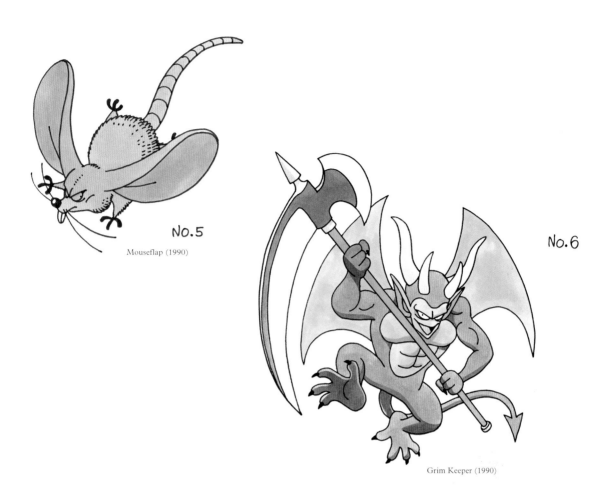

NO.5

Mouseflap (1990)

NO.6

Grim Keeper (1990)

NO.8

REVISED

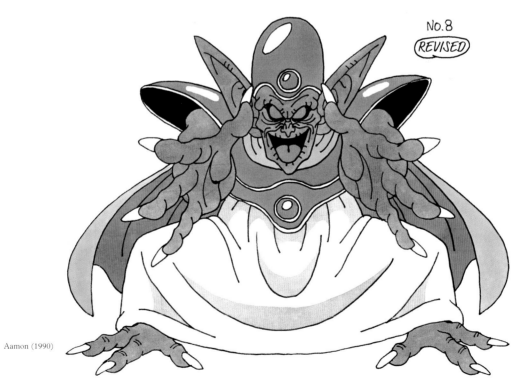

Aamon (1990)

53

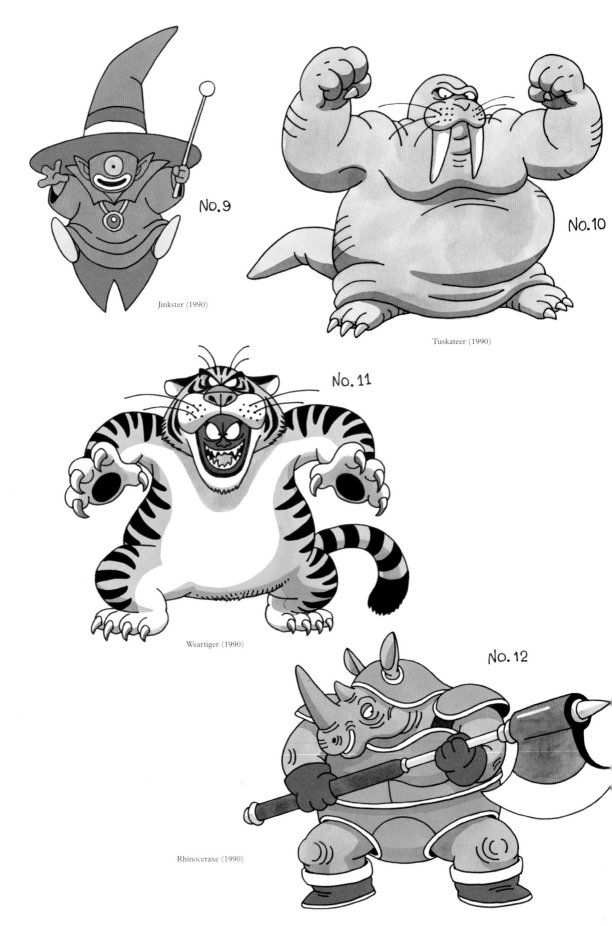

No. 9

Jinkster (1990)

No.10

Tuskateer (1990)

No. 11

Weartiger (1990)

No. 12

Rhinoceraxe (1990)

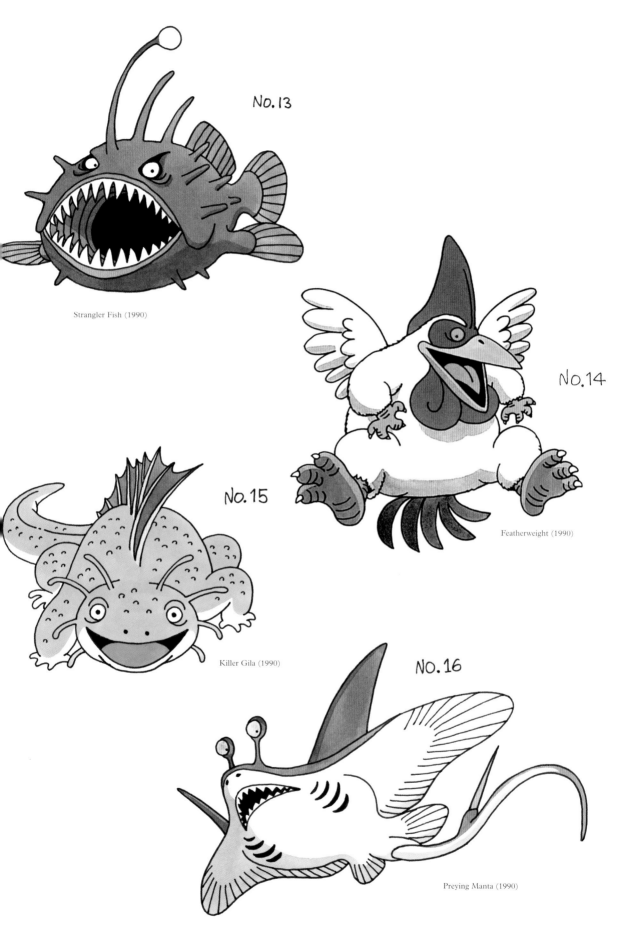

No. 13

Strangler Fish (1990)

No. 14

Featherweight (1990)

No. 15

Killer Gila (1990)

No. 16

Preying Manta (1990)

55

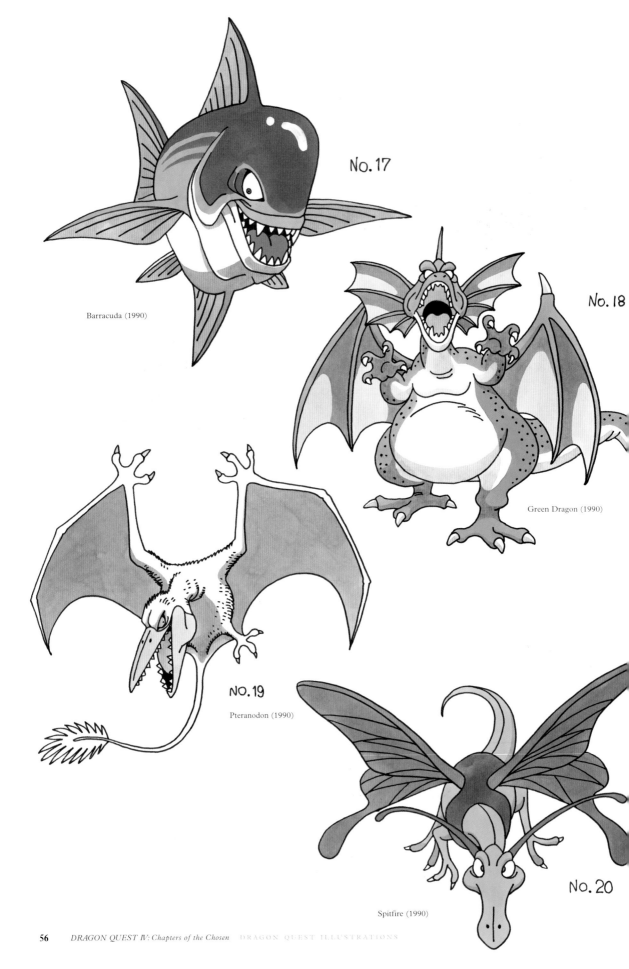

No. 17

Barracuda (1990)

No. 18

Green Dragon (1990)

No. 19

Pteranodon (1990)

No. 20

Spitfire (1990)

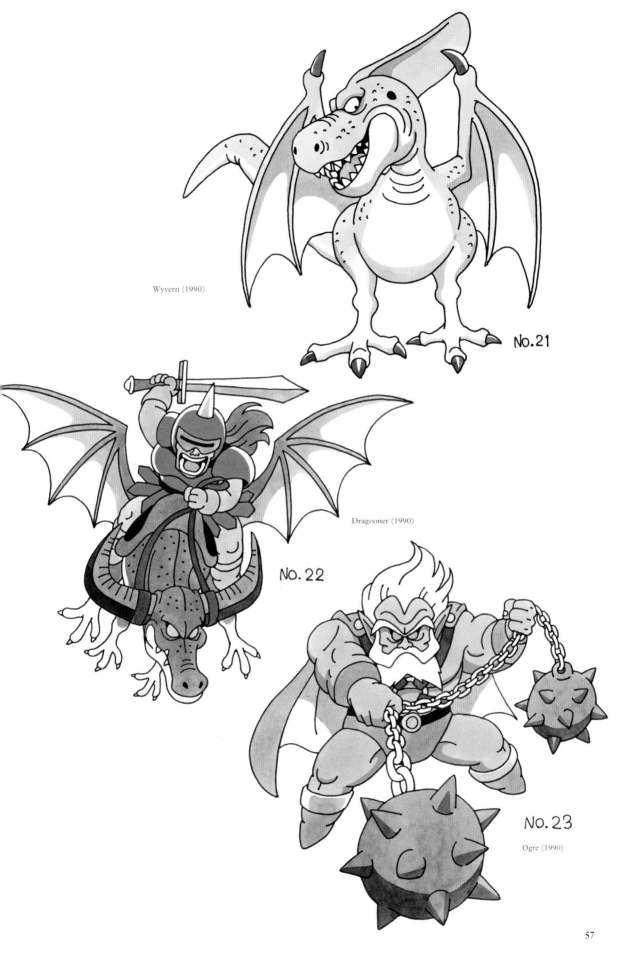

Wyvern (1990)

No.21

Dragooner (1990)

No. 22

No.23

Ogre (1990)

57

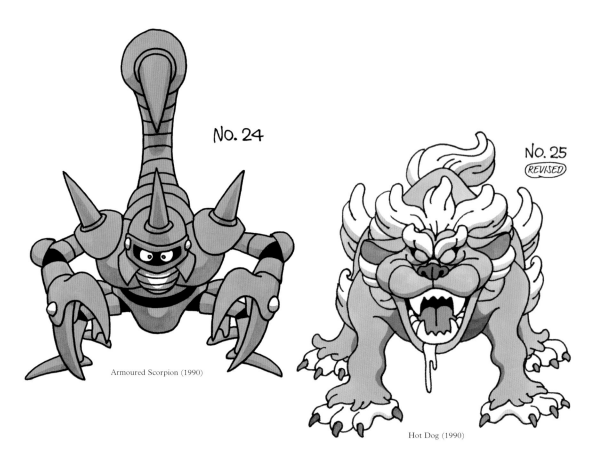

NO. 24

Armoured Scorpion (1990)

NO. 25
(REVISED)

Hot Dog (1990)

NO. 26
(REVISED)

Cyclown (1990)

No. 27

Carnivine (1990)

No. 28

Walking Stick (1990)

No. 29

Flamethrower (1990)

No. 30

Lost Soul (1990)

No. 31

Terracotta Warrior (1990)

TOP

No. 32

BOTTOM

Vampire Bat (1990)

No. 33

Fat Bat (1990)

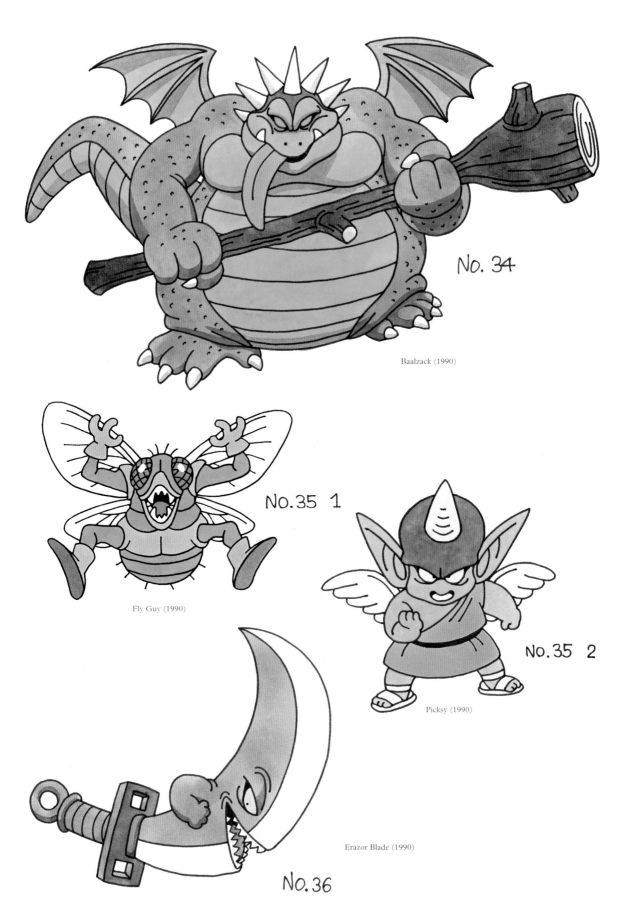

No. 34

Baalzack (1990)

No.35 1

Fly Guy (1990)

No.35 2

Picksy (1990)

Erazor Blade (1990)

No.36

61

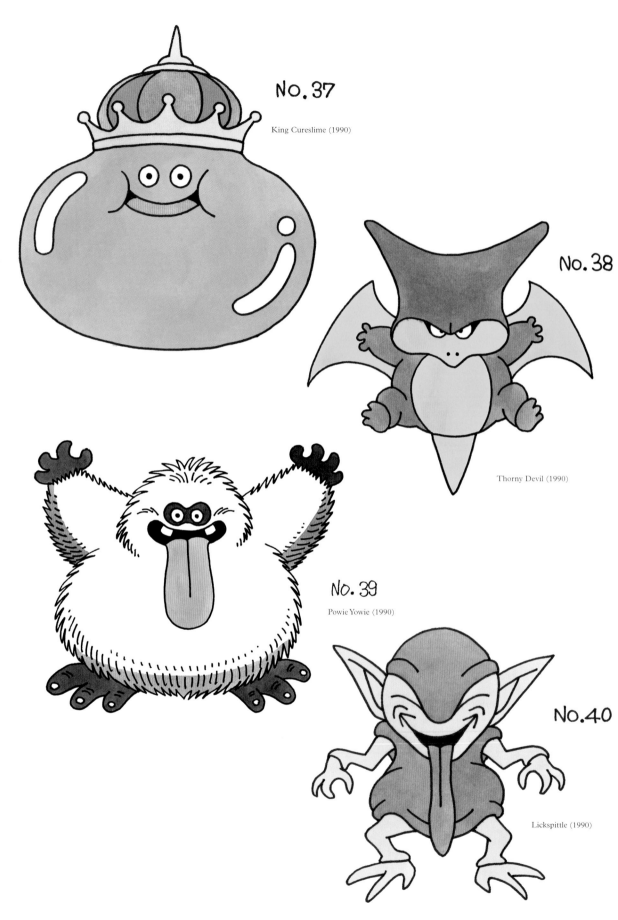

NO. 37

King Cureslime (1990)

NO. 38

Thorny Devil (1990)

NO. 39

Powie Yowie (1990)

NO. 40

Lickspittle (1990)

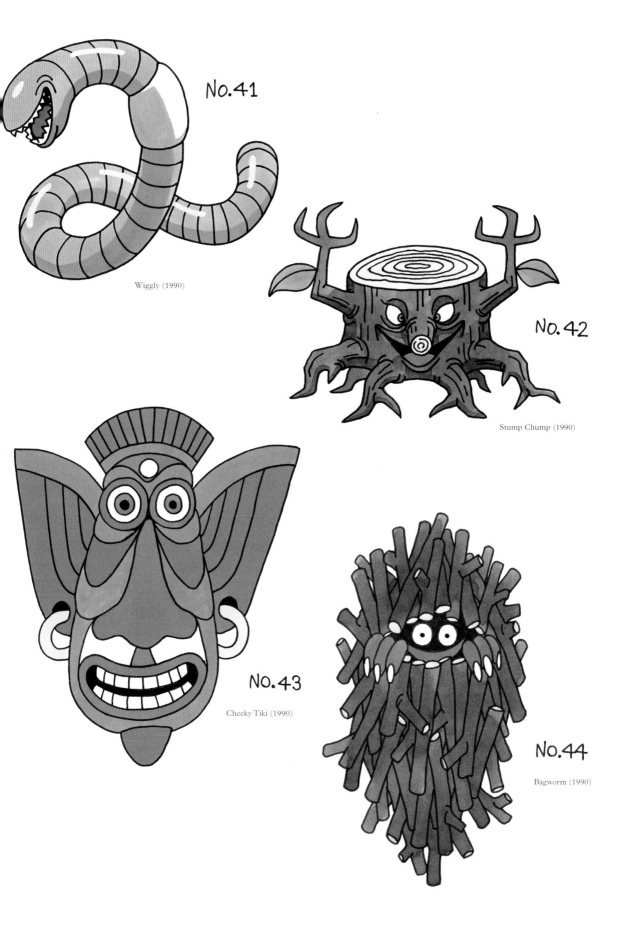

No.41

Wiggly (1990)

No.42

Stump Chump (1990)

No.43

Cheeky Tiki (1990)

No.44

Bagworm (1990)

63

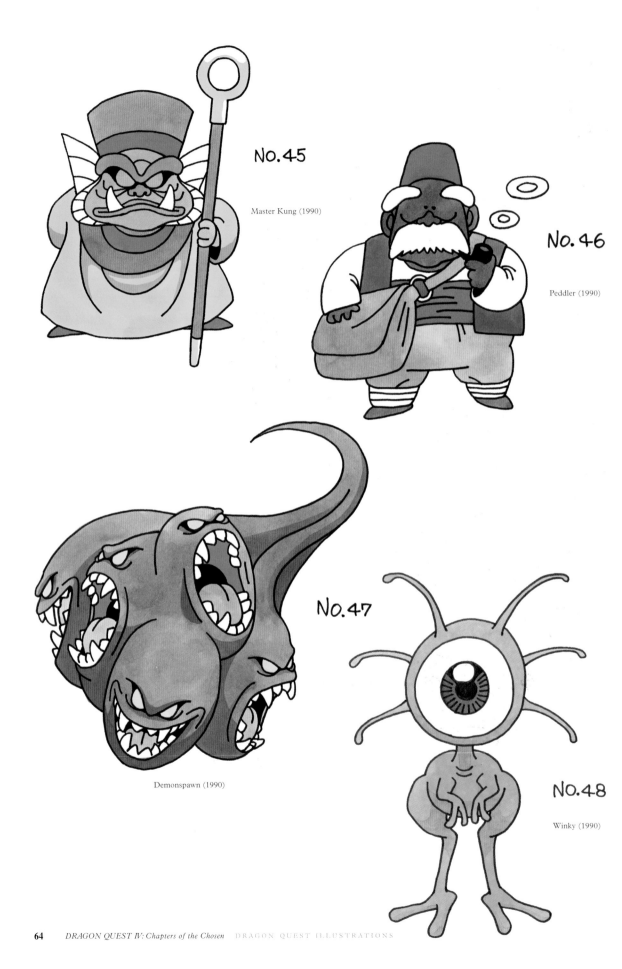

NO.45

Master Kung (1990)

NO.46

Peddler (1990)

NO.47

Demonspawn (1990)

NO.48

Winky (1990)

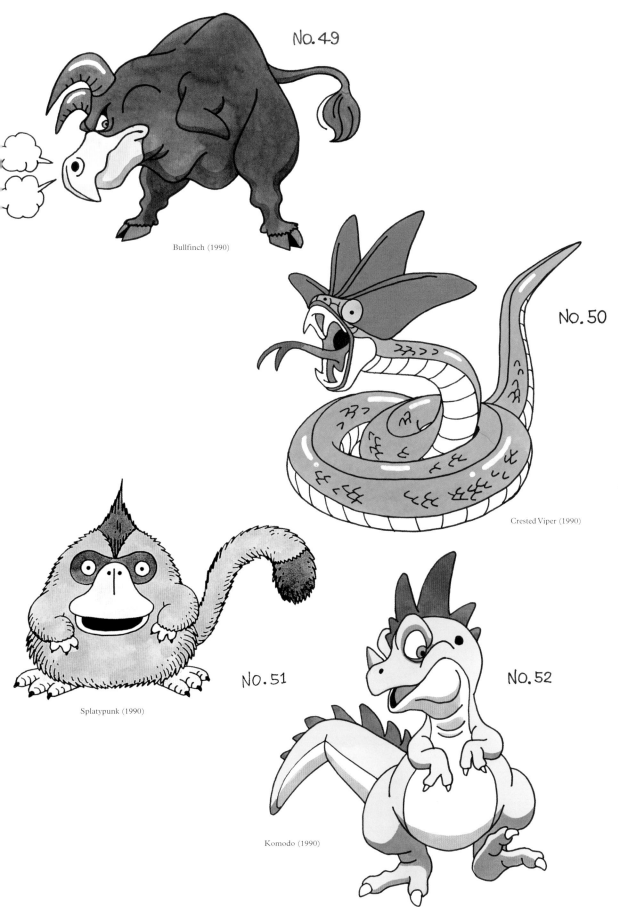

NO. 49

Bullfinch (1990)

NO. 50

Crested Viper (1990)

NO. 51

Splatypunk (1990)

NO. 52

Komodo (1990)

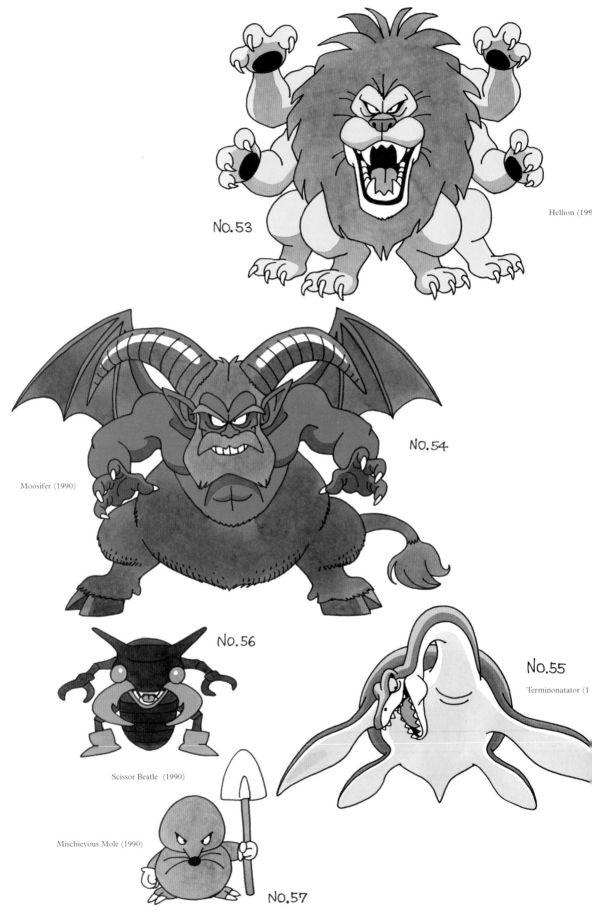

NO.53

Hellion (19

NO.54

Moosifer (1990)

NO.56

NO.55

Terminonatator (1

Scissor Beatle (1990)

Mischievous Mole (1990)

NO.57

Chow Mein (2001)

Foo Yung (2001)

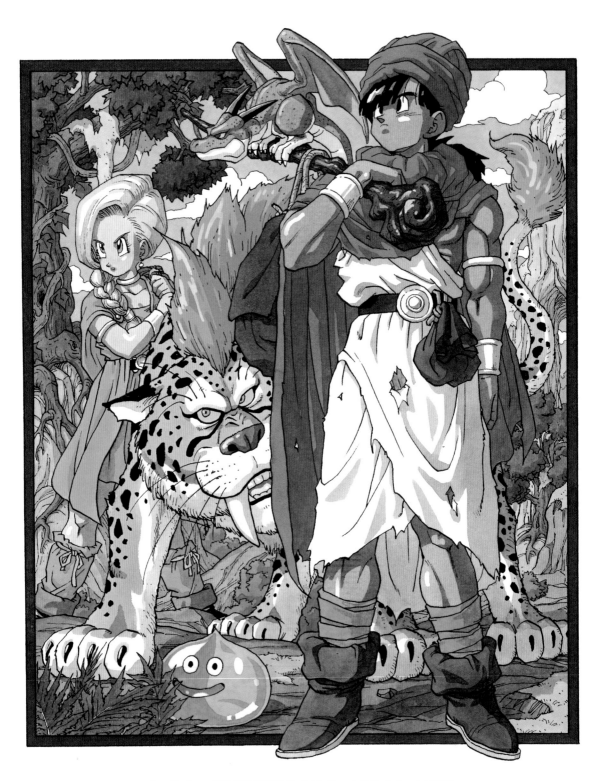

Super Famicom • *DRAGON QUEST V: Hand of the Heavenly Bride* • Package Art (1992)

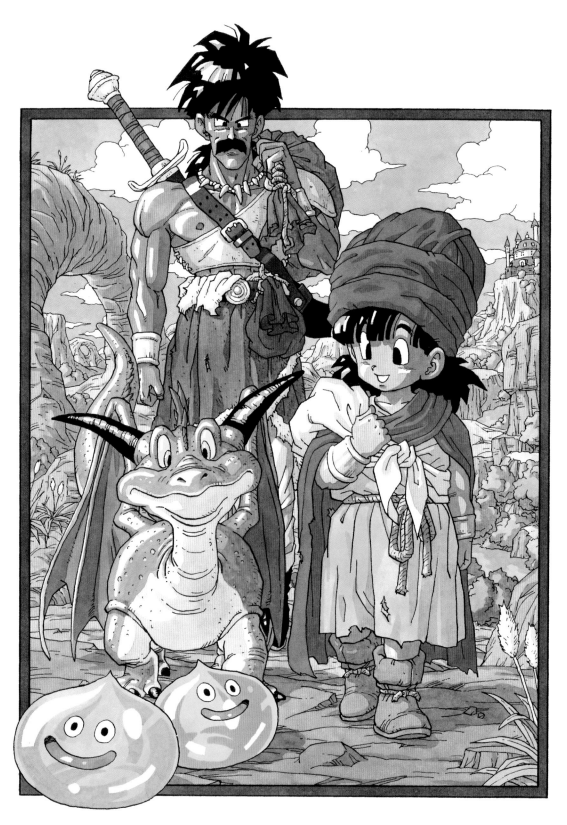

Super Famicom • *DRAGON QUEST V: Hand of the Heavenly Bride* • Instruction Manual Cover (1992)

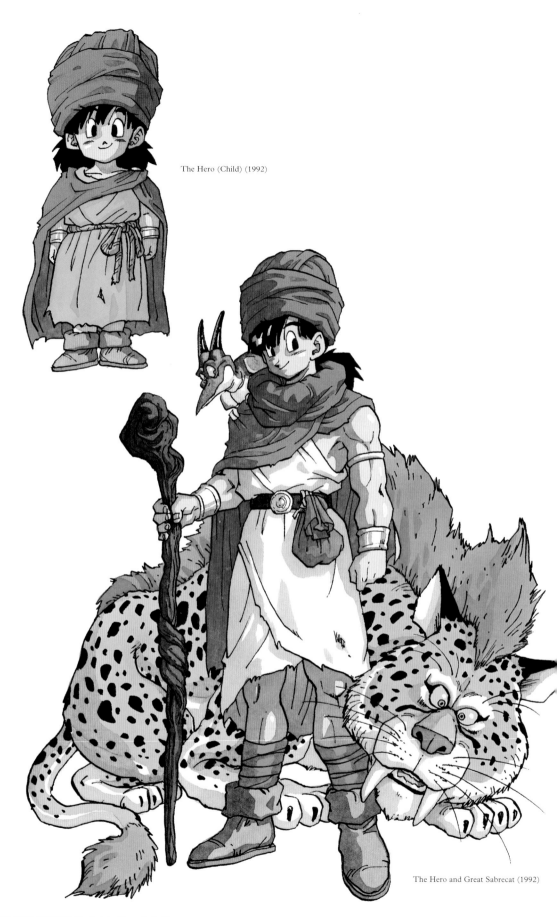

The Hero (Child) (1992)

The Hero and Great Sabrecat (1992)

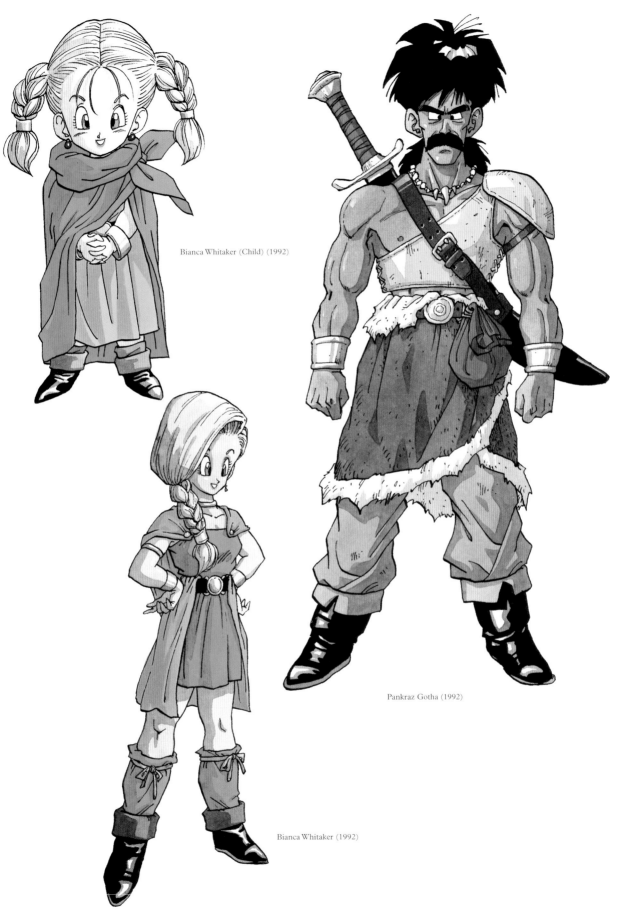

Bianca Whitaker (Child) (1992)

Pankraz Gotha (1992)

Bianca Whitaker (1992)

71

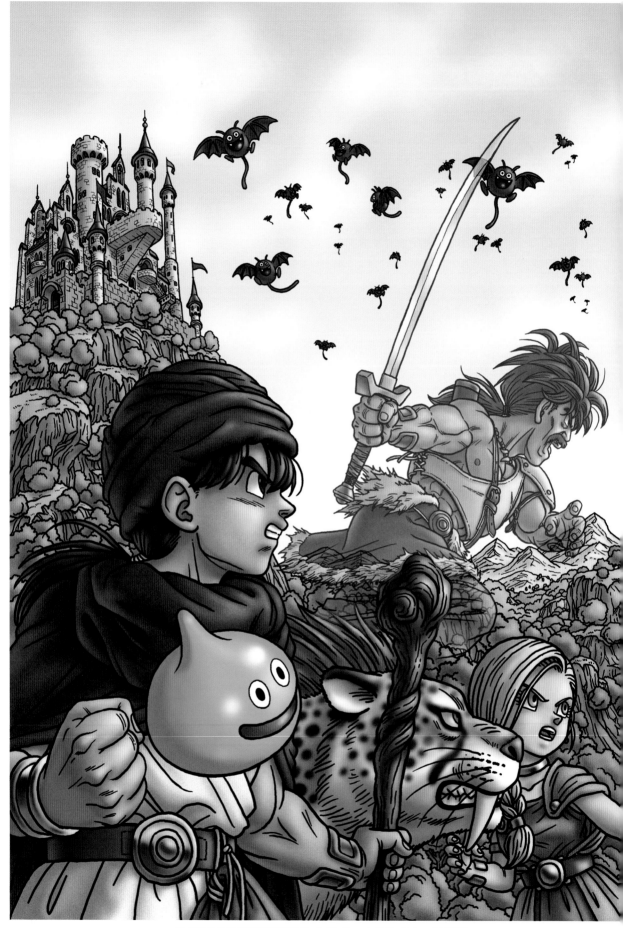

PlayStation 2 • *DRAGON QUEST V: Hand of the Heavenly Bride* • Package Art (2004)

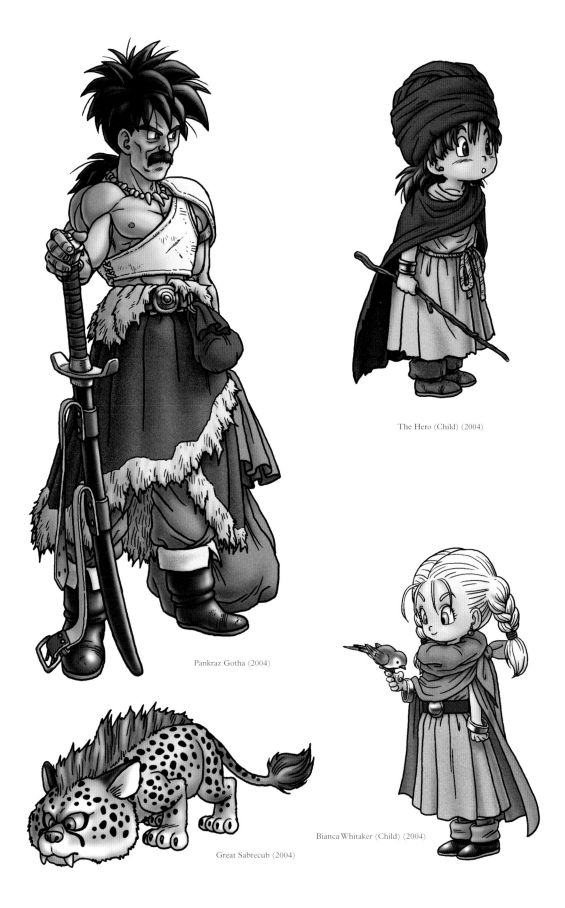

The Hero (Child) (2004)

Pankraz Gotha (2004)

Great Sabrecub (2004)

Bianca Whitaker (Child) (2004)

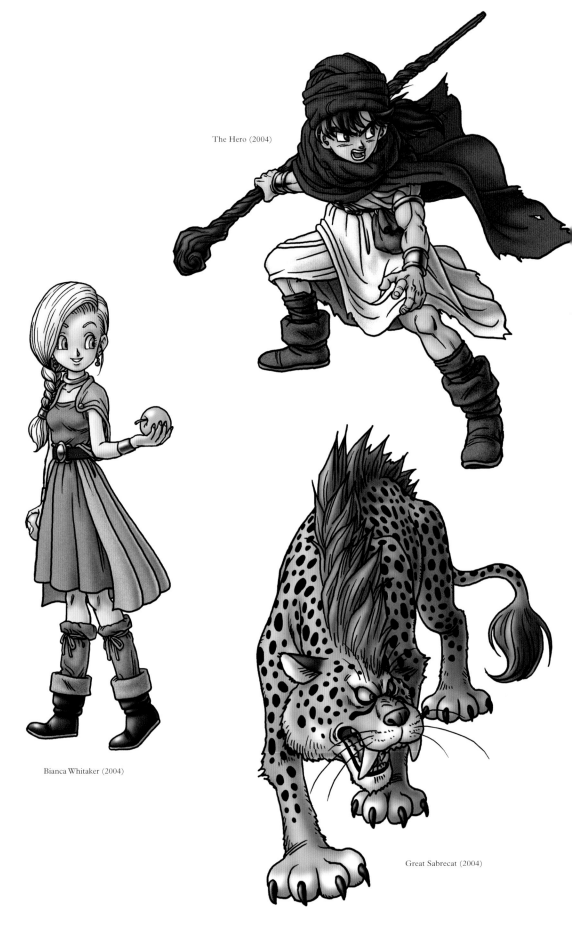

The Hero (2004)

Bianca Whitaker (2004)

Great Sabrecat (2004)

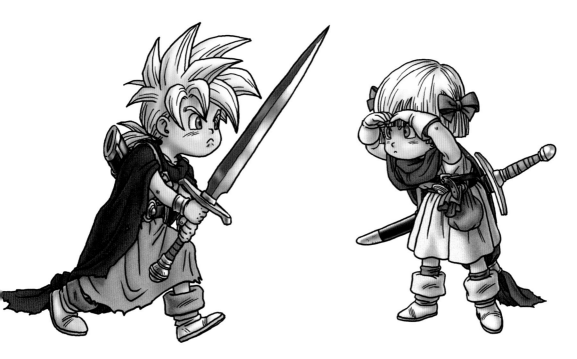

The Hero's Son (2004)

The Hero's Daughter (2004)

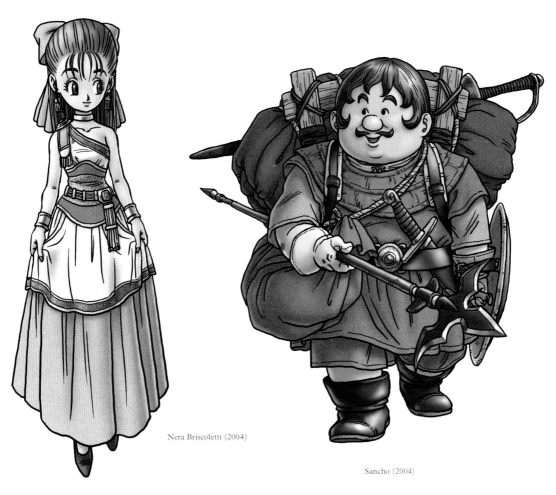

Nera Briscoletti (2004)

Sancho (2004)

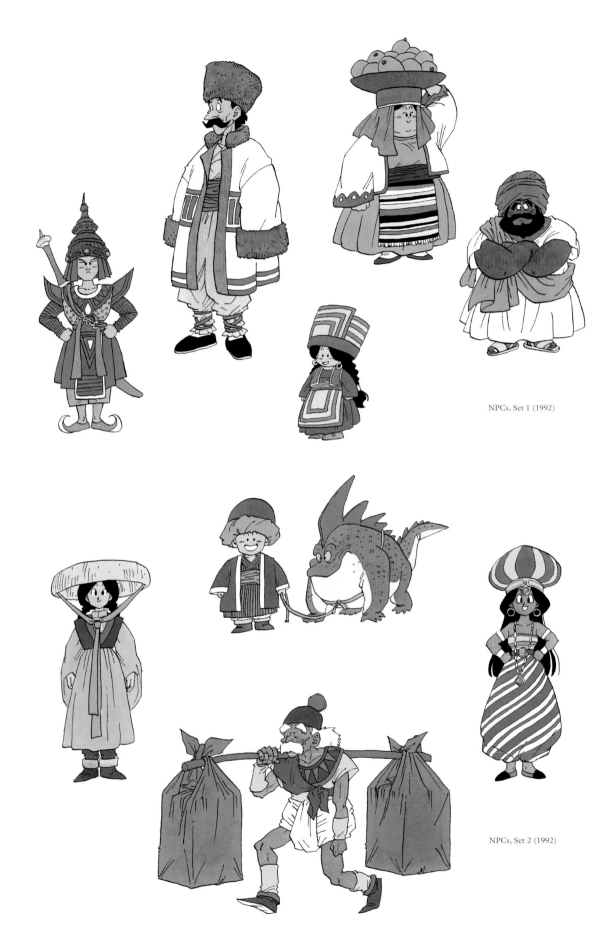

NPCs, Set 1 (1992)

NPCs, Set 2 (1992)

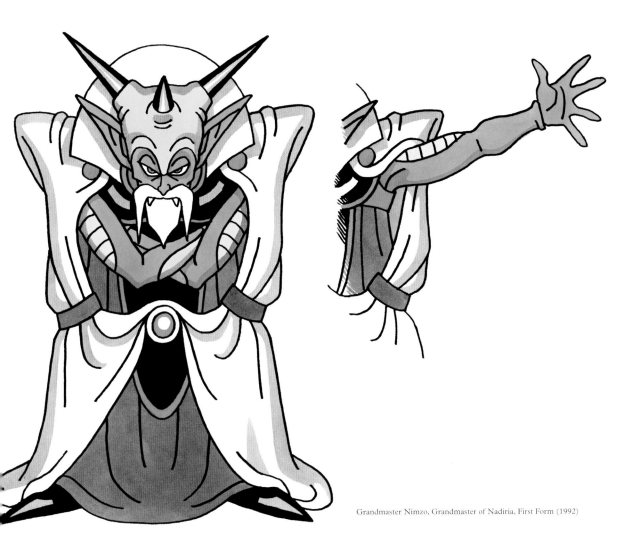

Grandmaster Nimzo, Grandmaster of Nadiria, First Form (1992)

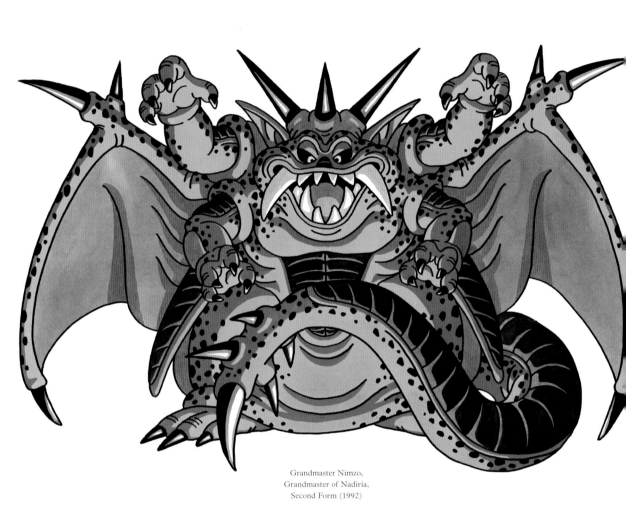

Grandmaster Nimzo,
Grandmaster of Nadiria,
Second Form (1992)

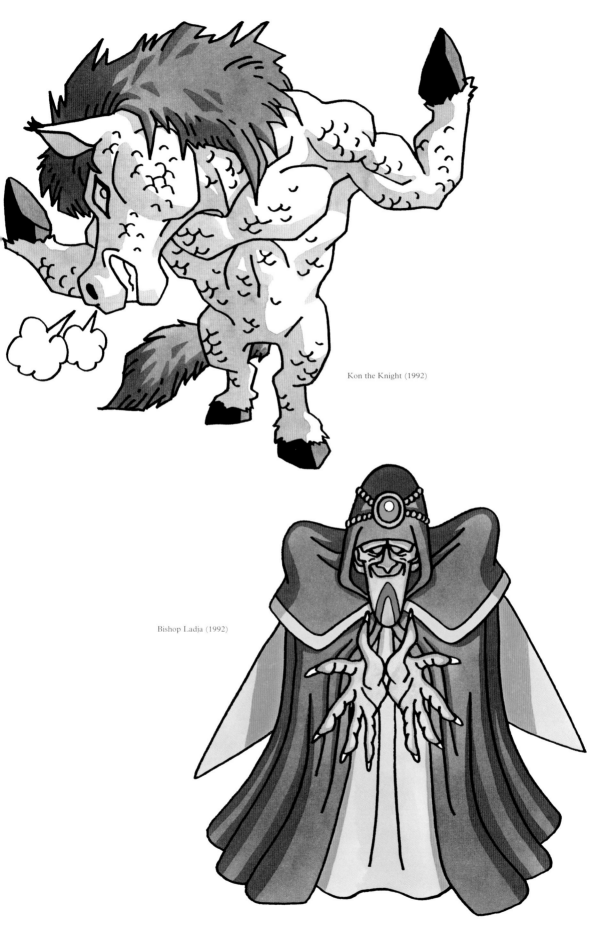

Kon the Knight (1992)

Bishop Ladja (1992)

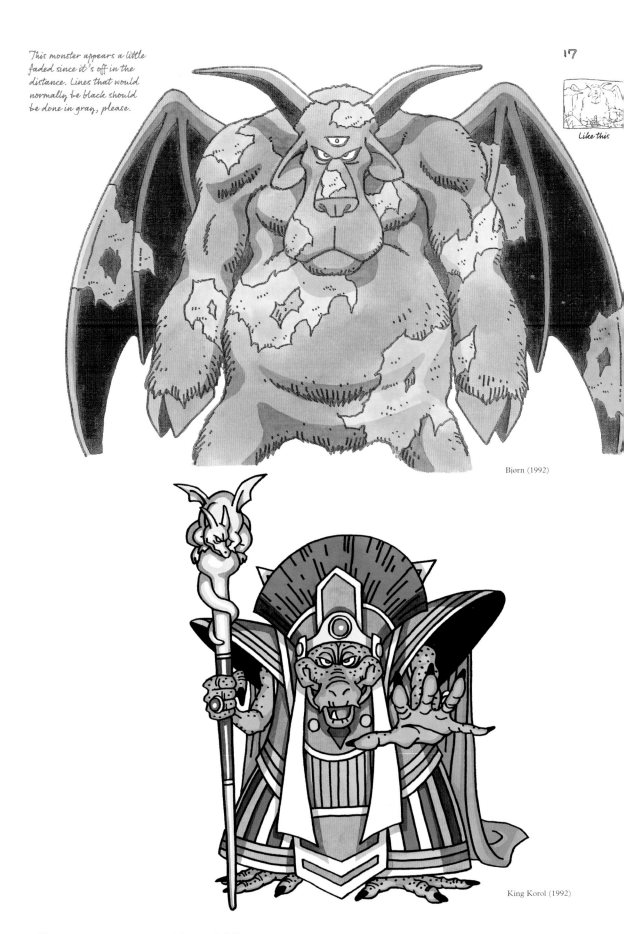

This monster appears a little faded since it's off in the distance. Lines that would normally be black should be done in gray, please.

Like this

Bjørn (1992)

King Korol (1992)

Urnexpected (1992)

Beastmaster (1992)

Hulagan (1992)

Hammerhood (1992)

Wax Murderer (1992)

Quadrahead (1992)

Gastank (1992)

Bad Apple (1992)

Pink Elephant (1992)

Great Sabrecat (1992)

Great Dragon (1992)

Combatterpillar (1992)

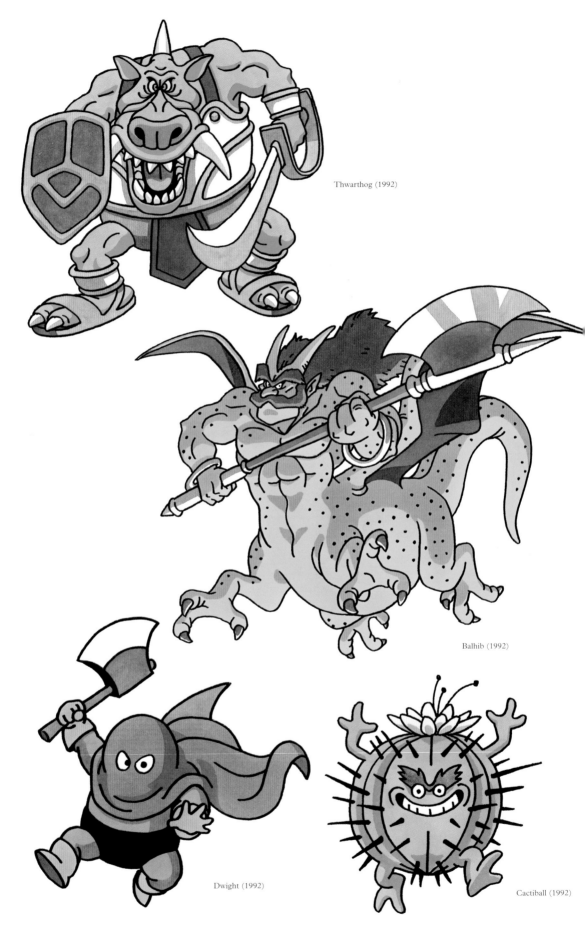

Thwarthog (1992)

Balhib (1992)

Dwight (1992)

Cactiball (1992)

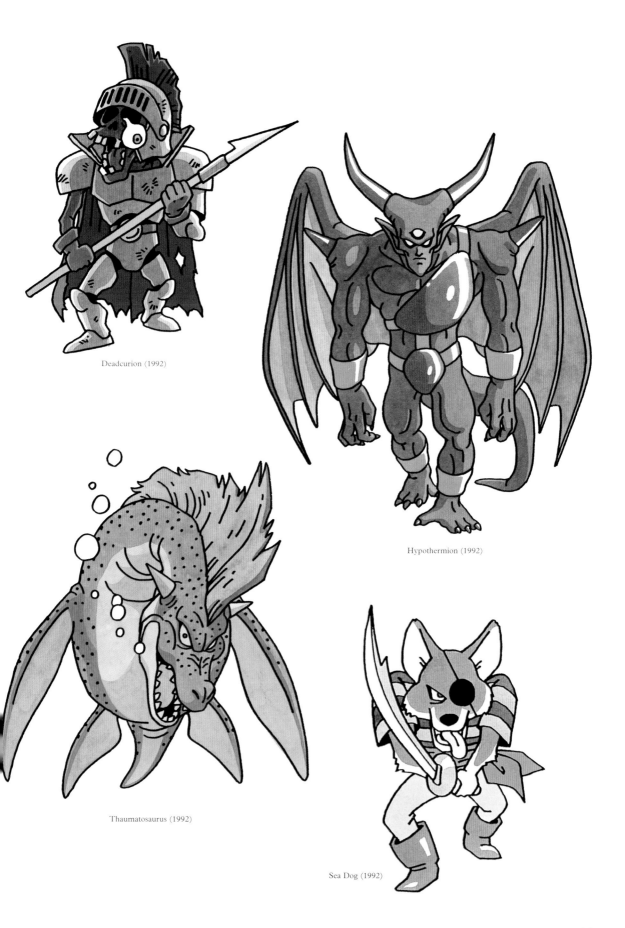

Deadcurion (1992)

Hypothermion (1992)

Thaumatosaurus (1992)

Sea Dog (1992)

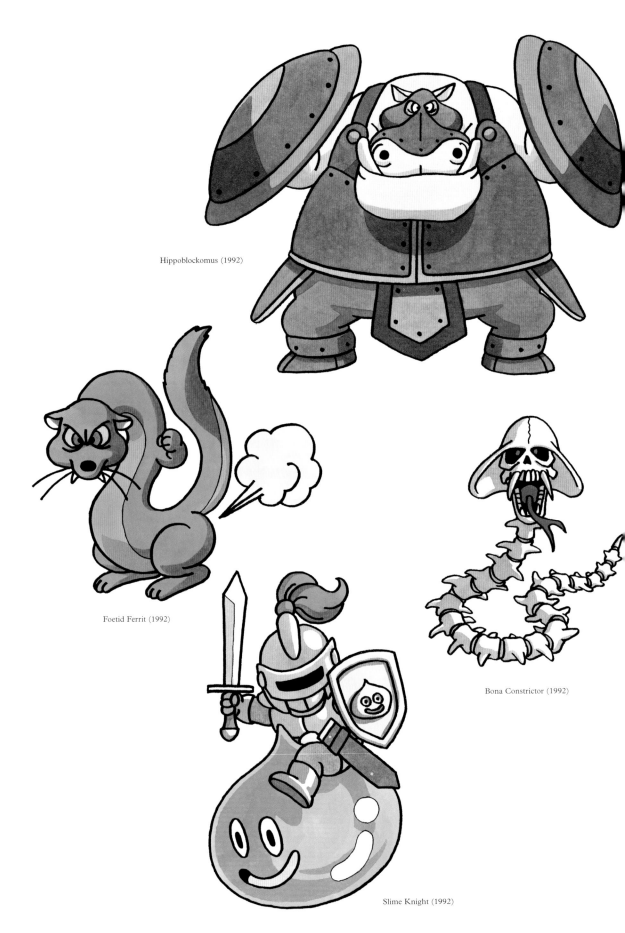

Hippoblockomus (1992)

Foetid Ferrit (1992)

Bona Constrictor (1992)

Slime Knight (1992)

Quack Up (1992)

Boring Bug (1992)

Snake Handler (1992)

Morphean Mollusc (1992)

Wight Prince (1992)

Mudraker (1992)

Drag-goof (1992)

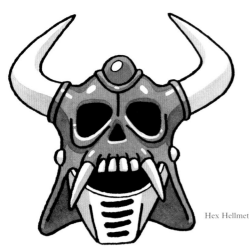

Hex Hellmet (1992)

Will-o'-the-Whips (1992)

Ticking Timeburrm (1992)

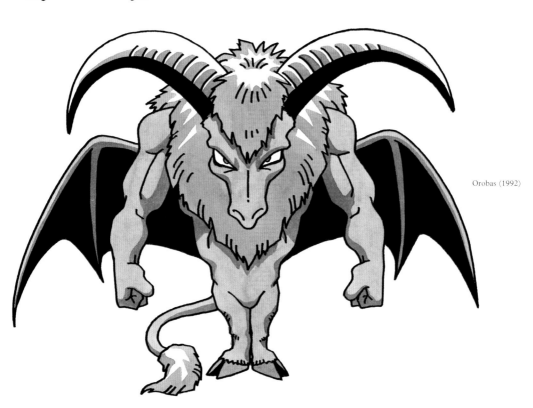

Orobas (1992)

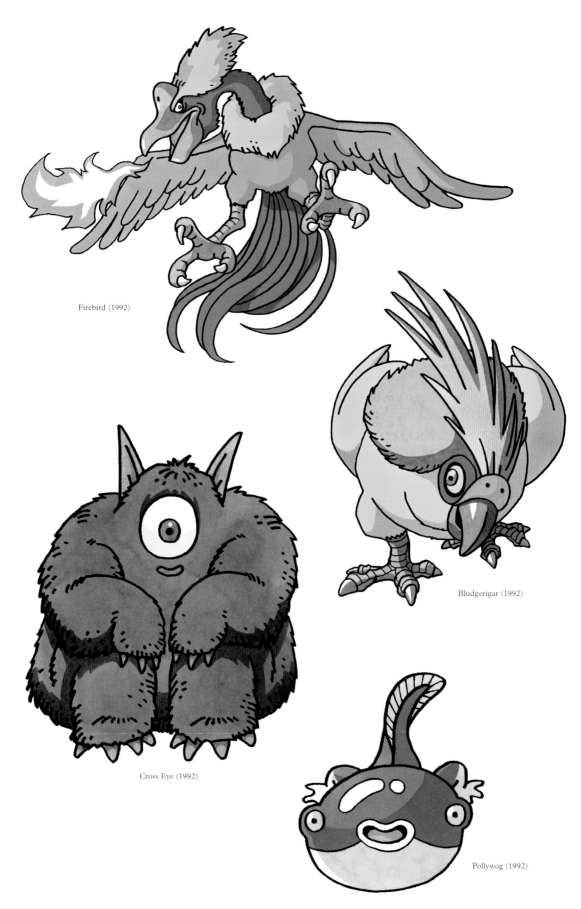

Firebird (1992)

Bludgerigar (1992)

Cross Eye (1992)

Pollywog (1992)

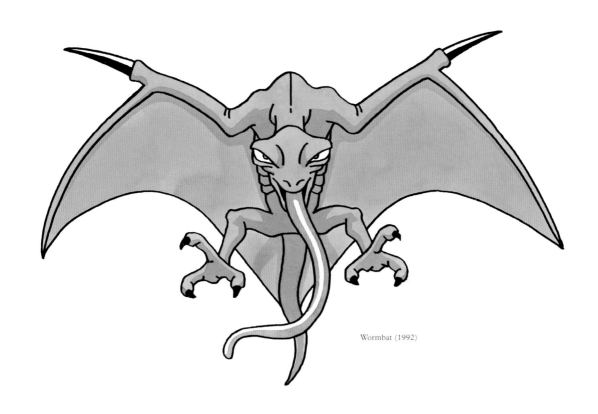

Wormbat (1992)

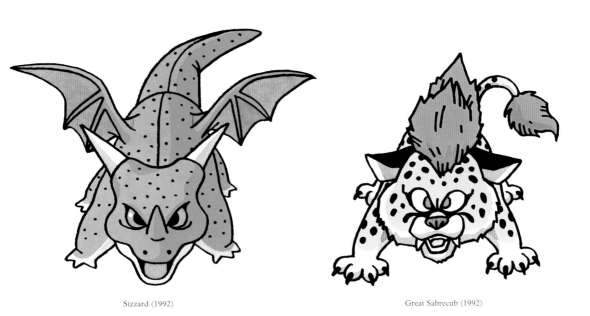

Sizzard (1992)

Great Sabrecub (1992)

Poxtongue (1992)

Mental Pitcher (1992)

Legerdeman (1992)

Wizened Wizard (1992)

Jowler (1992)

Metal Dragon (1992)

Cross Bones (1992)

Growlbear (1992)

Mandrake Major (1992)

Jiggery-Pokerer (1992)

Fire-Eater/Ice-Breaker (1992)

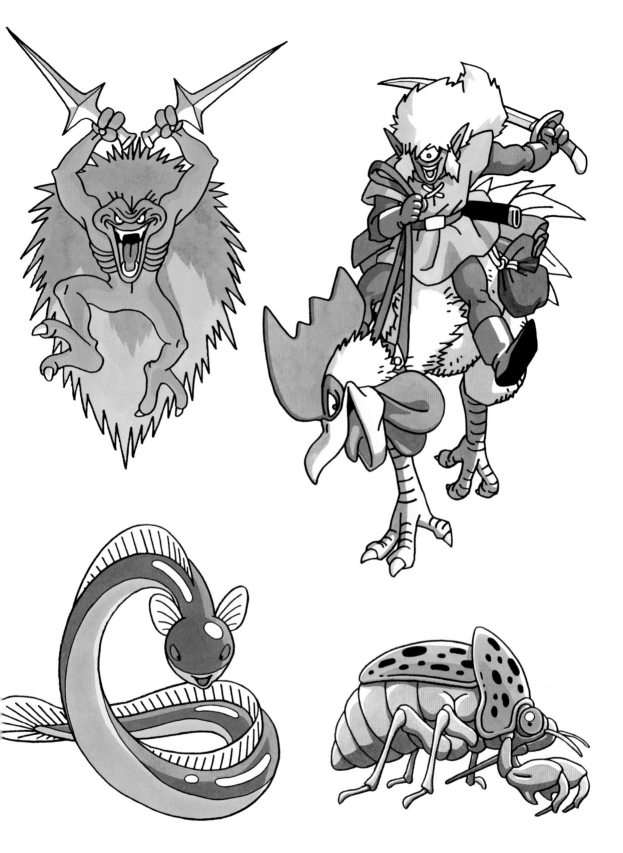

Four unused monsters (1992)

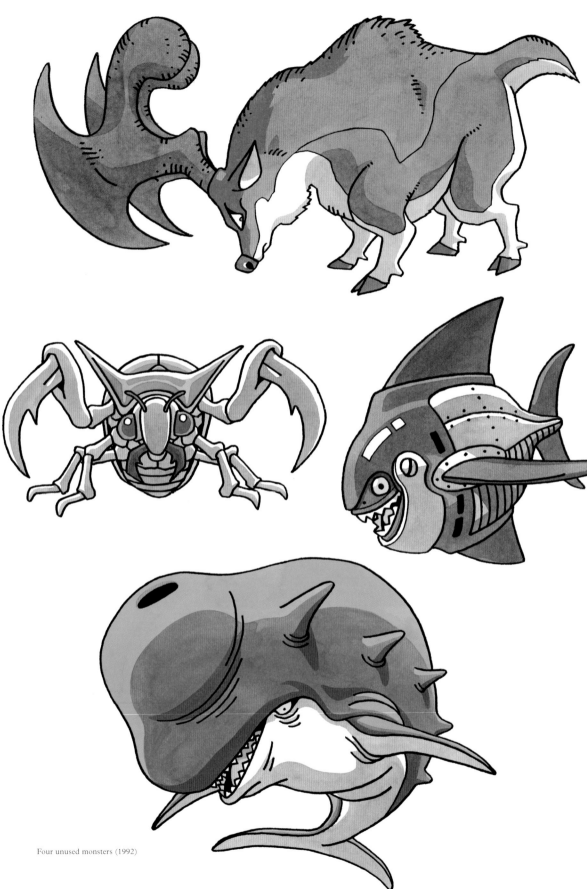

Four unused monsters (1992)

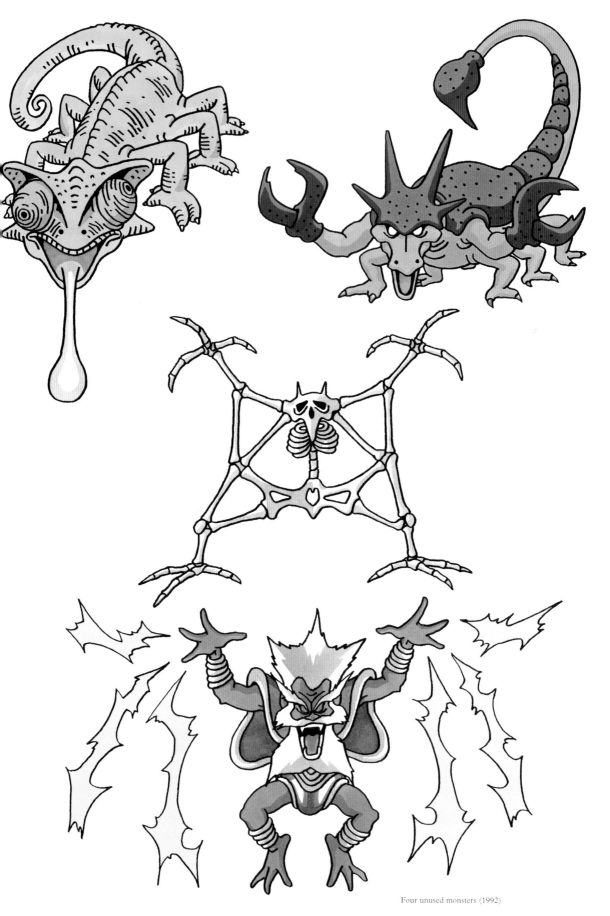

Four unused monsters (1992)

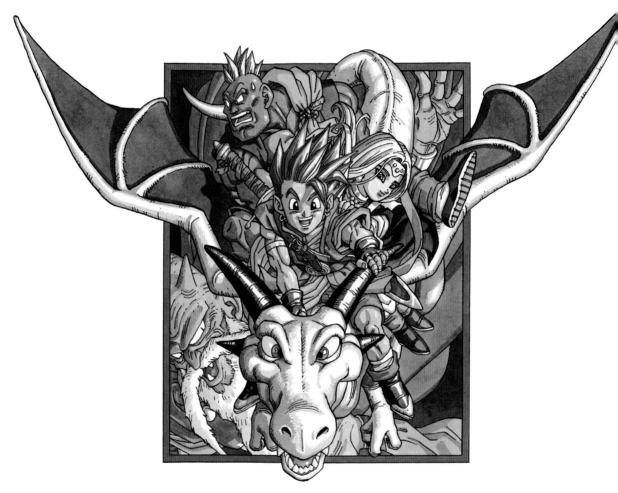

Super Famicom • *DRAGON QUEST VI: Realms of Revelation* • Package Art (1996)

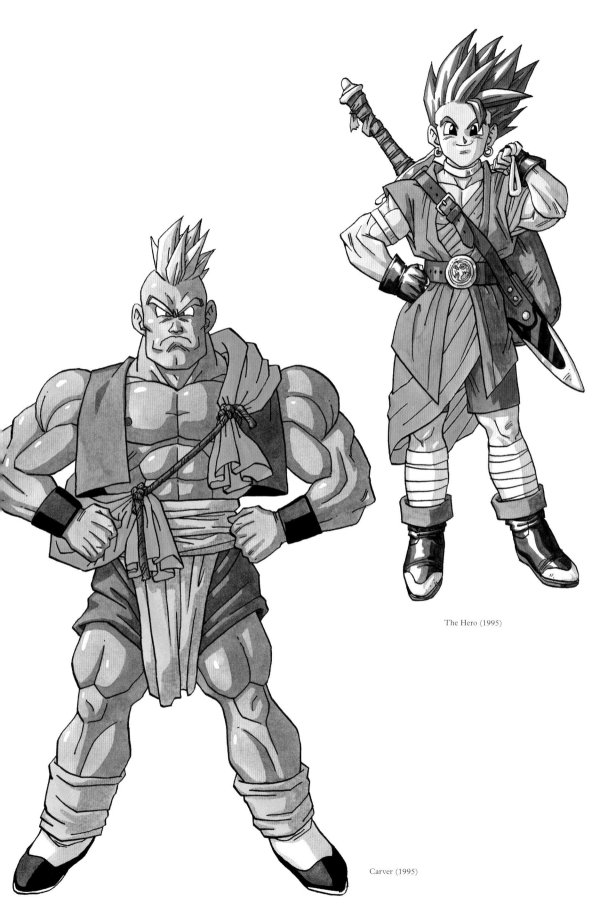

The Hero (1995)

Carver (1995)

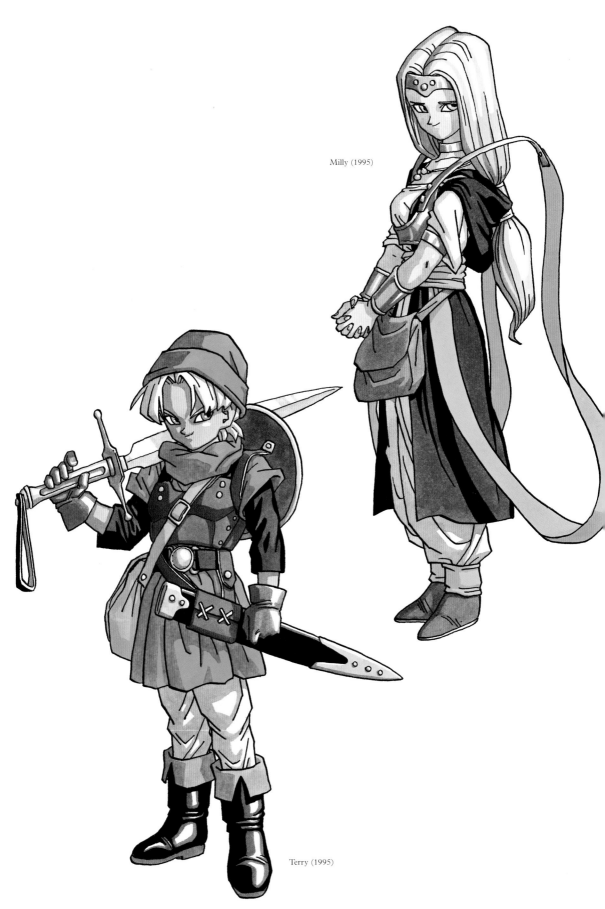

Milly (1995)

Terry (1995)

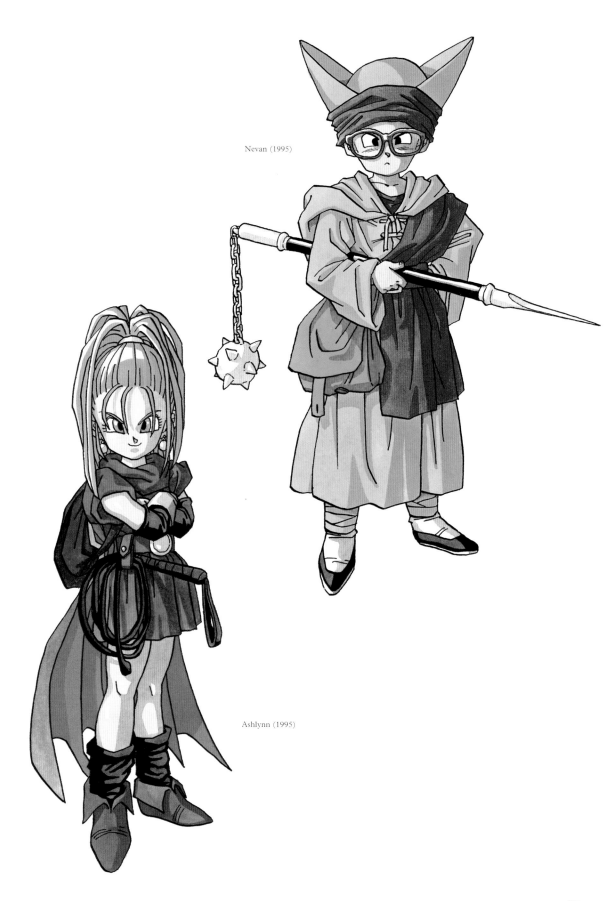

Nevan (1995)

Ashlynn (1995)

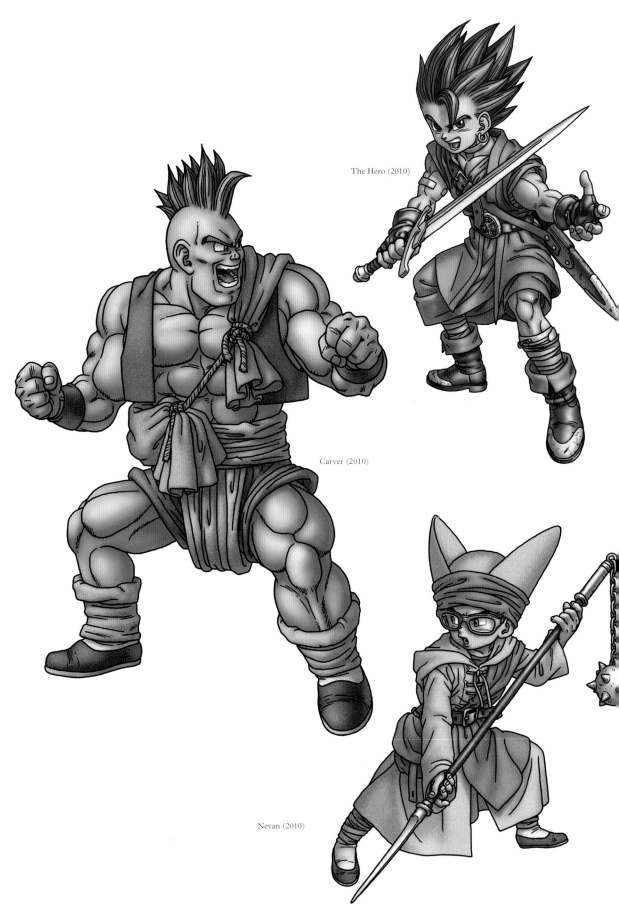

The Hero (2010)

Carver (2010)

Nevan (2010)

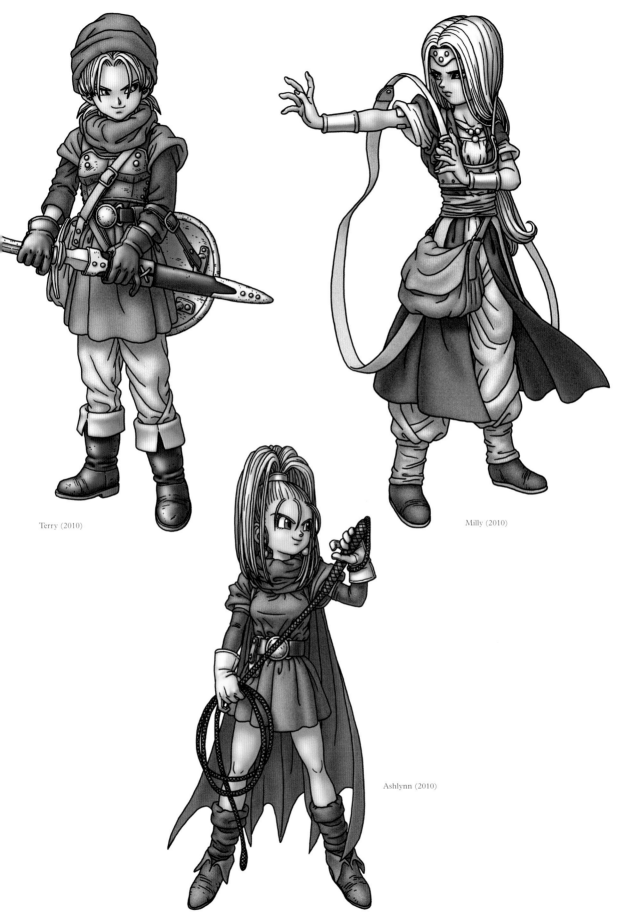

Terry (2010)

Milly (2010)

Ashlynn (2010)

103

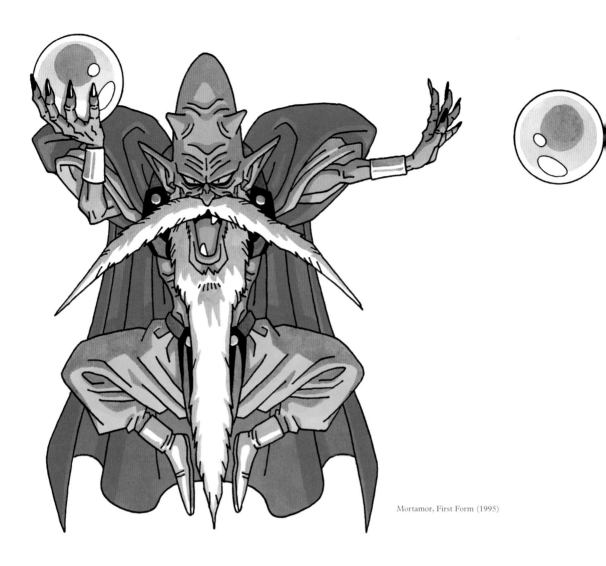

Mortamor, First Form (1995)

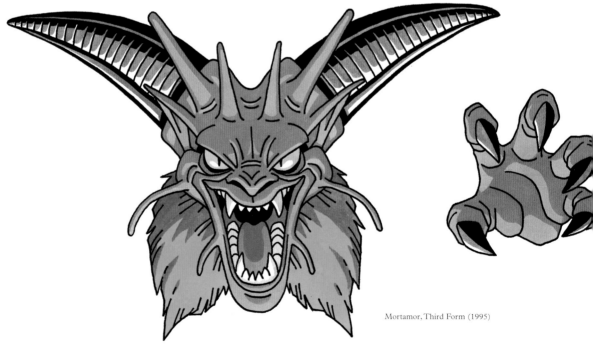

Mortamor, Third Form (1995)

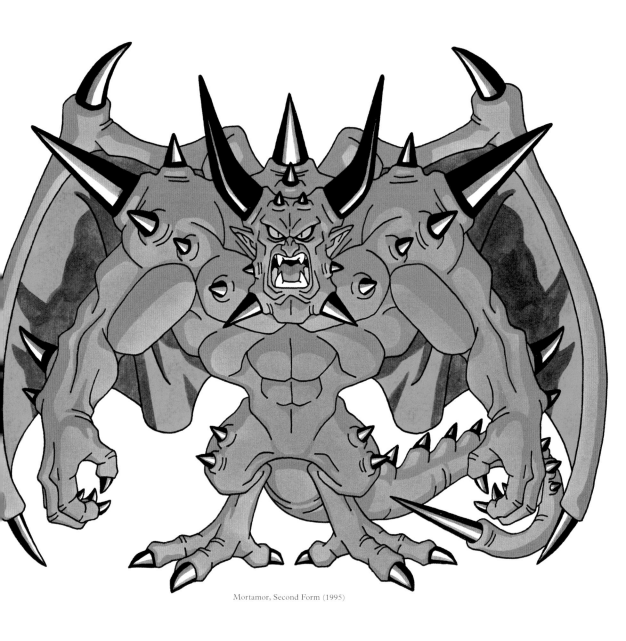

Mortamor, Second Form (1995)

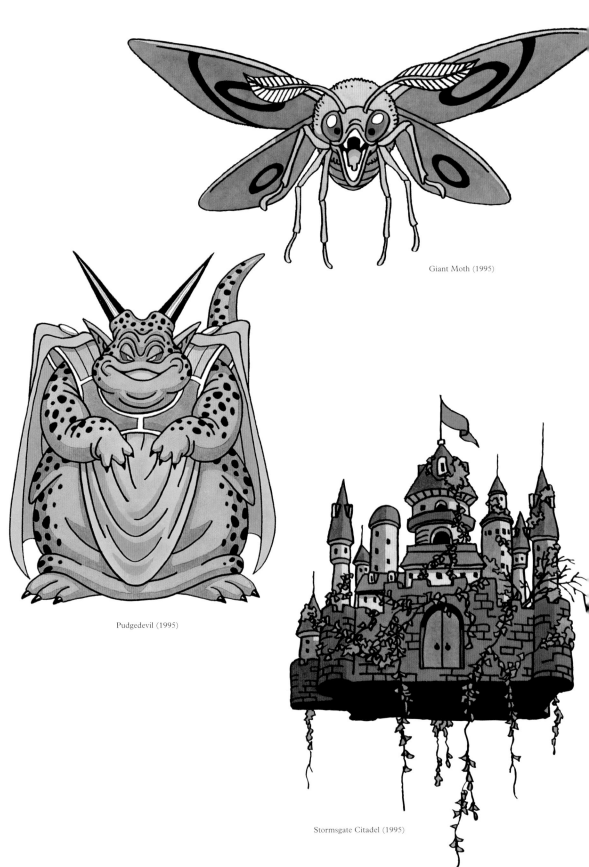

Giant Moth (1995)

Pudgedevil (1995)

Stormsgate Citadel (1995)

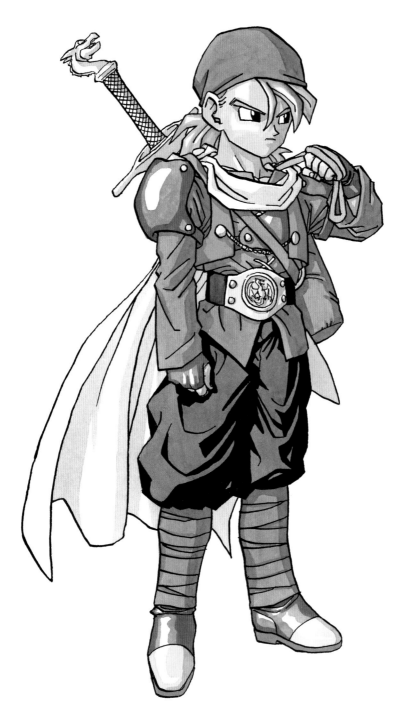

Unused character (1995)

DRAGON QUEST
SPIN-OFF SERIES
ILLUSTRATIONS Part 1

DRAGON QUEST MONSTERS (Released December 18, 1996) • Title Illustration

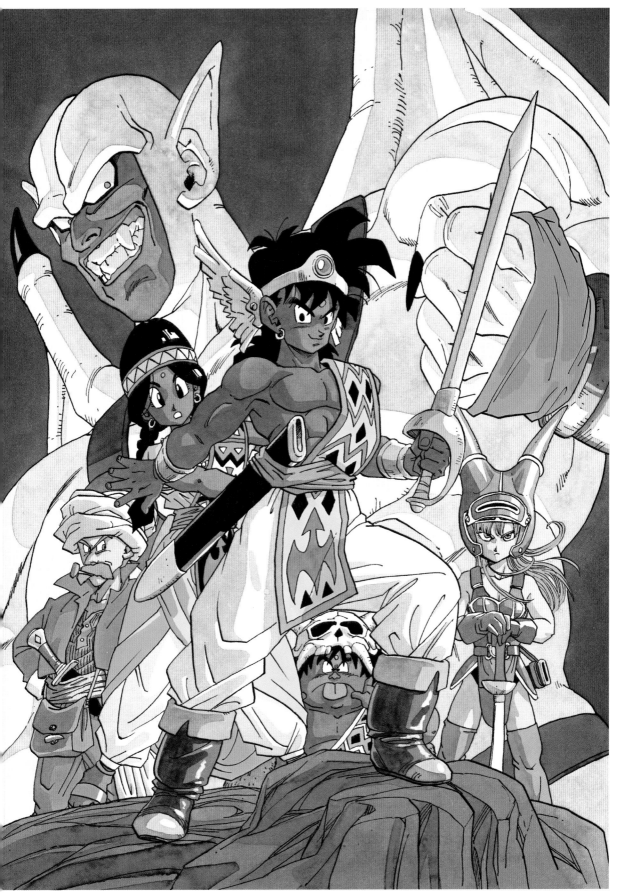

Weekly Shonen Jump, 1990 Issue 5 (Released December 19, 1989) • Calendar Illustration for *DRAGON QUEST: Yuusha Aberu Densetsu*

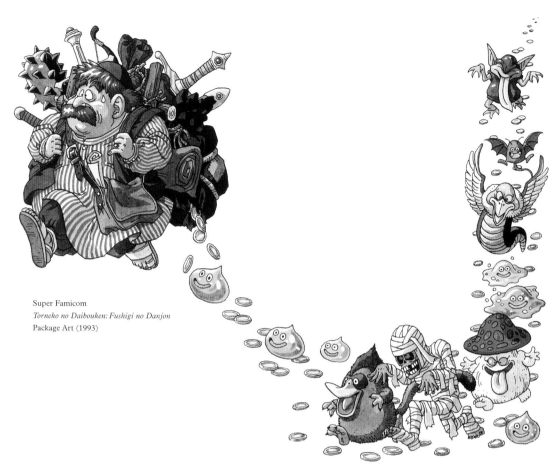

Super Famicom
Torneko no Daibouken: Fushigi no Danjon
Package Art (1993)

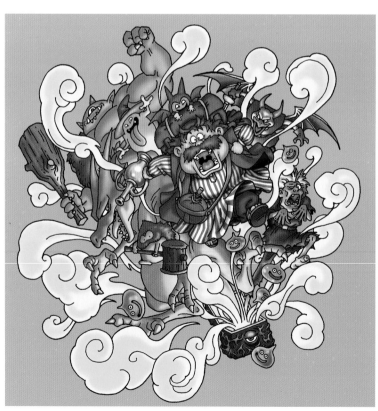

PlayStation
Torneko: Last Hope
Package Art (1999)

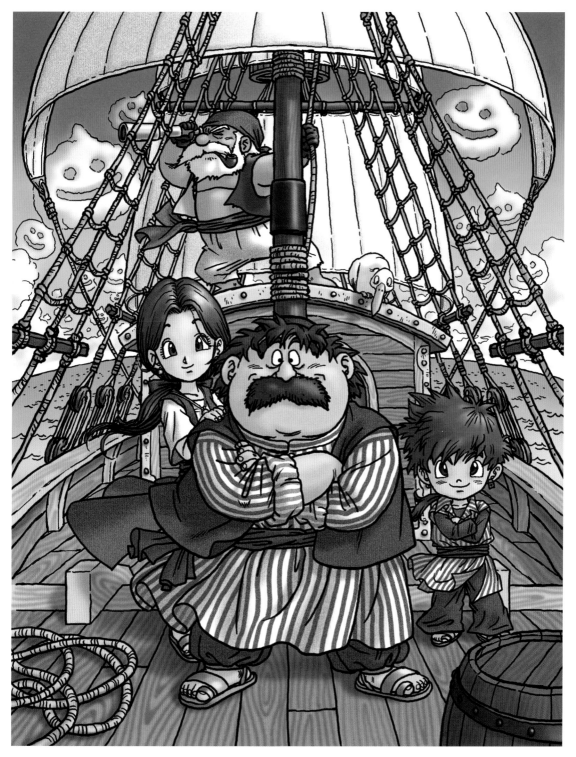

PlayStation 2 • *DRAGON QUEST CHARACTERS: Torneko no Daibouken 3: Fushigi no Danjon* • Package Art (2002)

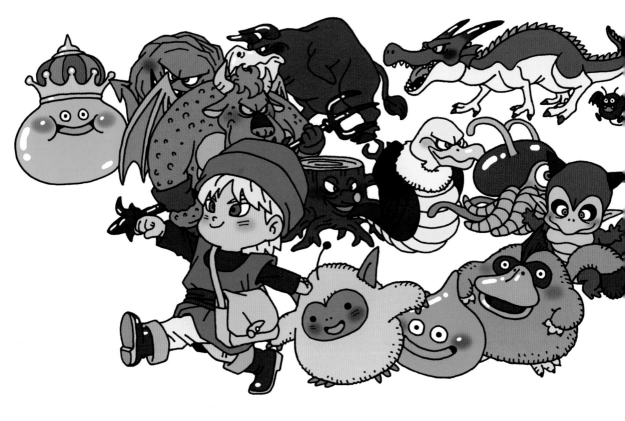

Game Boy • *DRAGON QUEST MONSTERS: Terry no Wandaarando* • Package Art (1998)

Watabou (1998)

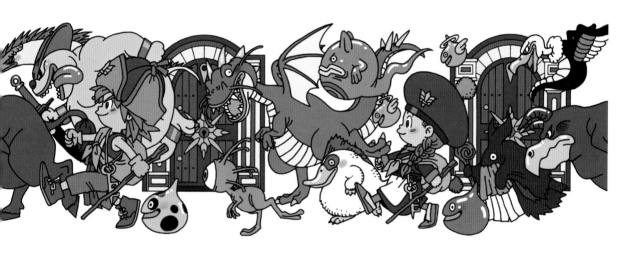

Game Boy
DRAGON QUEST MONSTERS 2: Maruta no Fushigi na Kagi: Ruka no Tabidachi
DRAGON QUEST MONSTERS 2: Maruta no Fushigi na Kagi: Iru no Bouken
Package Art (2001)

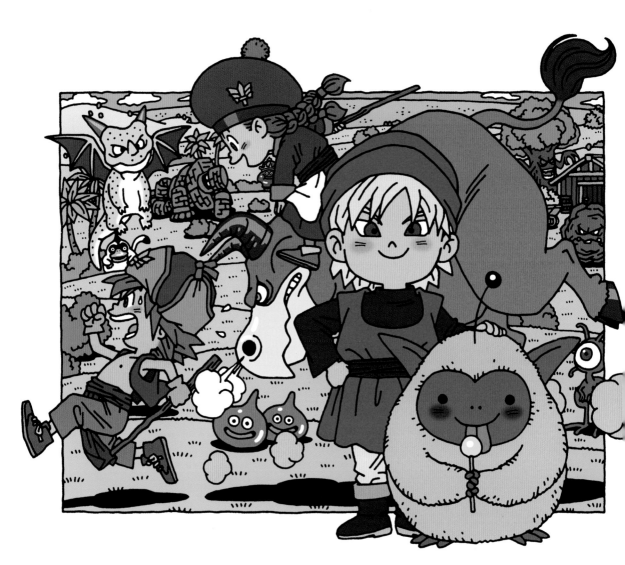

PlayStation • *DRAGON QUEST MONSTERS 1+2: Hoshifuri no Yuusha to Bokujou no Nakamatachi* • Package Art (2002)

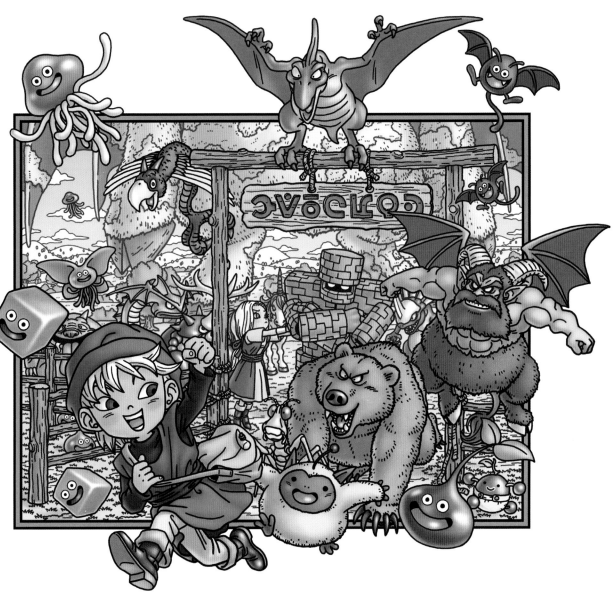

Nintendo 3DS • *DRAGON QUEST MONSTERS: Terry no Wandaarando 3D* • Package Art (2012)

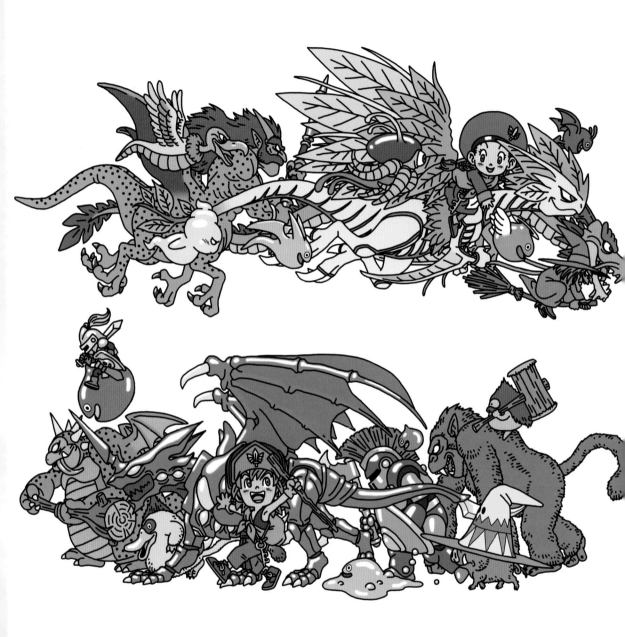

Nintendo 3DS • *DRAGON QUEST MONSTERS 2: Iru to Ruka no Fushigi na Fushigi na Kagi* • Package Art (2014)

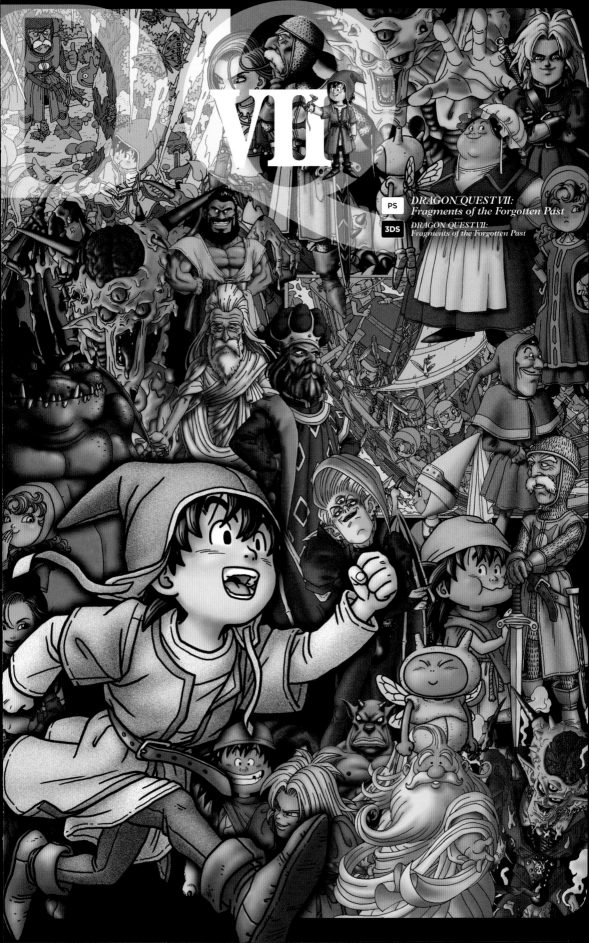

DRAGON QUEST VII:
Fragments of the Forgotten Past

DRAGON QUEST VII:
Fragments of the Forgotten Past

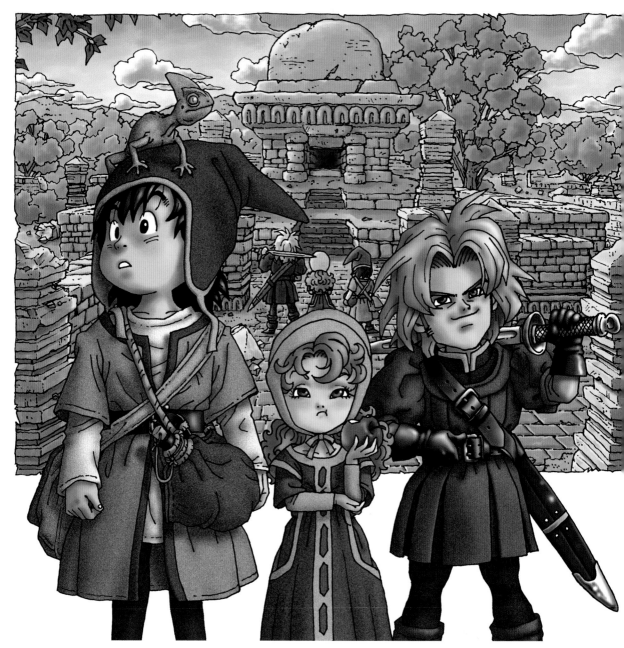

PlayStation • *DRAGON QUEST VII: Fragments of the Forgotten Past* • Package Art (2000)

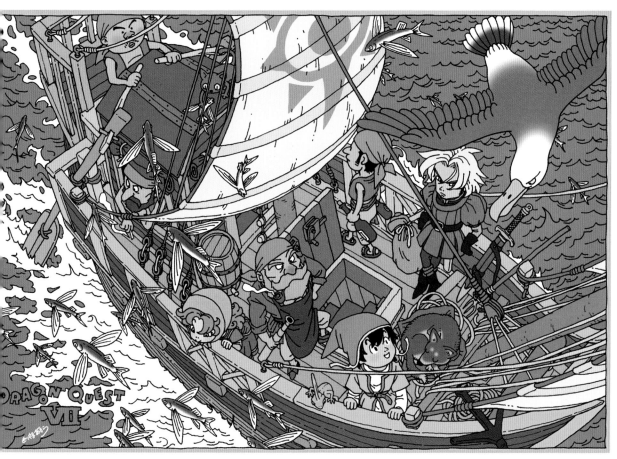

V Jump, April 2000 Issue (Released February 21, 2000) • Cover

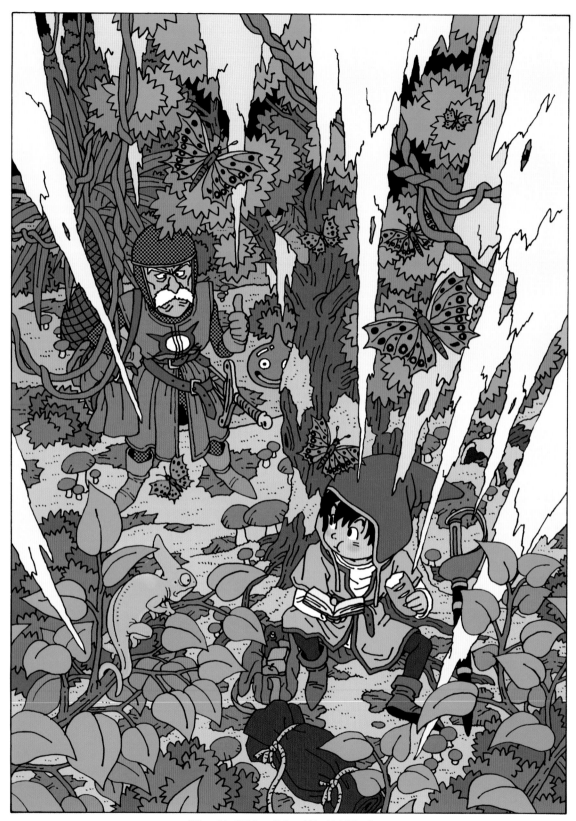

V Jump, July 2000 Issue (Released May 20, 2000) • Cover

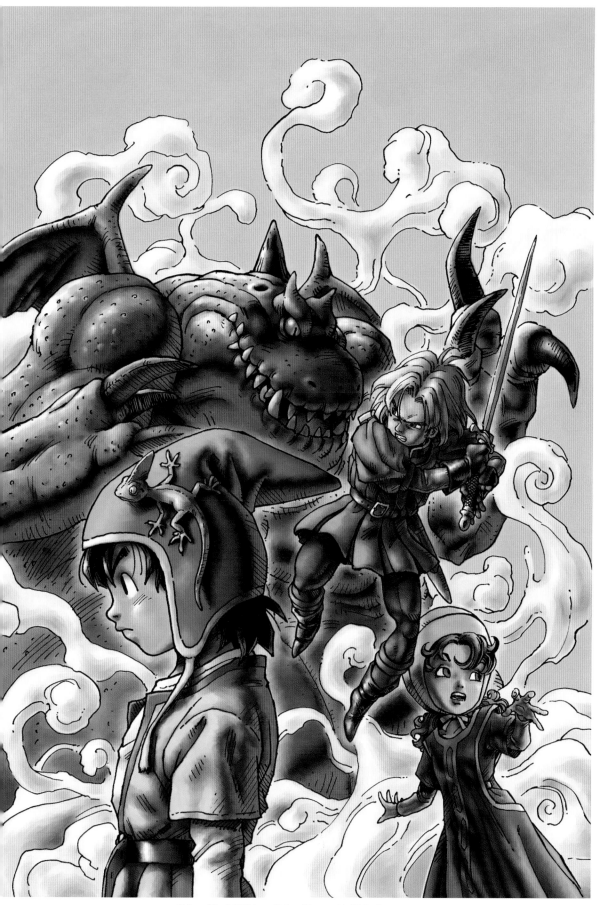

V Jump, March 2000 Issue (Released January 21, 2000) • Cover

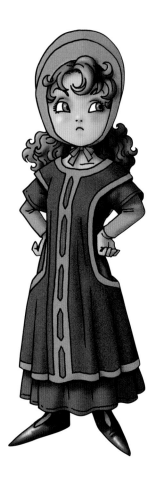

Maribel (2000)

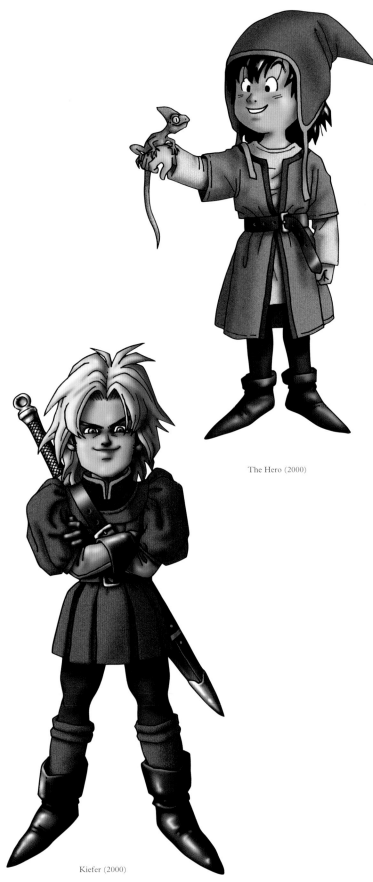

The Hero (2000)

Kiefer (2000)

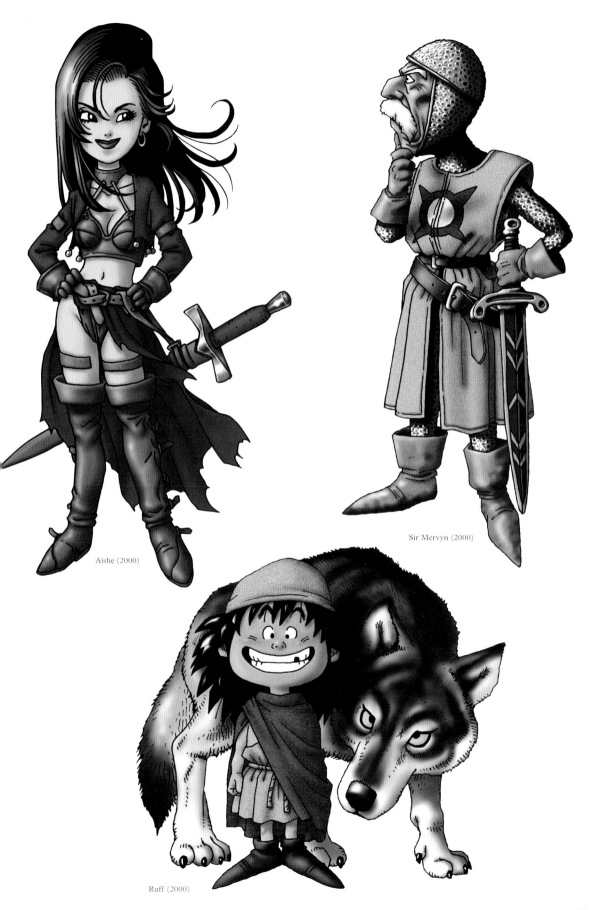

Aishe (2000)

Sir Mervyn (2000)

Ruff (2000)

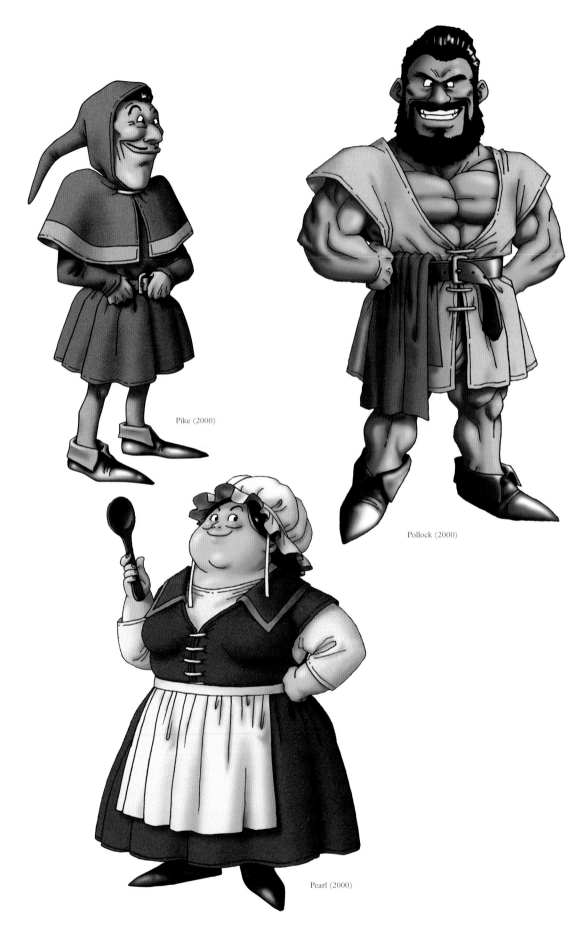

Pike (2000)

Pollock (2000)

Pearl (2000)

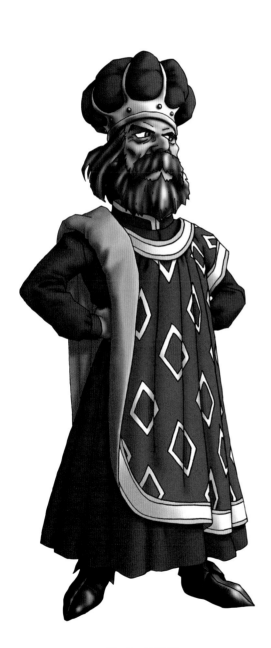

King Donald (2000)

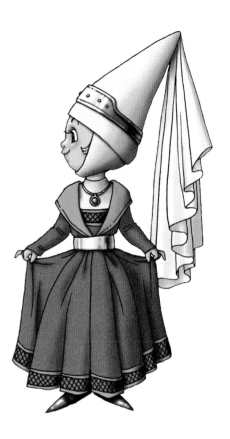

Princess Lisette (2000)

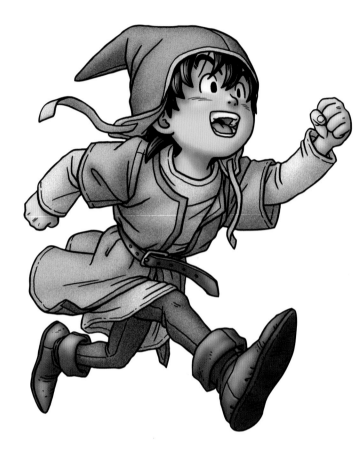

The Hero (2013)

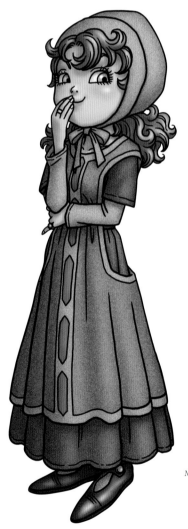

Maribel (2013)

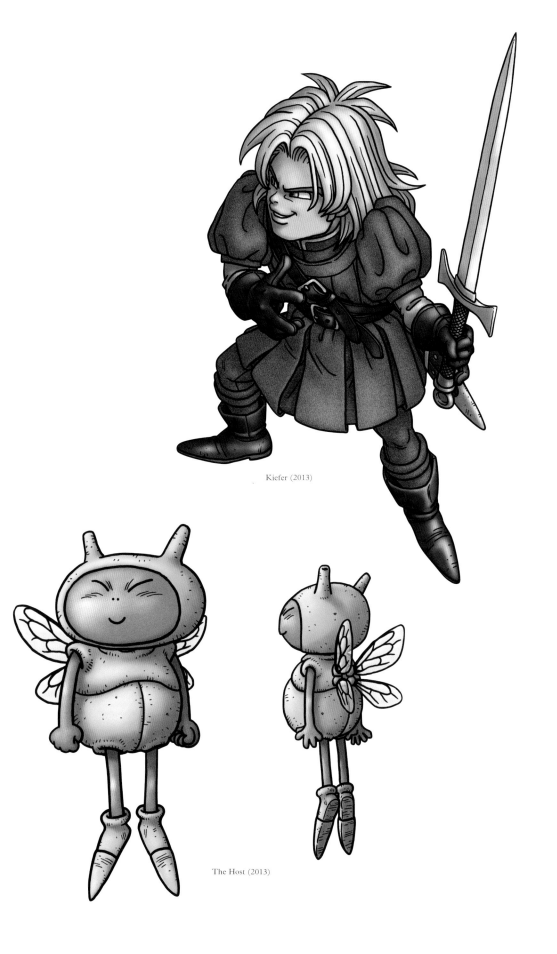

Kiefer (2013)

The Host (2013)

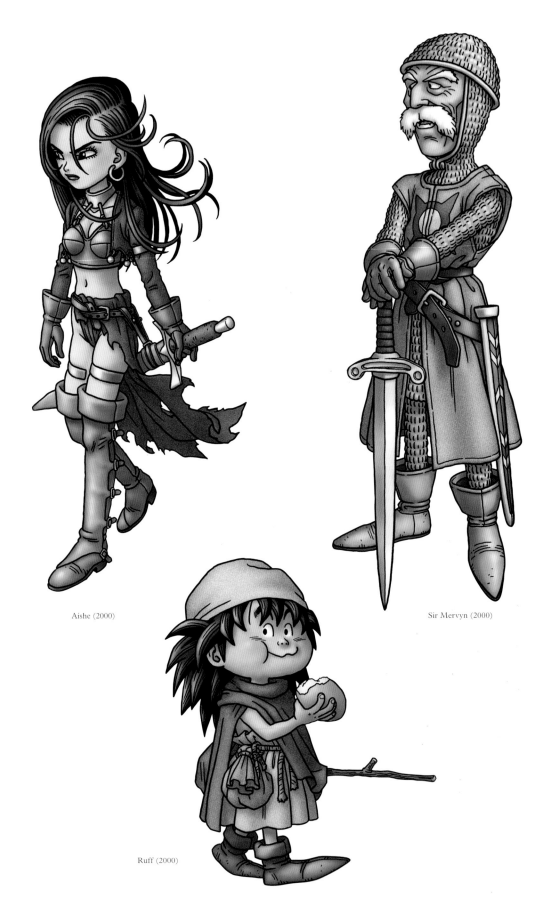

Aishe (2000)

Sir Mervyn (2000)

Ruff (2000)

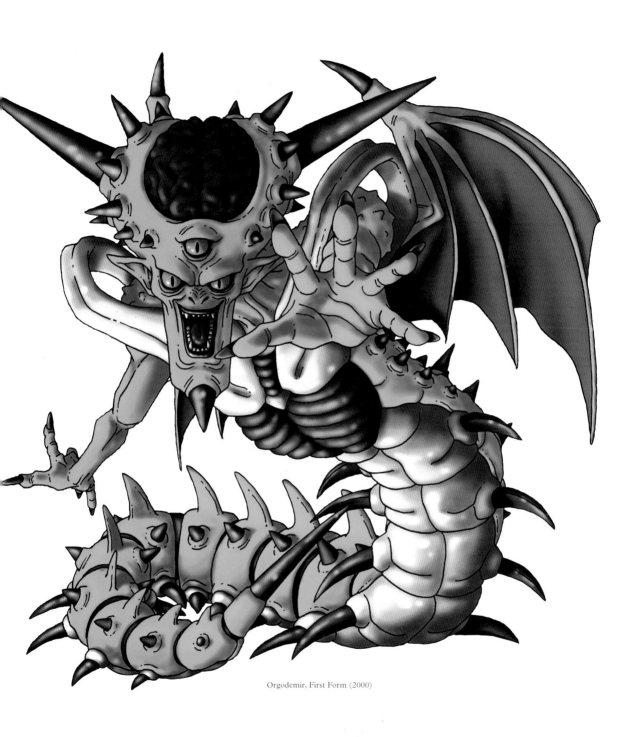

Orgodemir, First Form (2000)

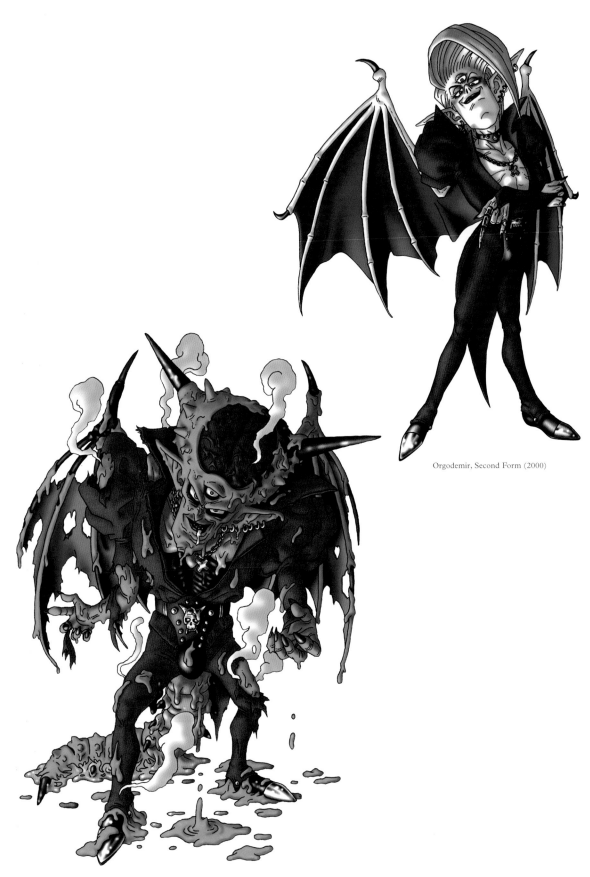

Orgodemir, Second Form (2000)

Orgodemir, Third Form (2000)

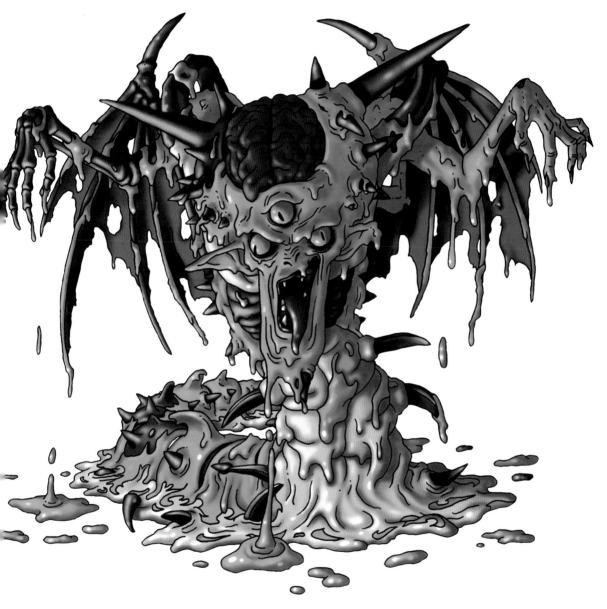

Orgodemir, Fourth Form (2000)

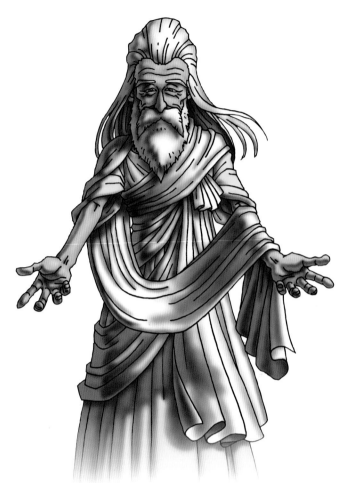

God (2000)

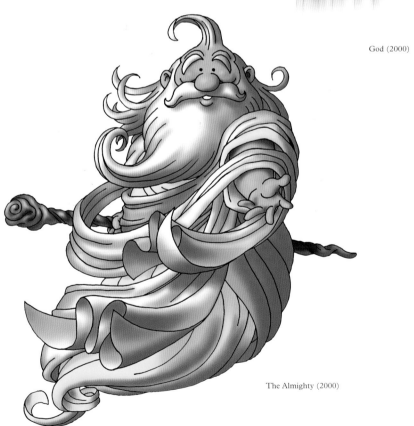

The Almighty (2000)

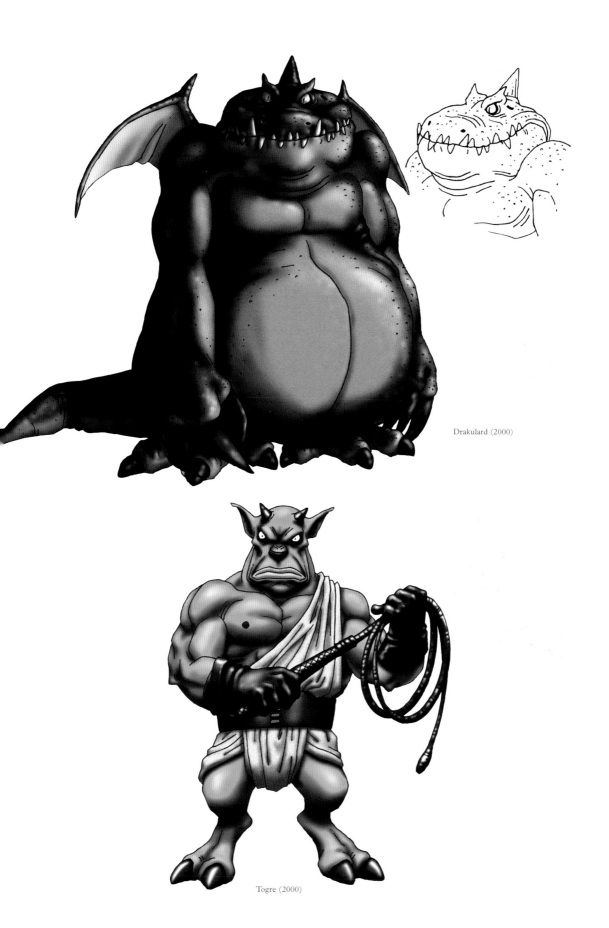

Drakulard (2000)

Togre (2000)

DRAGON QUEST
SPIN-OFF SERIES
ILLUSTRATIONS

Part 2

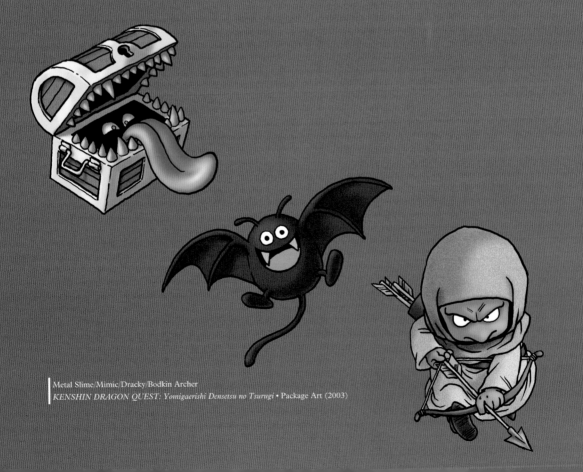

Metal Slime/Mimic/Dracky/Bodkin Archer
KENSHIN DRAGON QUEST: Yomigaerishi Densetsu no Tsurugi • Package Art (2003)

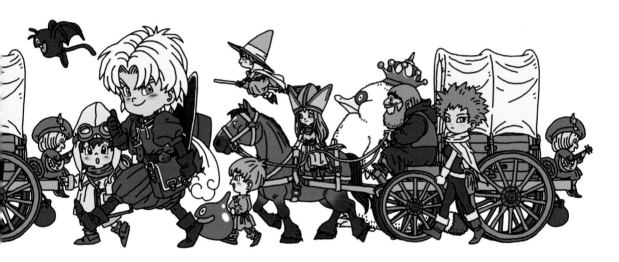

Game Boy Advance • *DRAGON QUEST MONSTERS: Kyaraban Hato* • Package Art (2003)

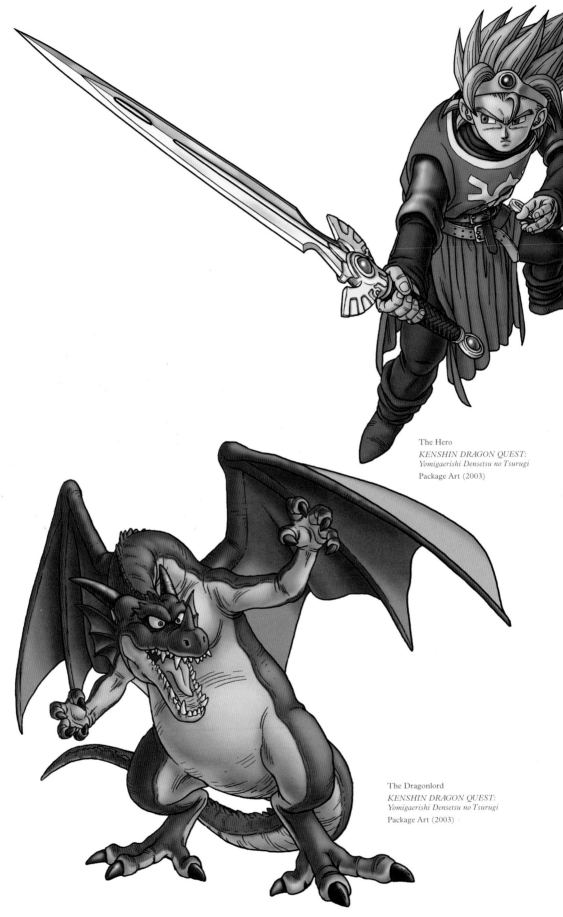

The Hero
KENSHIN DRAGON QUEST:
Yomigaerishi Densetsu no Tsurugi
Package Art (2003)

The Dragonlord
KENSHIN DRAGON QUEST:
Yomigaerishi Densetsu no Tsurugi
Package Art (2003)

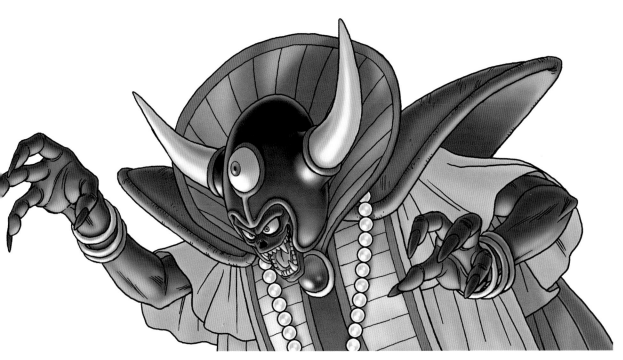

Zoma • *KENSHIN DRAGON QUEST: Yomigaerishi Densetsu no Tsurugi* • Package Art (2003)

Game Boy Advance • *SURAIMU MORIMORI DRAGON QUEST: Shougeki no Shippo Dan* • Package Art (2003)

Nintendo DS • *DRAGON QUEST HEROES: Rocket Slime* • Package Art (2005)

Nintendo 3DS • *SURAIMU MORIMORI DRAGON QUEST: Daikaizoku to Shippo Dan* • Package Art (2011)

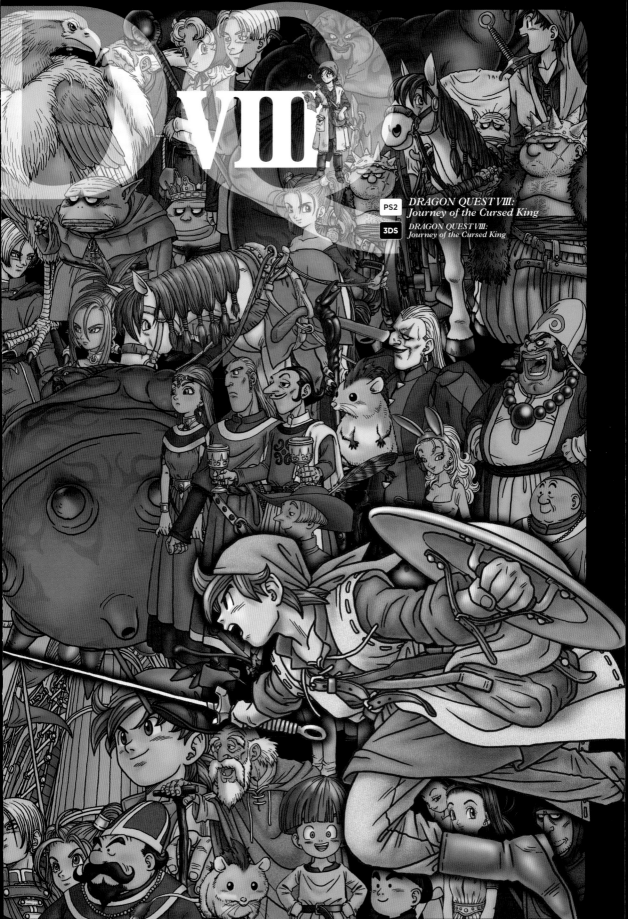

VIII

PS2 DRAGON QUEST VIII:
Journey of the Cursed King

3DS DRAGON QUEST VIII:
Journey of the Cursed King

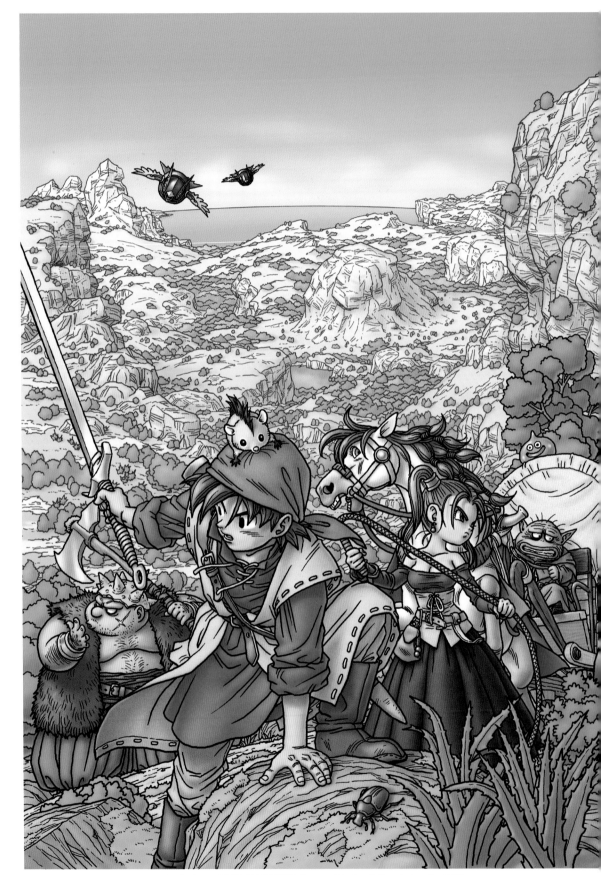

PlayStation 2 • *DRAGON QUEST VIII: Journey of the Cursed King* • Package Art (2004)

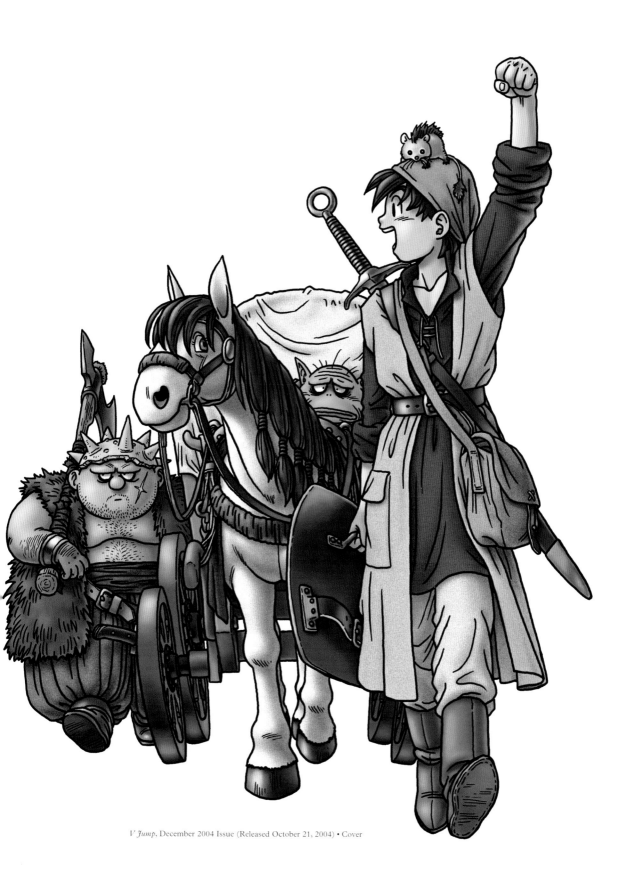

V Jump, December 2004 Issue (Released October 21, 2004) • Cover

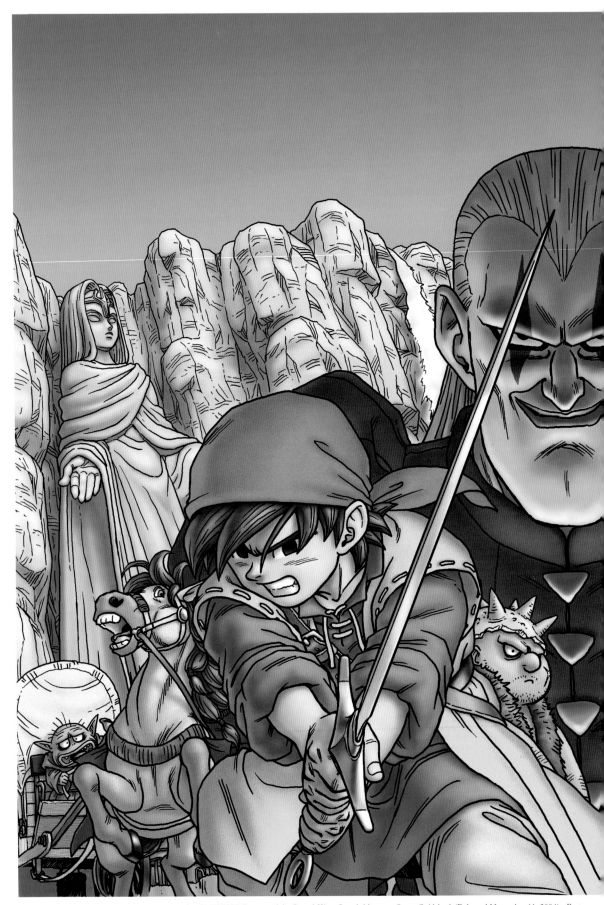

V Jump Extra Special Edition • *DRAGON QUEST VIII: Journey of the Cursed King: Grand Adventure Super Guidebook* (Released November 11, 2004) • Poster

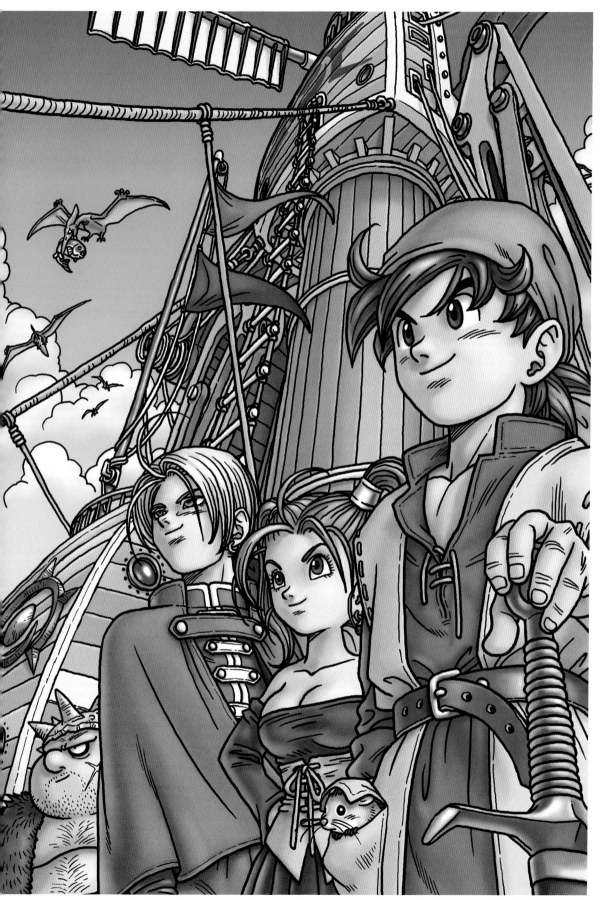

V Jump, May 2004 Issue (Released March 20, 2004) • Cover

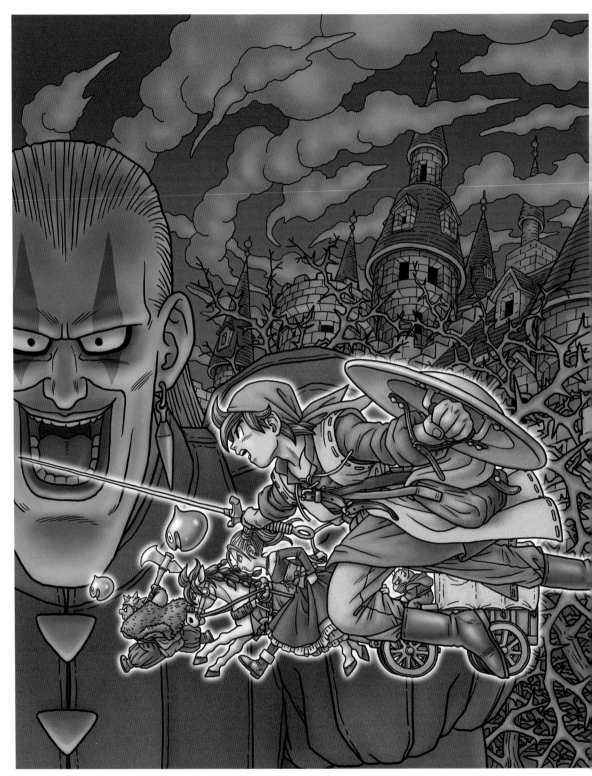

Nintendo 3DS • *DRAGON QUEST VIII: Journey of the Cursed King* • Package Art (2015)

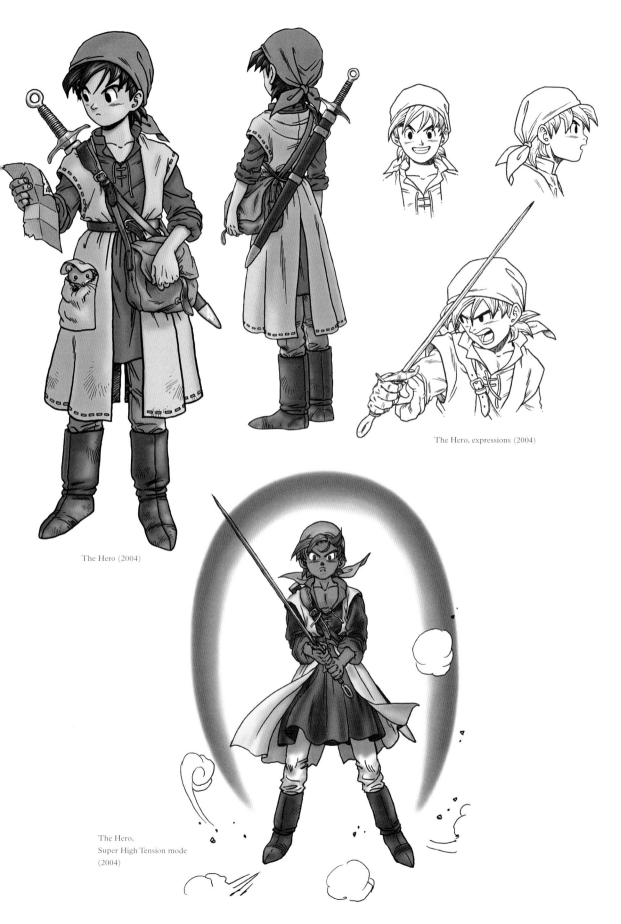

The Hero (2004)

The Hero, expressions (2004)

The Hero,
Super High Tension mode
(2004)

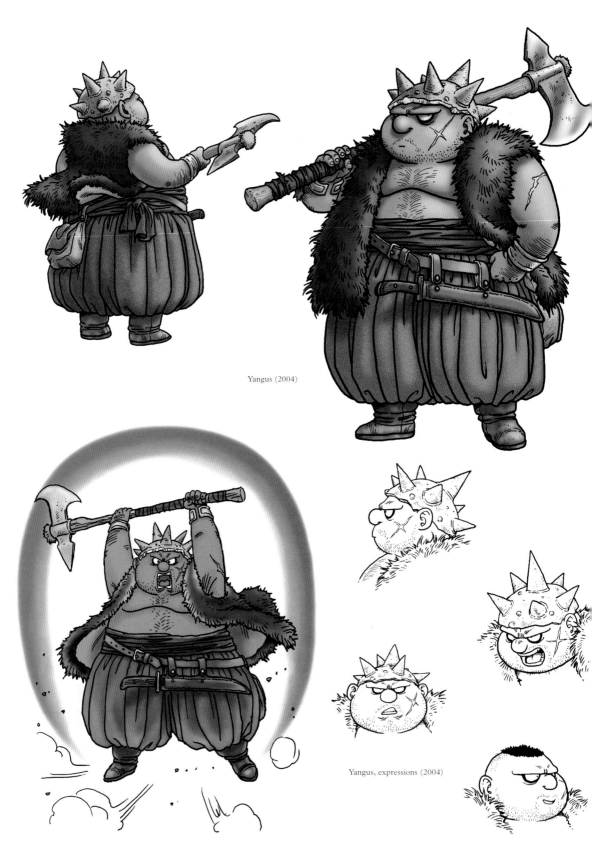

Yangus (2004)

Yangus, expressions (2004)

Yangus, Super High Tension mode (2004)

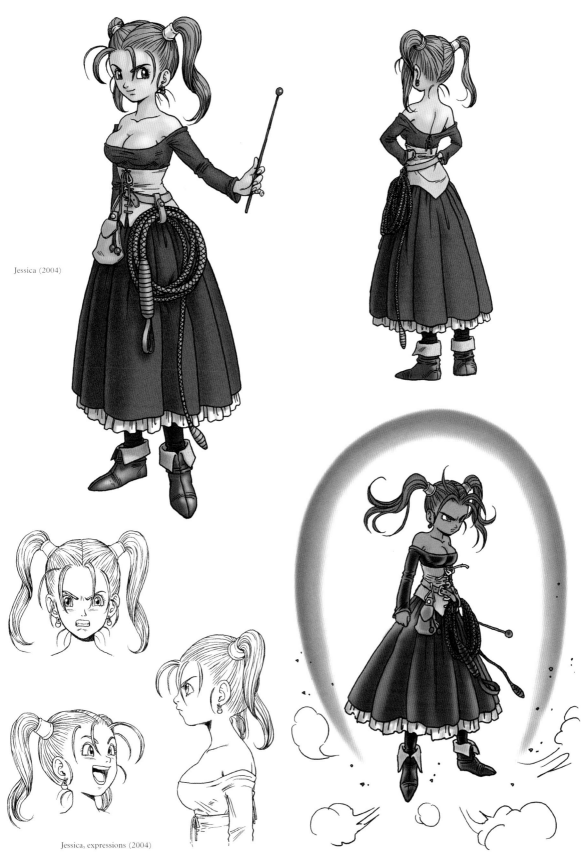

Jessica (2004)

Jessica, expressions (2004)

Jessica, Super High Tension mode (2004)

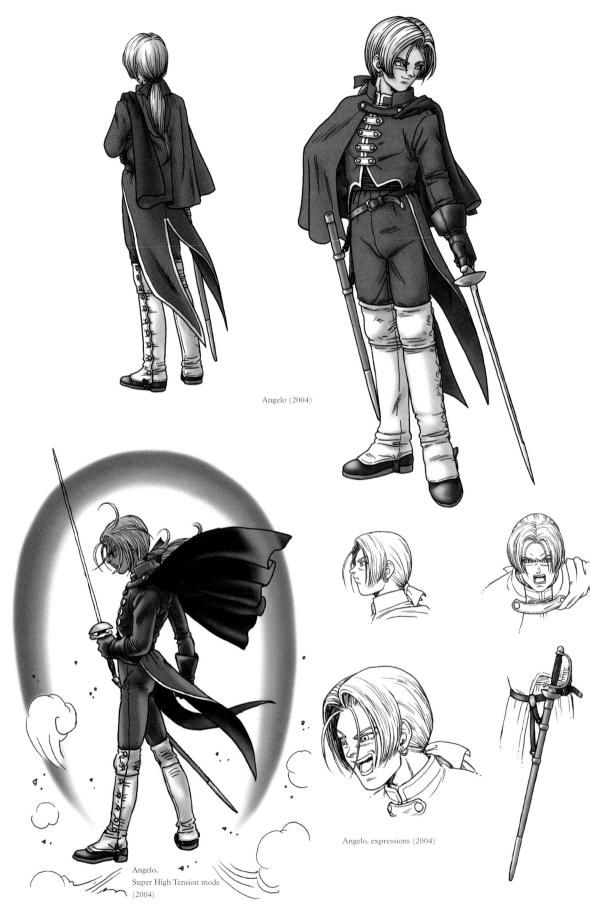

Angelo (2004)

Angelo,
Super High Tension mode
(2004)

Angelo, expressions (2004)

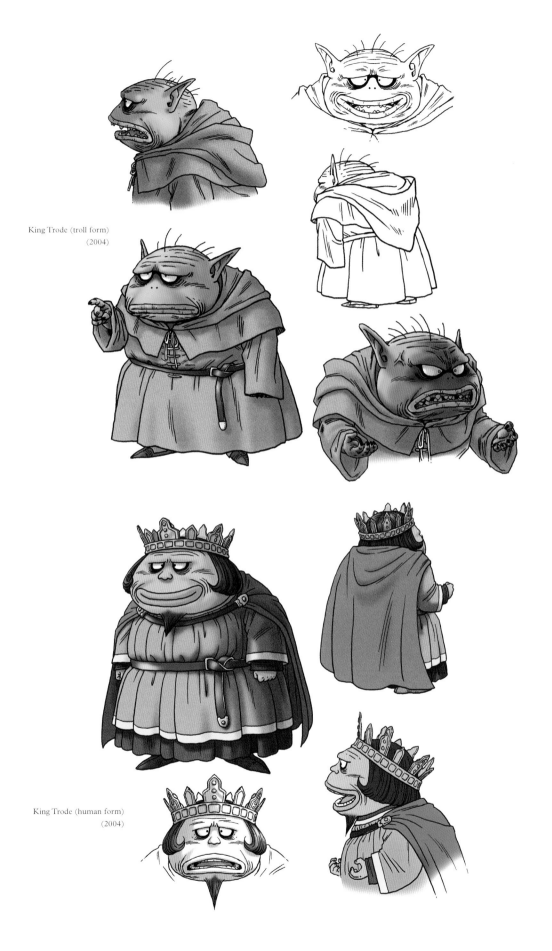

King Trode (troll form)
(2004)

King Trode (human form)
(2004)

151

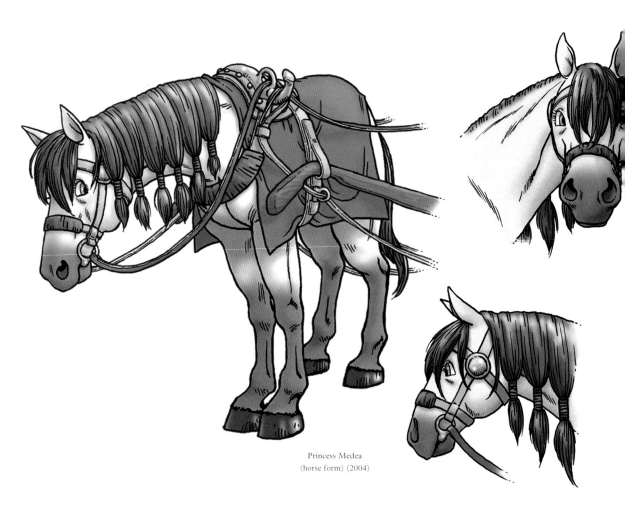

Princess Medea
(horse form) (2004)

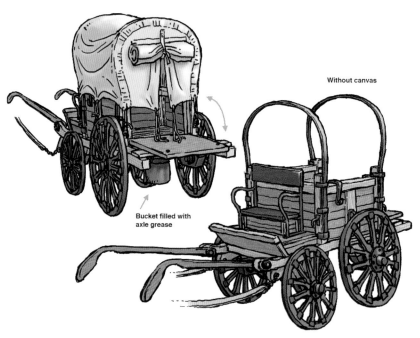

Without canvas

Bucket filled with
axle grease

Wagon (2004)

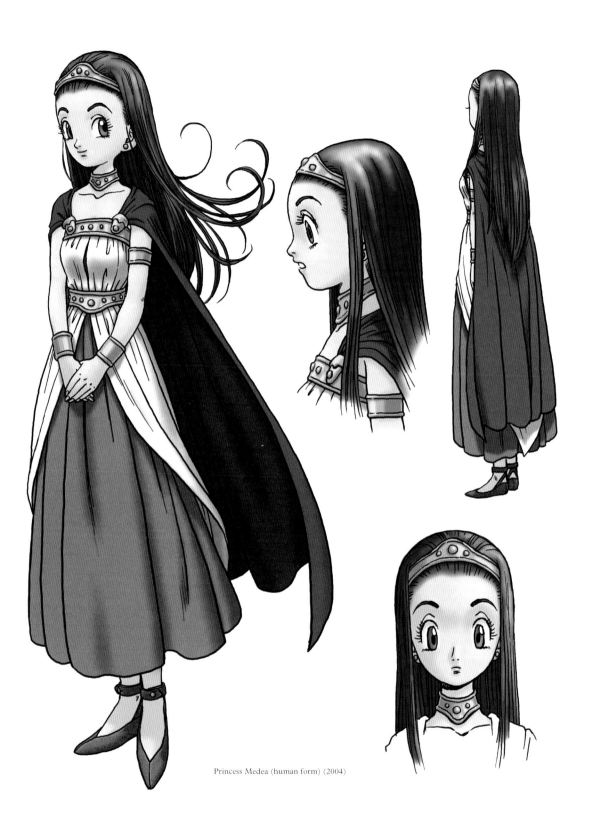

Princess Medea (human form) (2004)

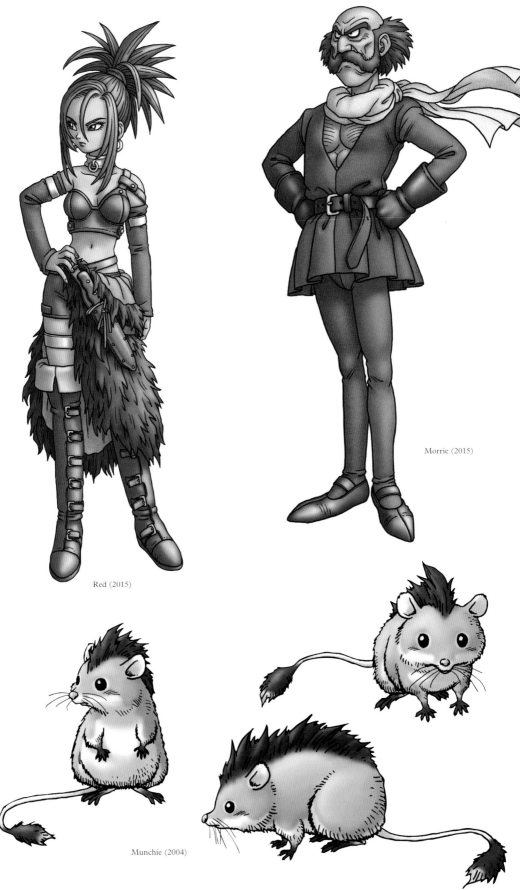

Morrie (2015)

Red (2015)

Munchie (2004)

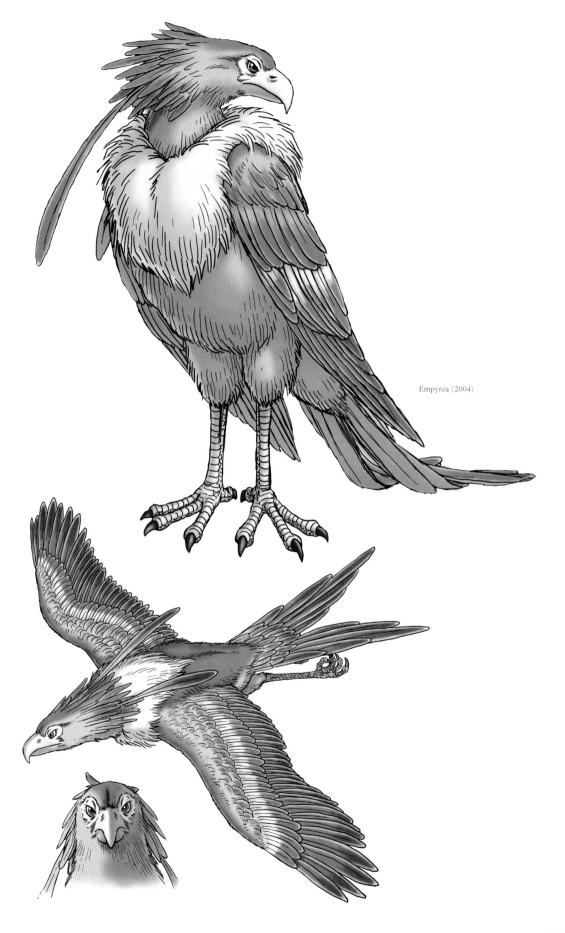

Empyrea (2004)

155

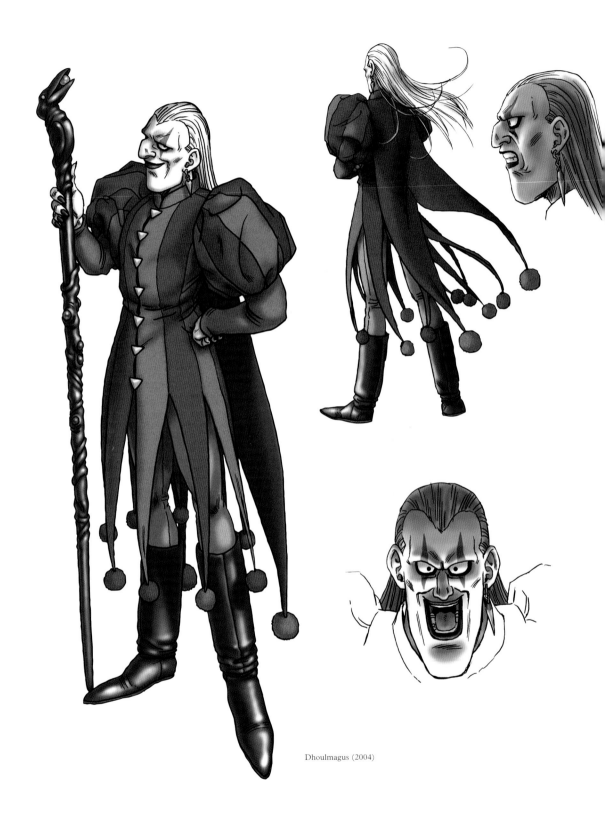

Dhoulmagus (2004)

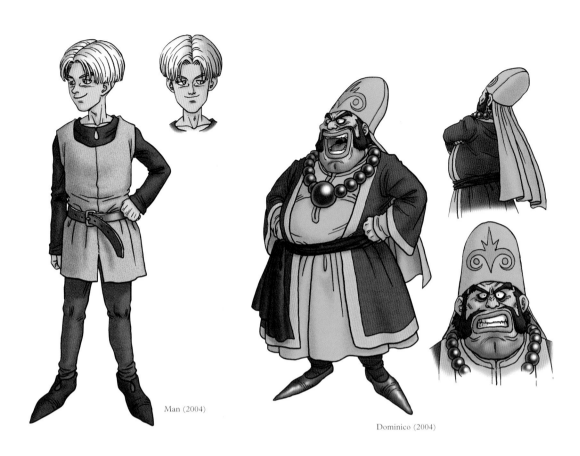

Man (2004)

Dominico (2004)

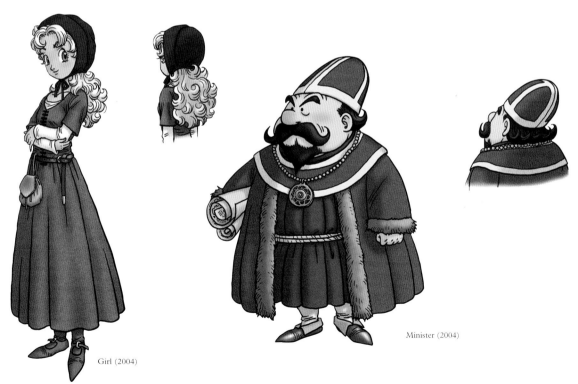

Girl (2004)

Minister (2004)

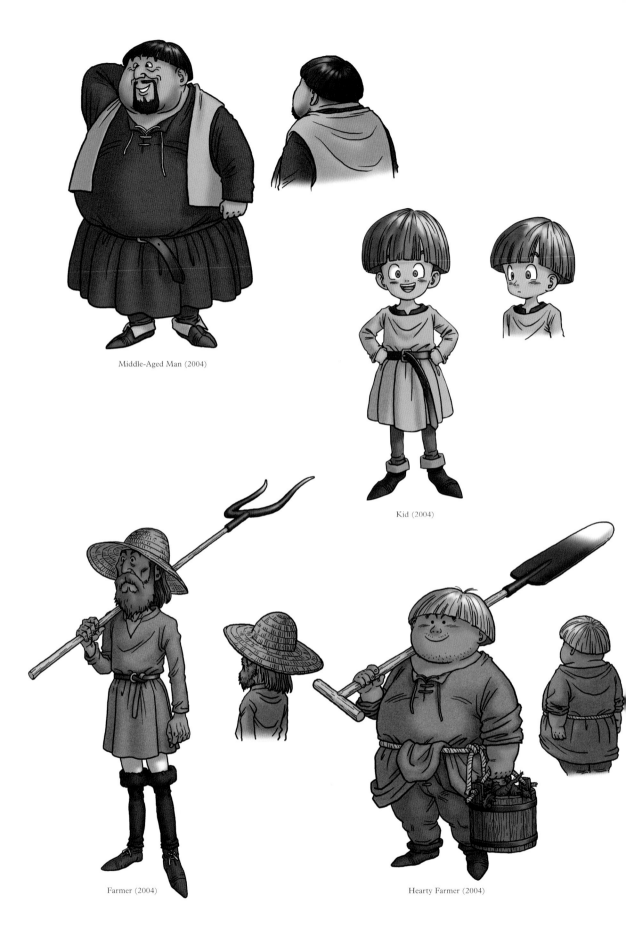

Middle-Aged Man (2004)

Kid (2004)

Farmer (2004)

Hearty Farmer (2004)

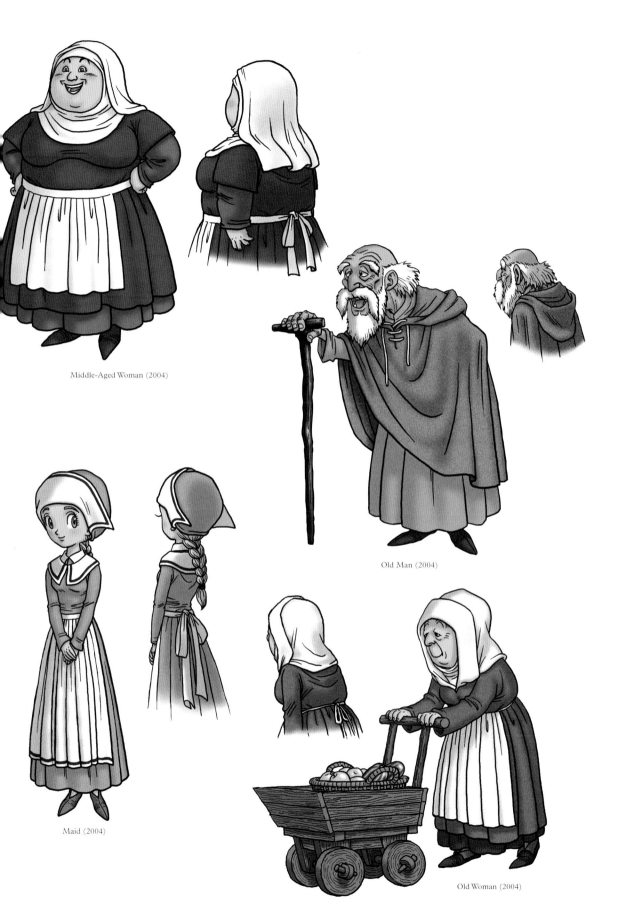

Middle-Aged Woman (2004)

Old Man (2004)

Maid (2004)

Old Woman (2004)

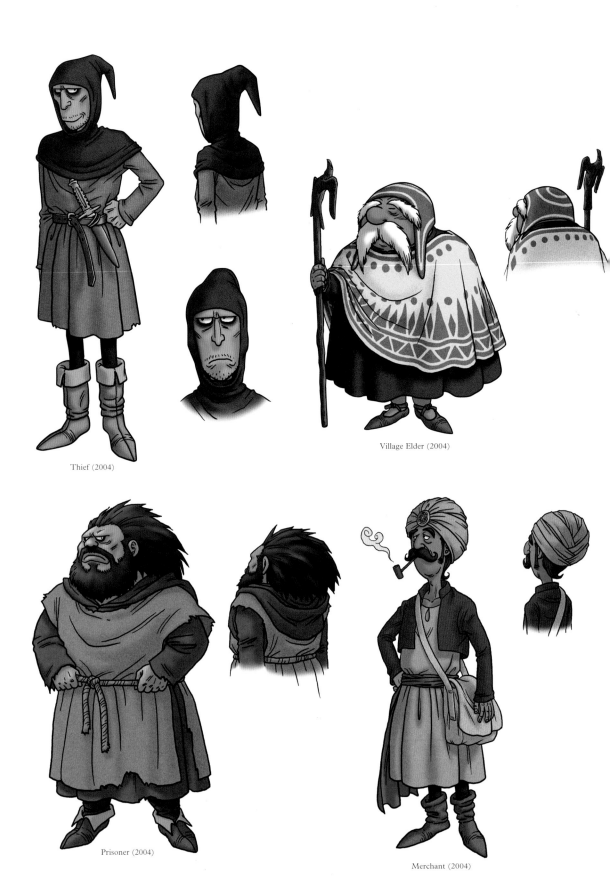

Thief (2004)

Village Elder (2004)

Prisoner (2004)

Merchant (2004)

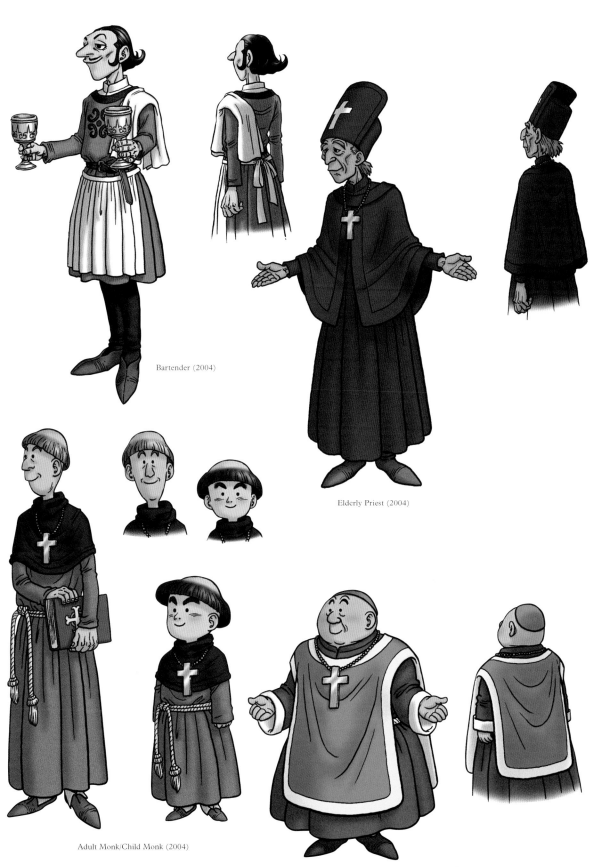

Bartender (2004)

Elderly Priest (2004)

Adult Monk/Child Monk (2004)

Fat Priest (2004)

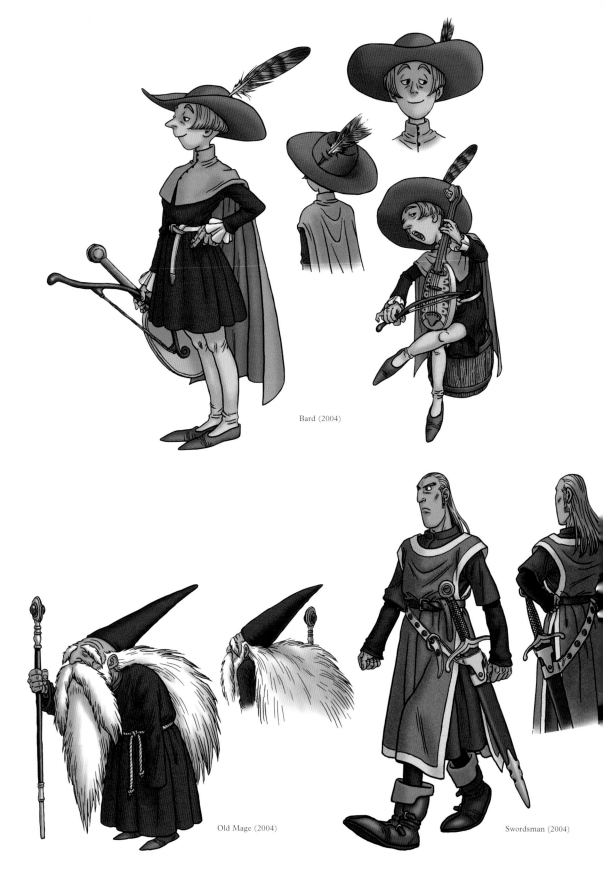

Bard (2004)

Old Mage (2004)

Swordsman (2004)

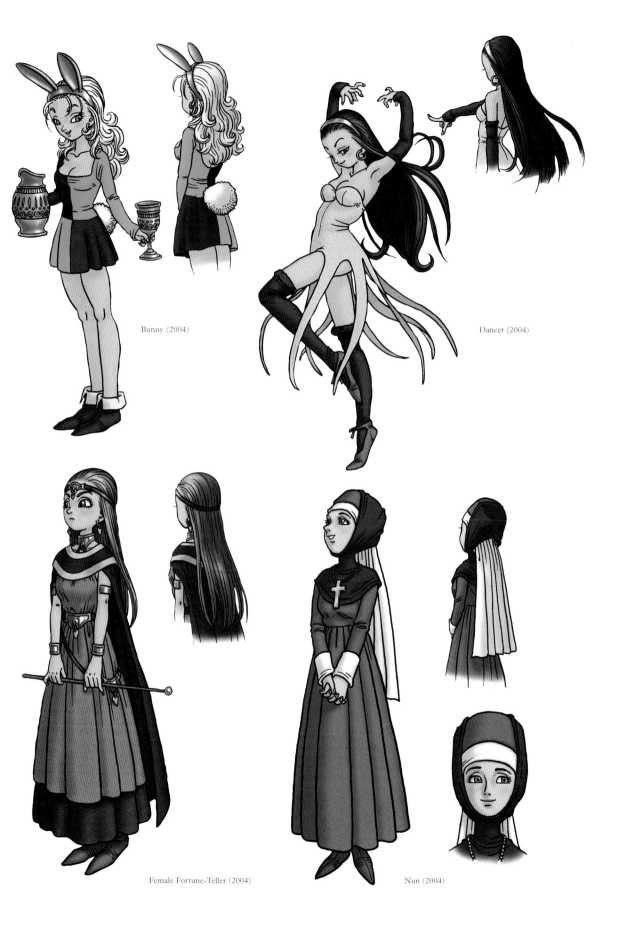

Bunny (2004)

Dancer (2004)

Female Fortune-Teller (2004)

Nun (2004)

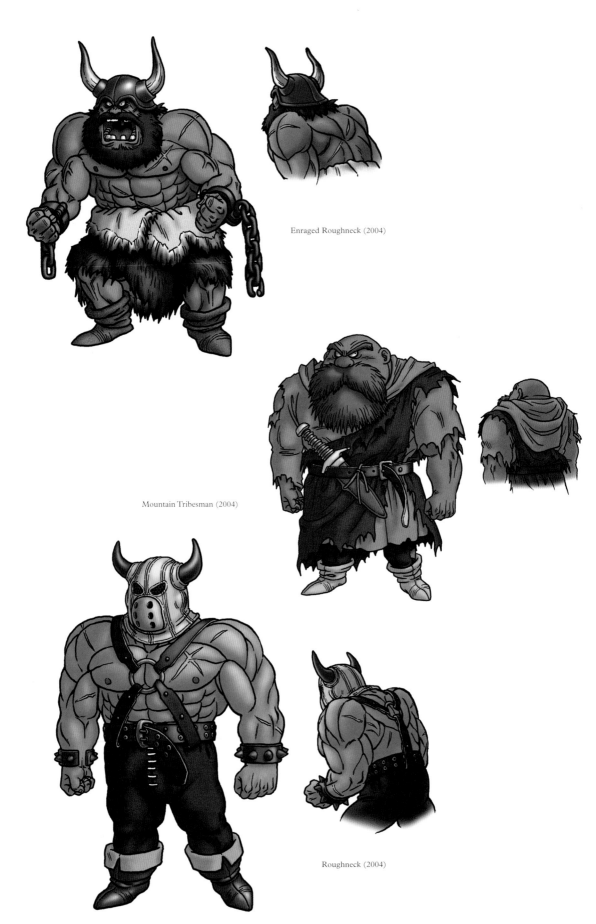

Enraged Roughneck (2004)

Mountain Tribesman (2004)

Roughneck (2004)

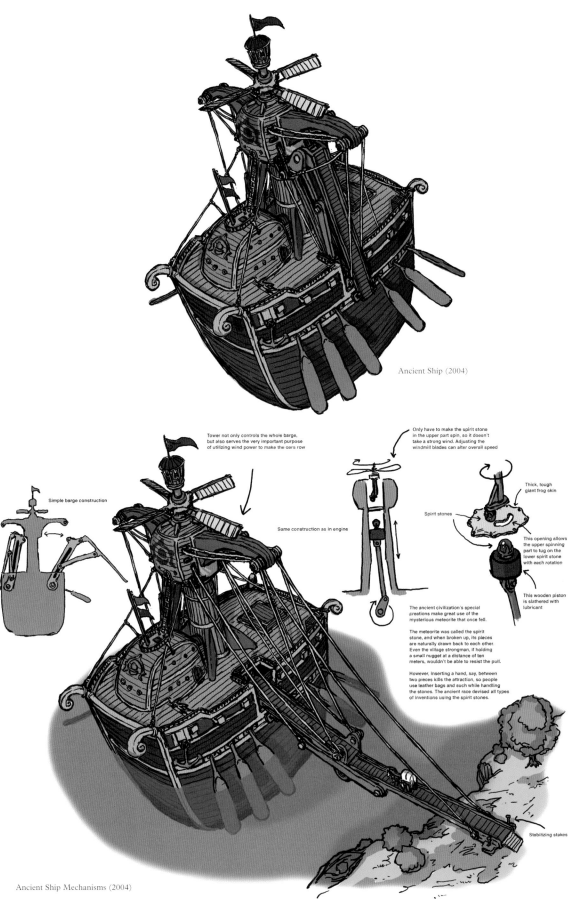

Ancient Ship (2004)

Ancient Ship Mechanisms (2004)

Tower not only controls the whole barge, but also serves the very important purpose of utilizing wind power to make the oars row

Only have to make the spirit stone in the upper part spin, so it doesn't take a strong wind. Adjusting the windmill blades can alter overall speed

Simple barge construction

Same construction as in engine

Thick, tough giant frog skin

Spirit stones

This opening allows the upper spinning part to tug on the lower spirit stone with each rotation

This wooden piston is slathered with lubricant

The ancient civilization's special creations make great use of the mysterious meteorite that once fell.

The meteorite was called the spirit stone, and when broken up, its pieces are naturally drawn back to each other. Even the village strongman, if holding a small nugget at a distance of ten meters, wouldn't be able to resist the pull.

However, inserting a hand, say, between two pieces kills the attraction, so people use leather bags and such while handling the stones. The ancient race devised all types of inventions using the spirit stones.

Stabilizing stakes

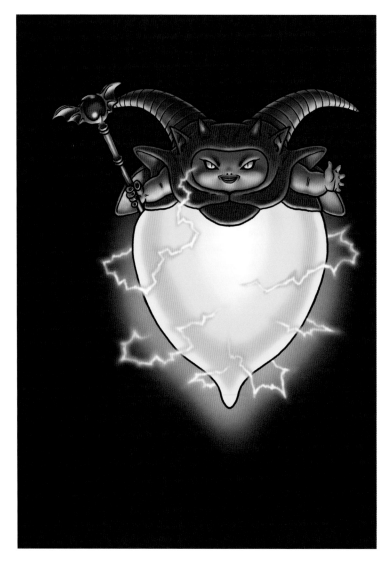

Rhapthorne, First Form (200■

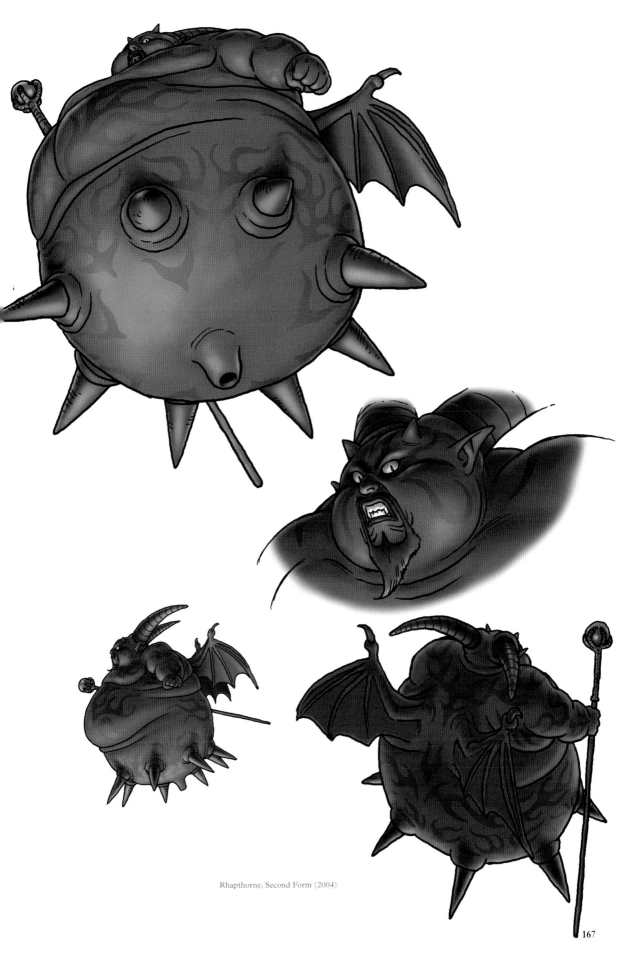

Rhapthorne, Second Form (2004)

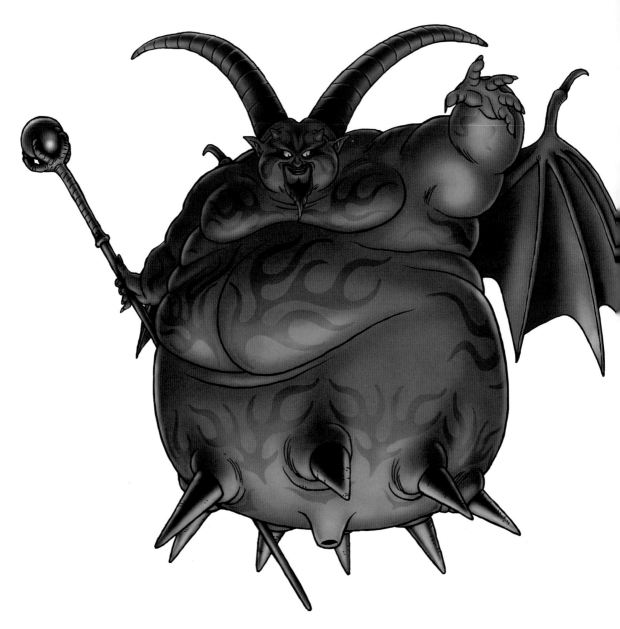

Rhapthorne, Second Form (2004)

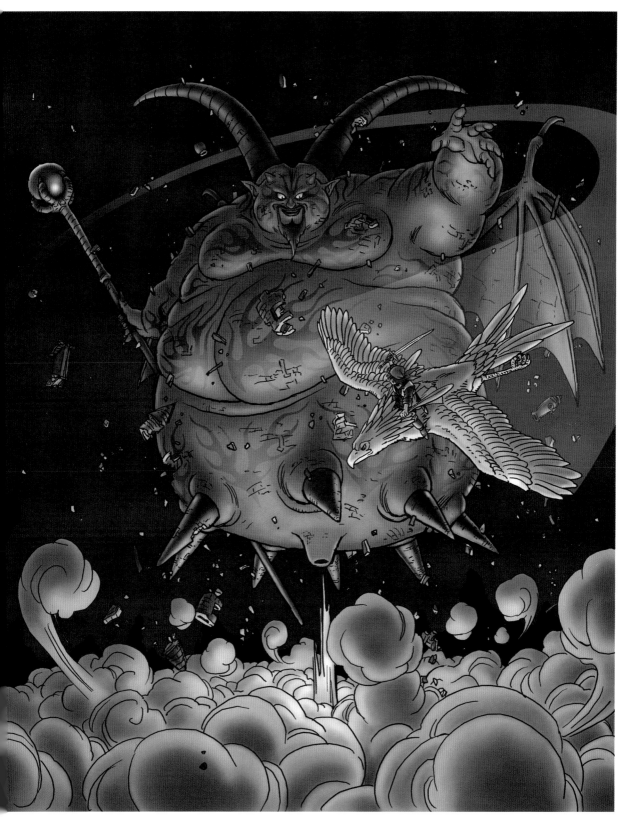

Rhapthorne battle concept art (2004)

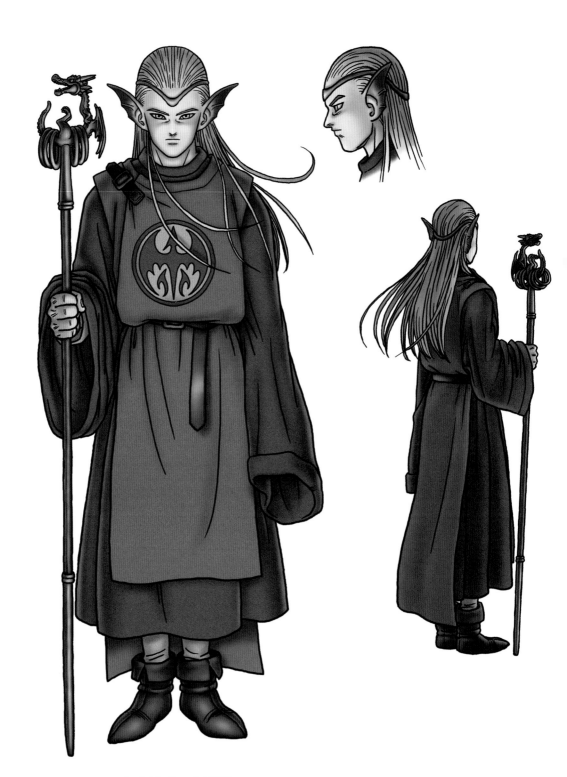

Lord of the Dragovians (2004)

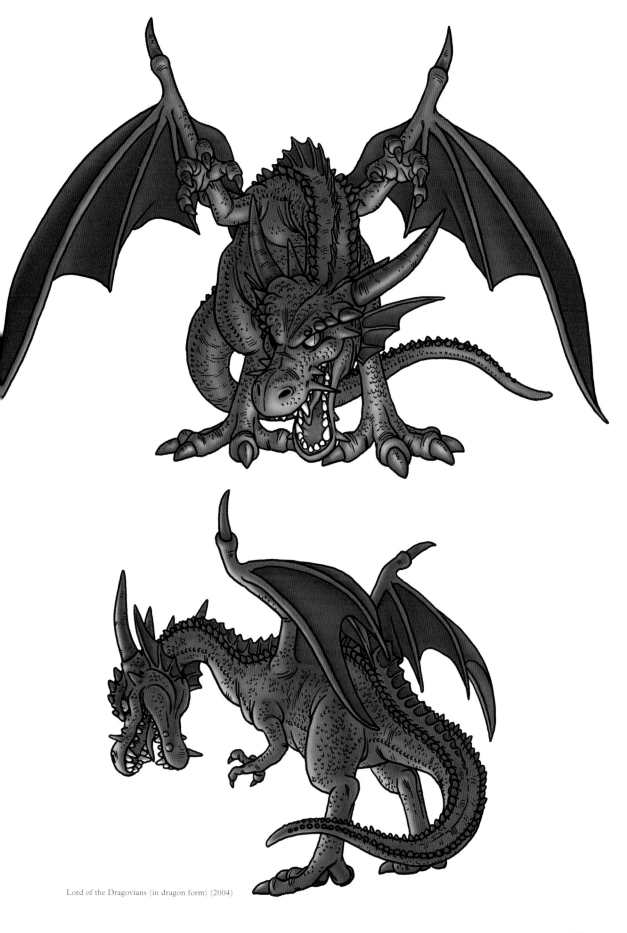

Lord of the Dragovians (in dragon form) (2004)

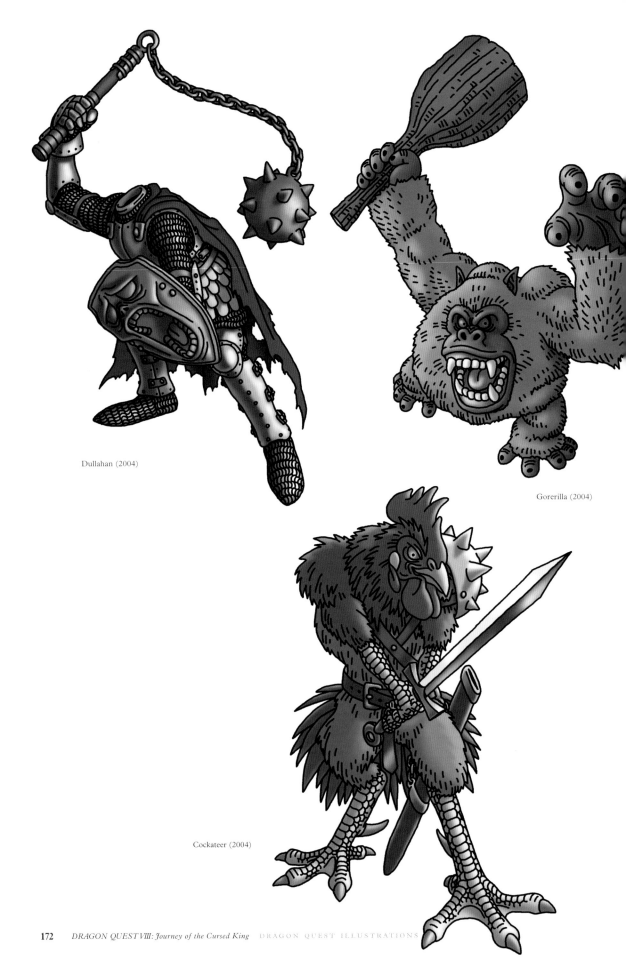

Dullahan (2004)

Gorerilla (2004)

Cockateer (2004)

Satyr (2004)

Dancing Devil (2004)

Dingaling (2004)

Wild Boarfish (2004)

DRAGON QUEST
SPIN-OFF SERIES
ILLUSTRATIONS

Part 3

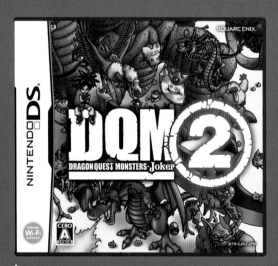

Nintendo DS
DRAGON QUEST MONSTERS: Joker 2 • Package Design (2010)

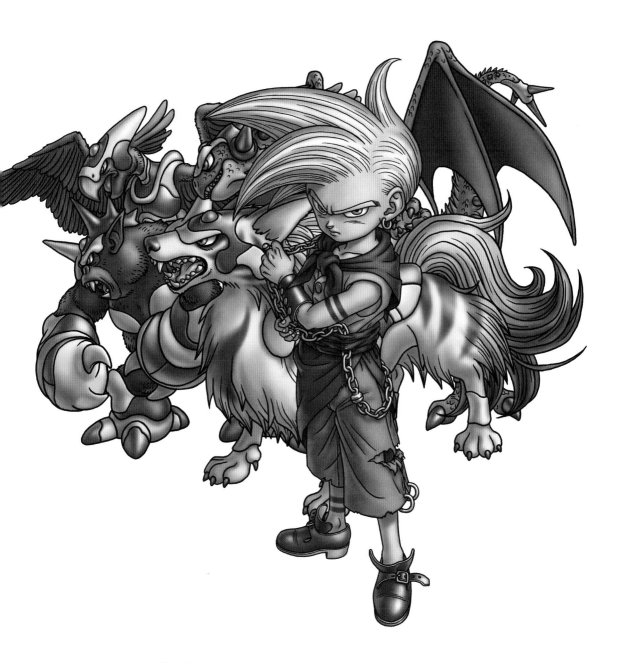

Nintendo DS • *DRAGON QUEST MONSTERS: Joker* • Package Art (2006)

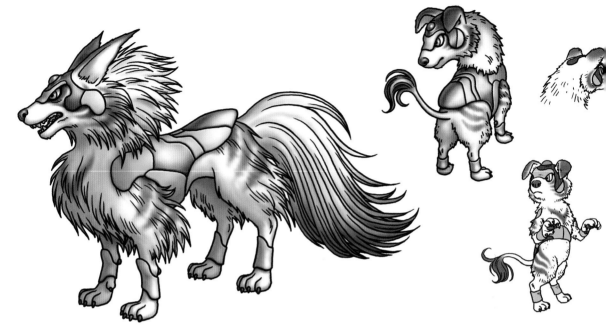

Wulfspade Ace/Wulfspade

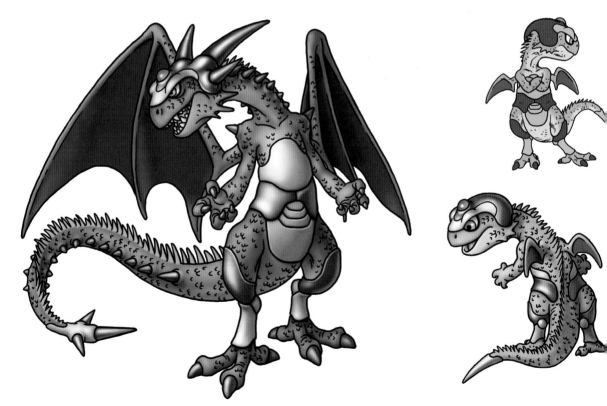

Diamagon Ace/Diamagon

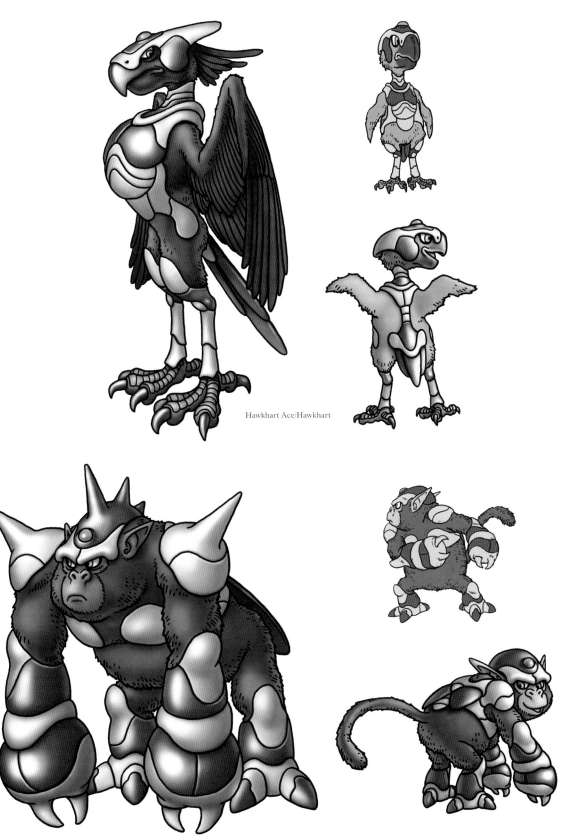

Hawkhart Ace/Hawkhart

Cluboon Ace/Cluboon

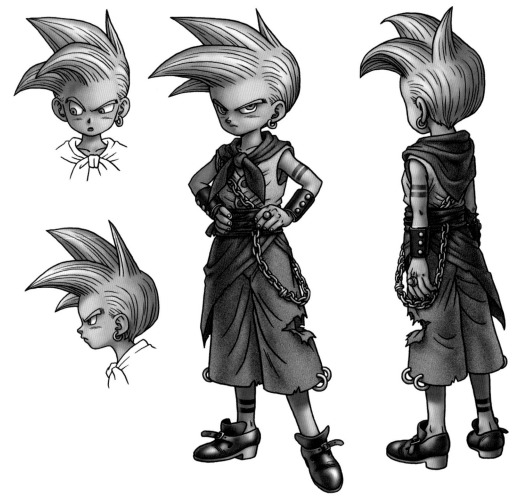

DRAGON QUEST MONSTERS: Joker • The Hero (2006)

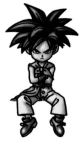

Nintendo DS
DRAGON QUEST MONSTERS: Joker 2
Professional
Package Art Character (2011)

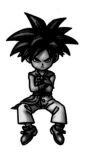

Nintendo DS
DRAGON QUEST MONSTERS: Joker 2
Package Art Character (2010)

Nintendo DS • *DRAGON QUEST MONSTERS: Joker 2 Professional* • Package De

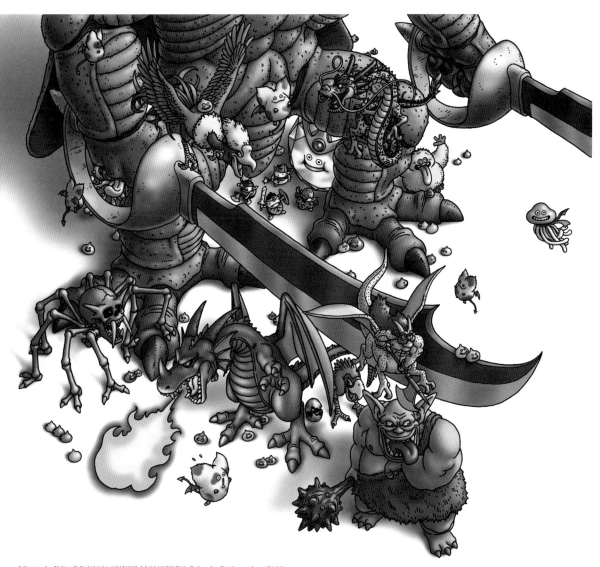

Nintendo DS • *DRAGON QUEST MONSTERS: Joker 2* • Package Art (2011)

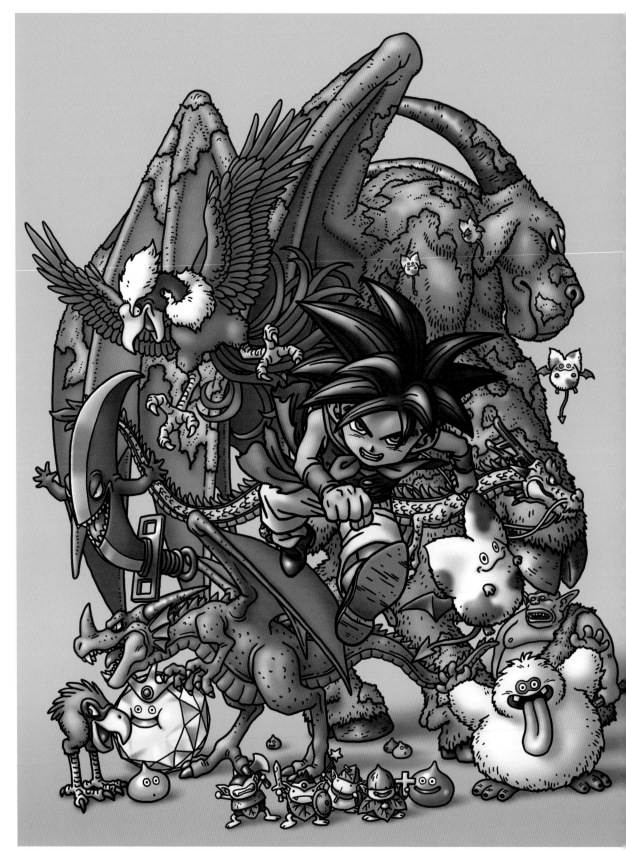

V Jump, June 2010 Special Issue (Released April 21, 2010) • Cover

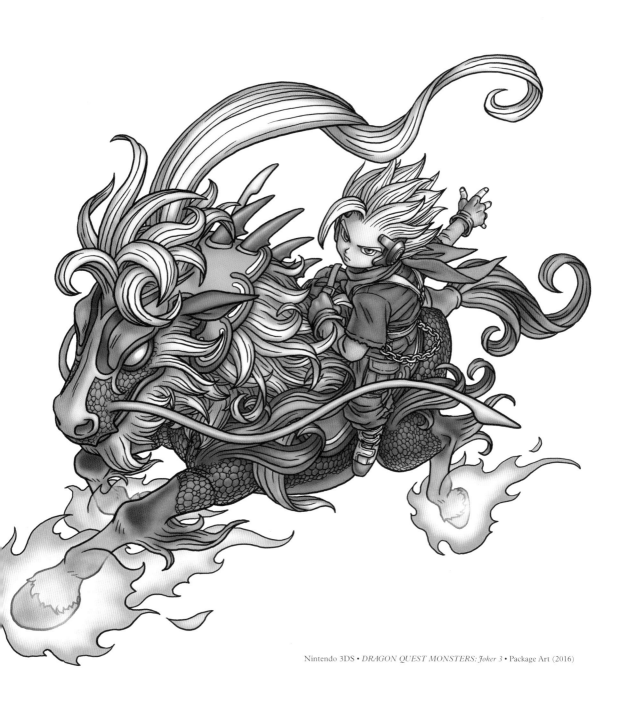

Nintendo 3DS • *DRAGON QUEST MONSTERS: Joker 3* • Package Art (2016)

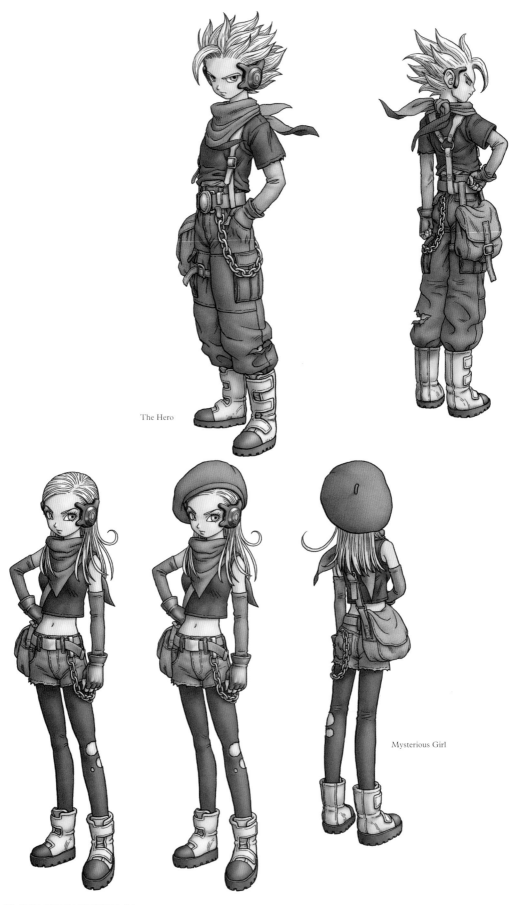

The Hero

Mysterious Girl

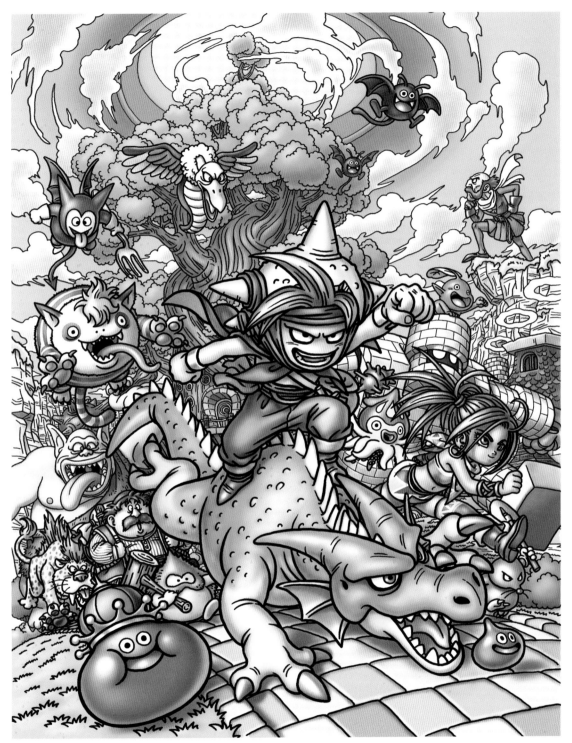

PlayStation 2 • *DRAGON QUEST: Shounen Yangus to Fushigi no Danjon* • Package Art (2006)

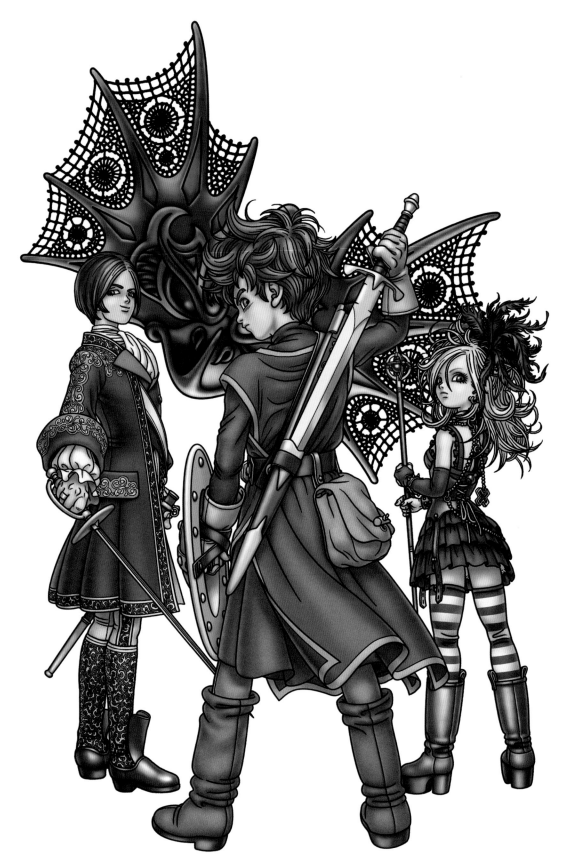

Wii • *DRAGON QUEST SWORDS:The Masked Queen and the Tower of Mirrors* • Package Art (2007)

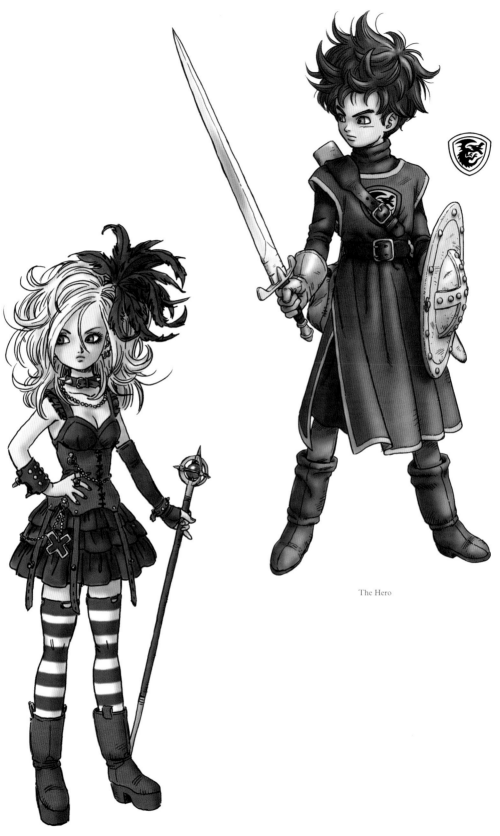

Fleurette

The Hero

185

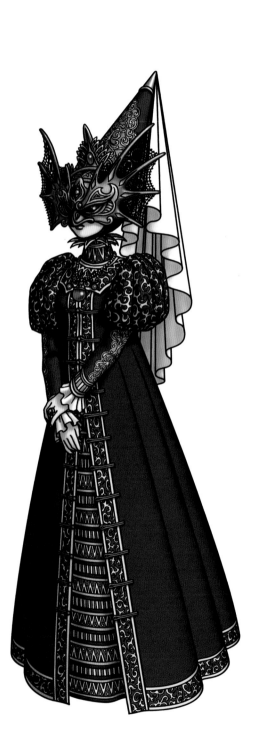

Queen Curtana (w/ sealing mask)

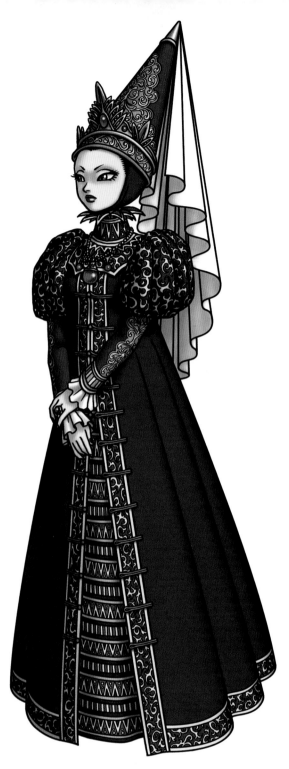

Queen Curtana

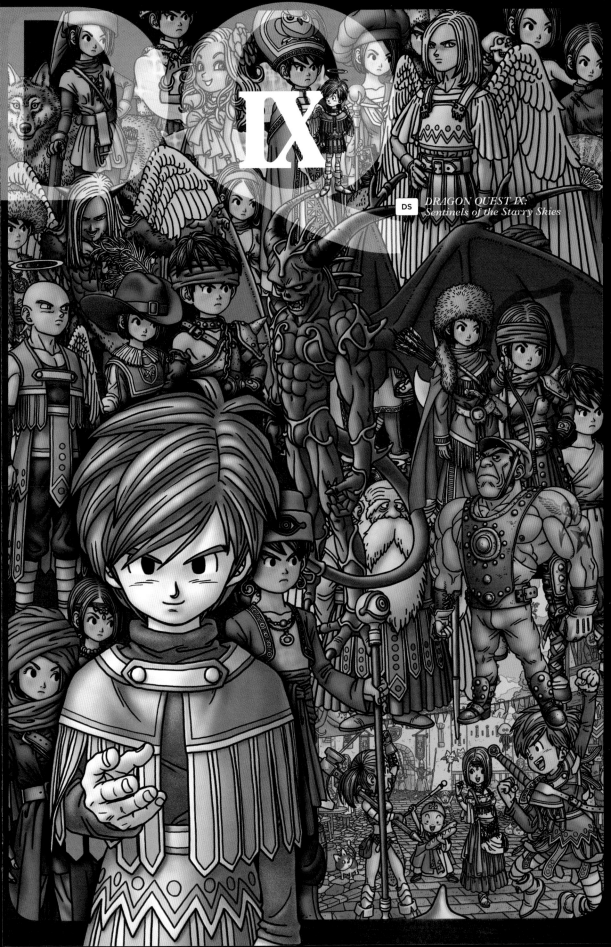

IX

Nintendo DS • *DRAGON QUEST IX: Sentinels of the Starry Skies* • Package Art (2009)

V Jump, August 2009 Issue (Released June 20, 2009) • Giga Jumbo Poster by Toriyama Sensei

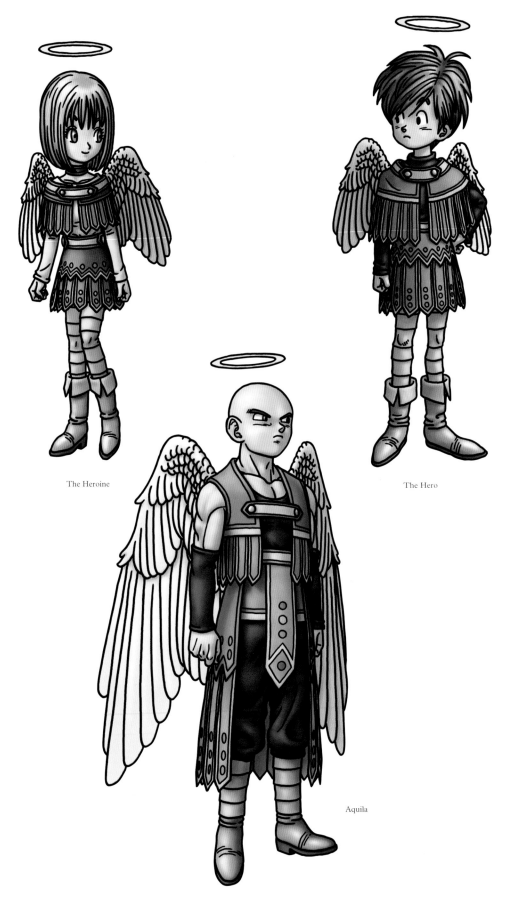

The Heroine

The Hero

Aquila

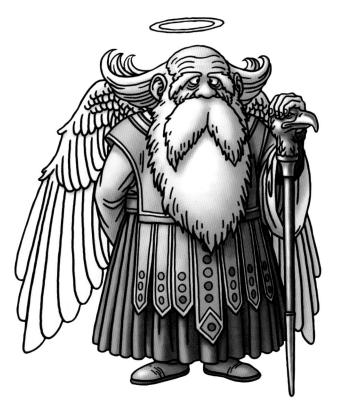

Apus

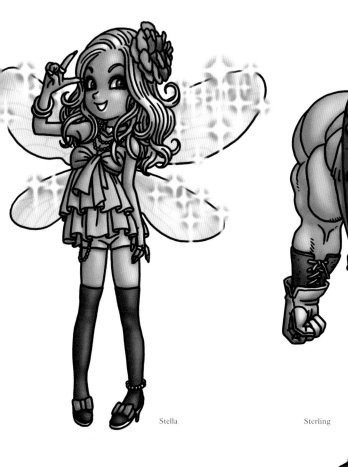

Stella

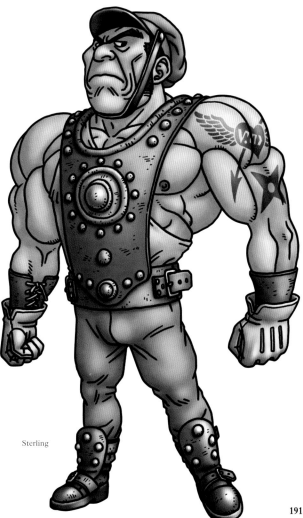

Sterling

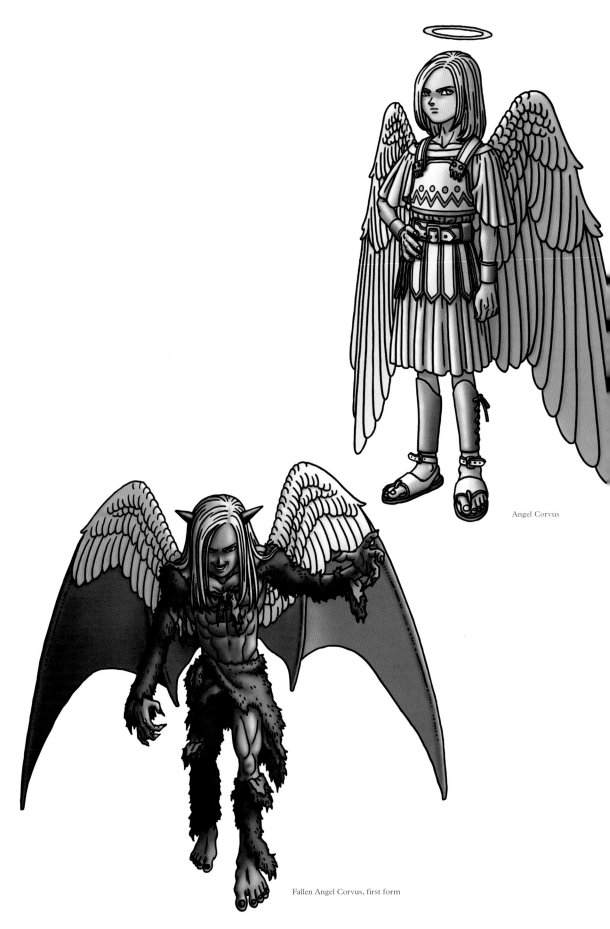

Angel Corvus

Fallen Angel Corvus, first form

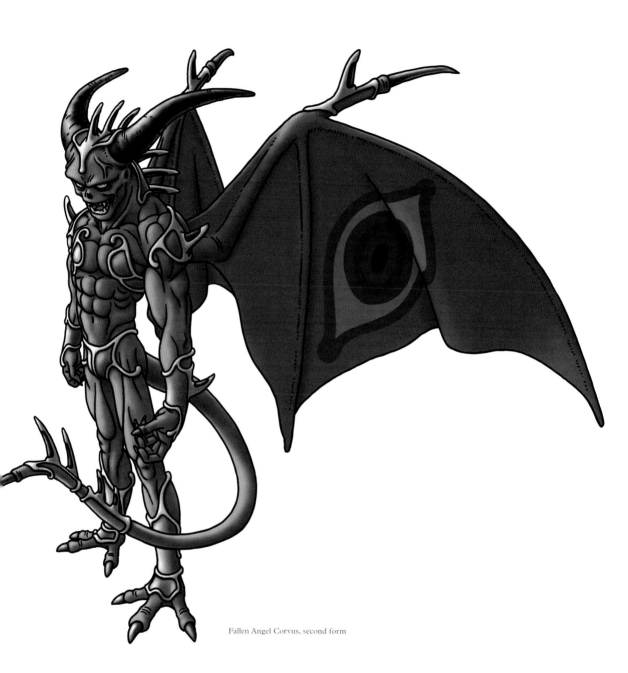

Fallen Angel Corvus, second form

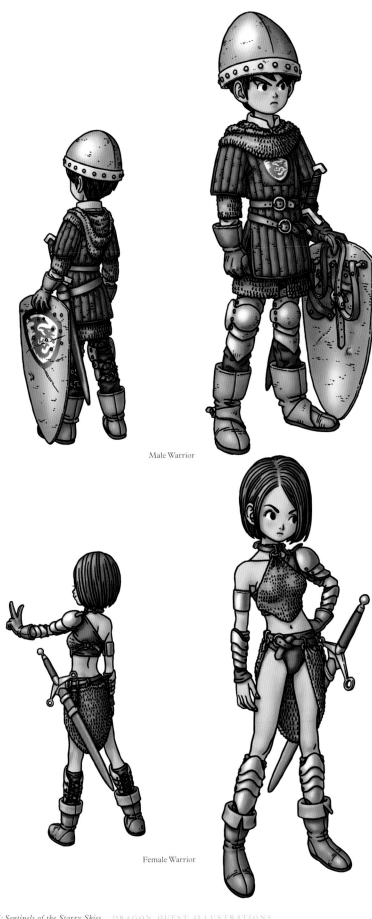

Male Warrior

Female Warrior

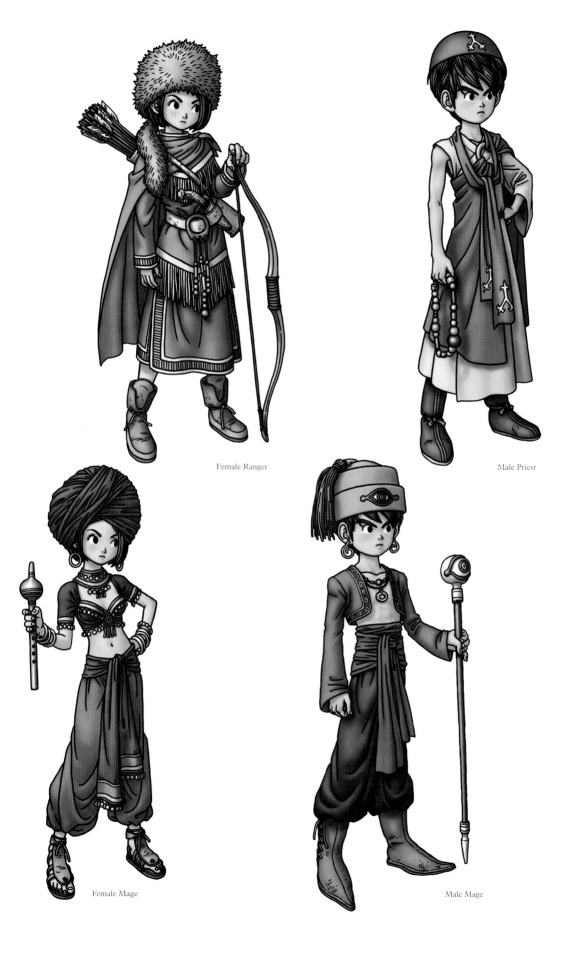

Female Ranger

Male Priest

Female Mage

Male Mage

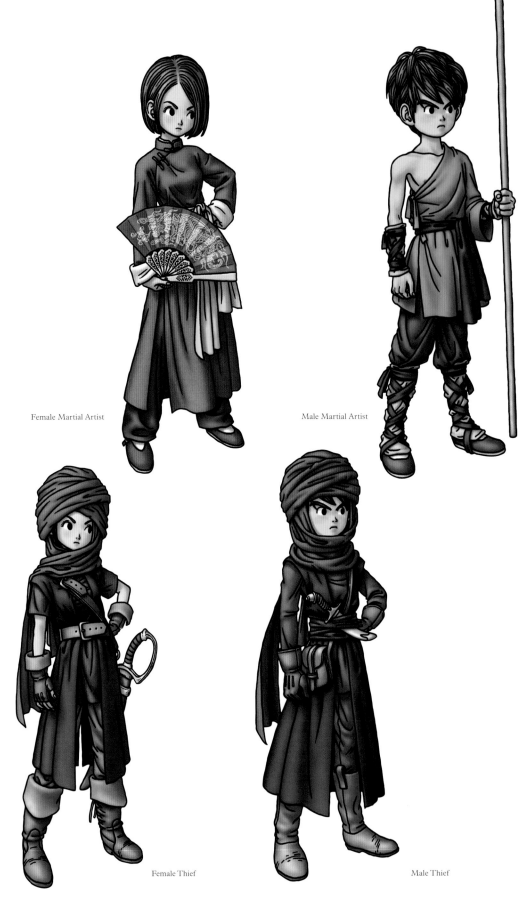

Female Martial Artist

Male Martial Artist

Female Thief

Male Thief

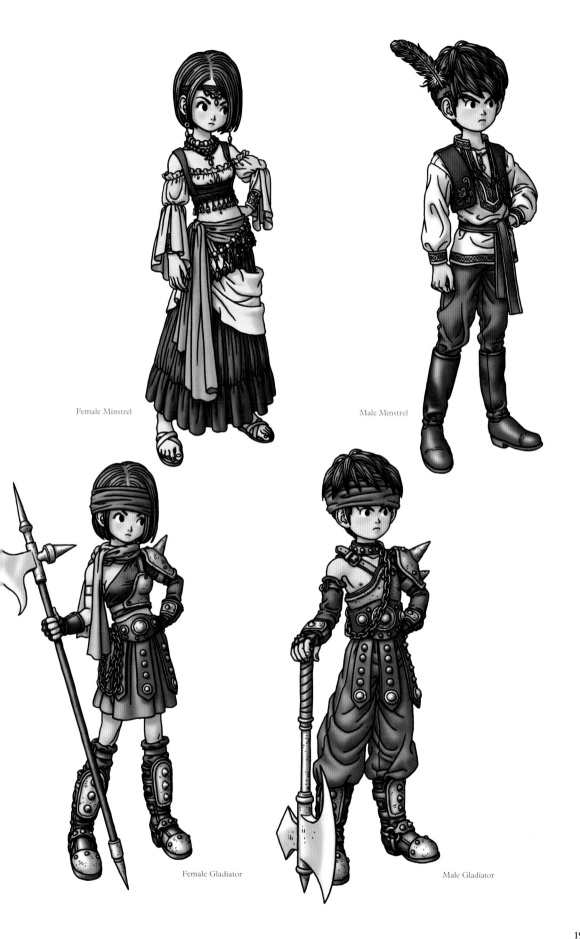

Female Minstrel

Male Minstrel

Female Gladiator

Male Gladiator

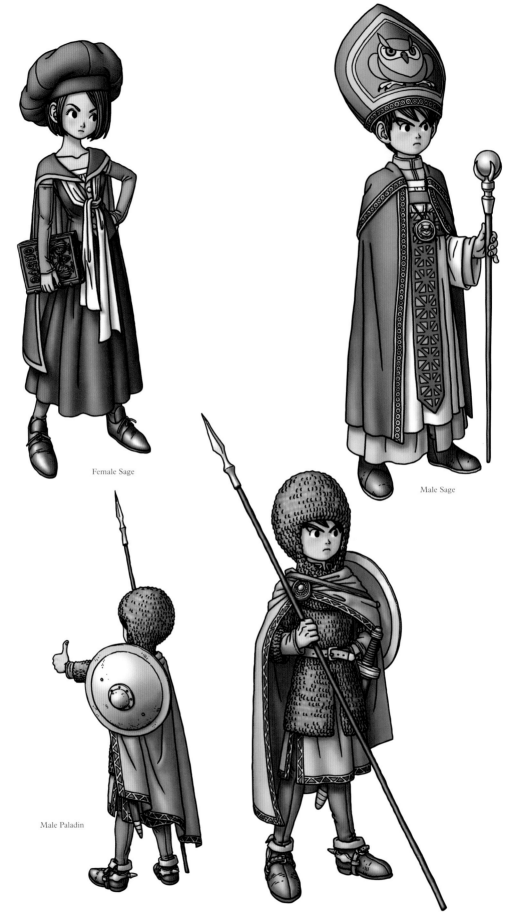

Female Sage

Male Sage

Male Paladin

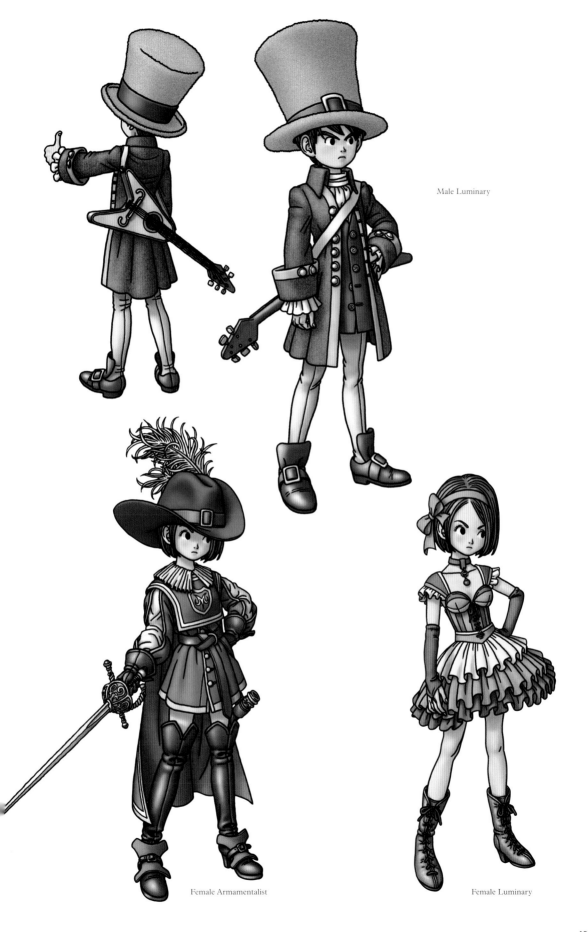

Male Luminary

Female Armamentalist

Female Luminary

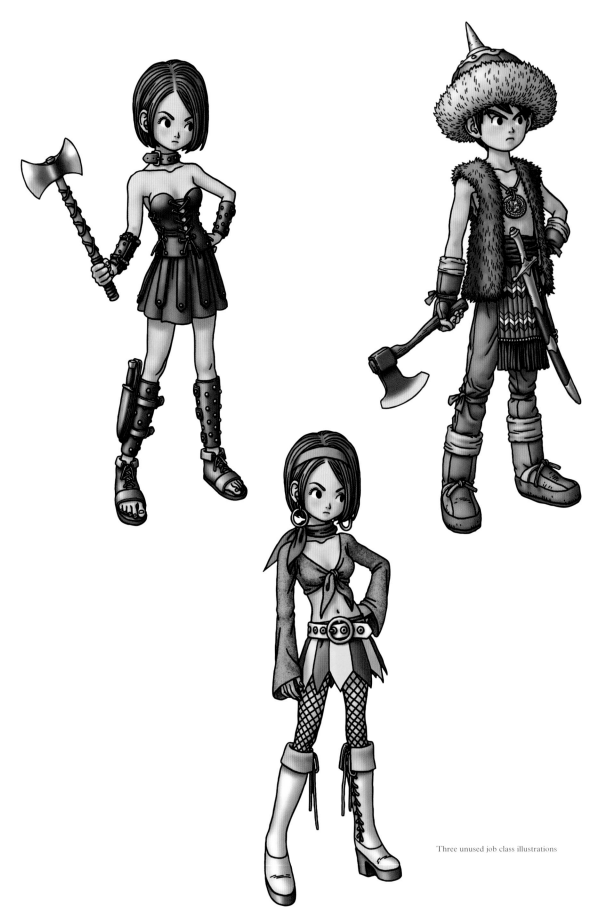

Three unused job class illustrations

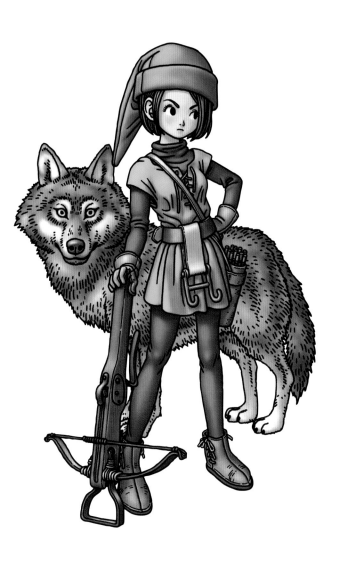

Two unused job class illustrations

DRAGON QUEST
SPIN-OFF SERIES
ILLUSTRATIONS

DRAGON QUEST: Monsutaa Batoru Roodo **(2007)**

DRAGON QUEST: Monsutaa Batoru Roodo II **(2008)**

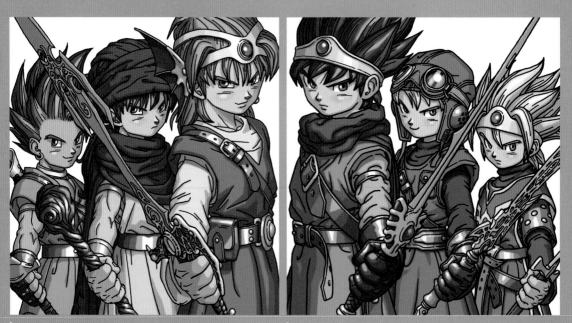

V Jump, January 2009 Issue (Released November 21, 2008) • Cover

V Jump, November 2008 Issue (Released September 20, 2008) • Cover
V Jump Special Limited SP Card "Erdrick's Crest/Ball of Light"

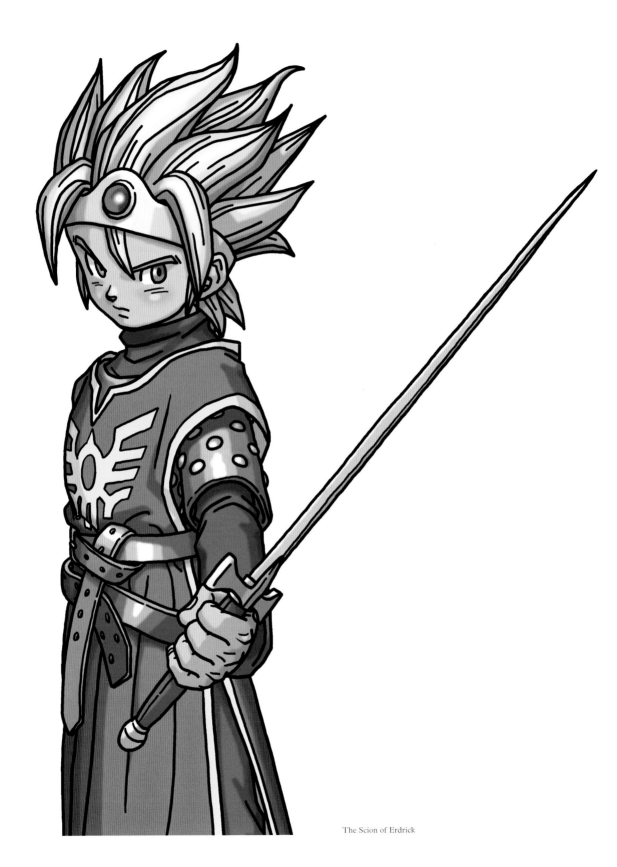

The Scion of Erdrick

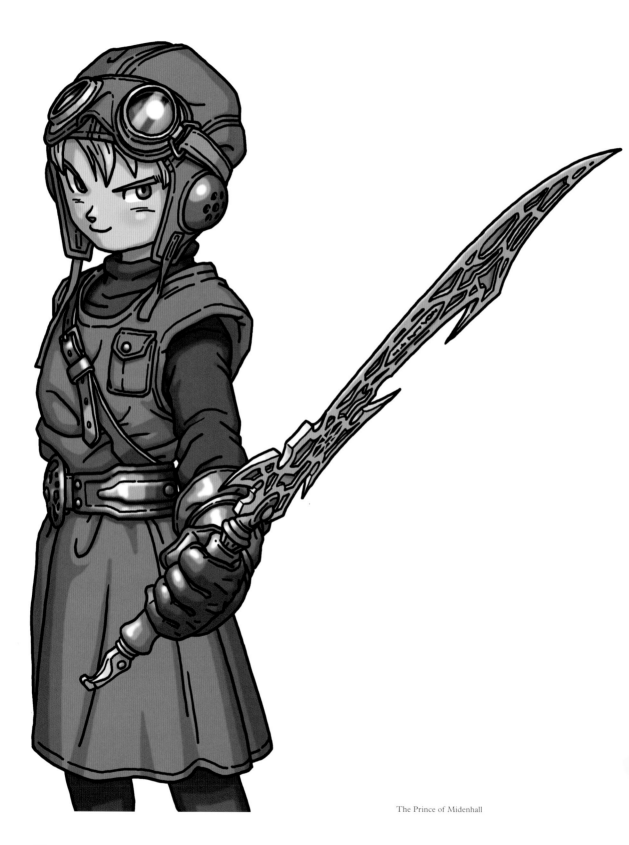

The Prince of Midenhall

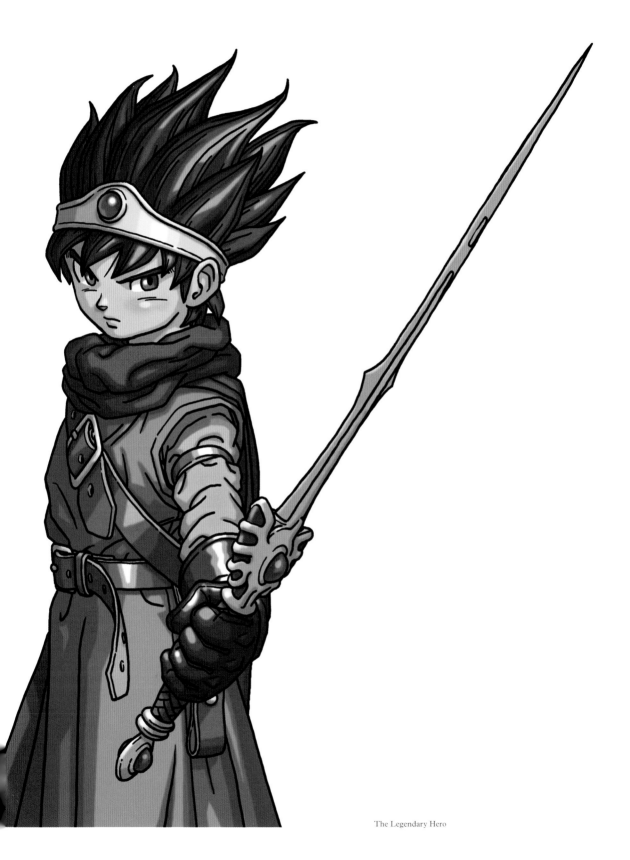

The Legendary Hero

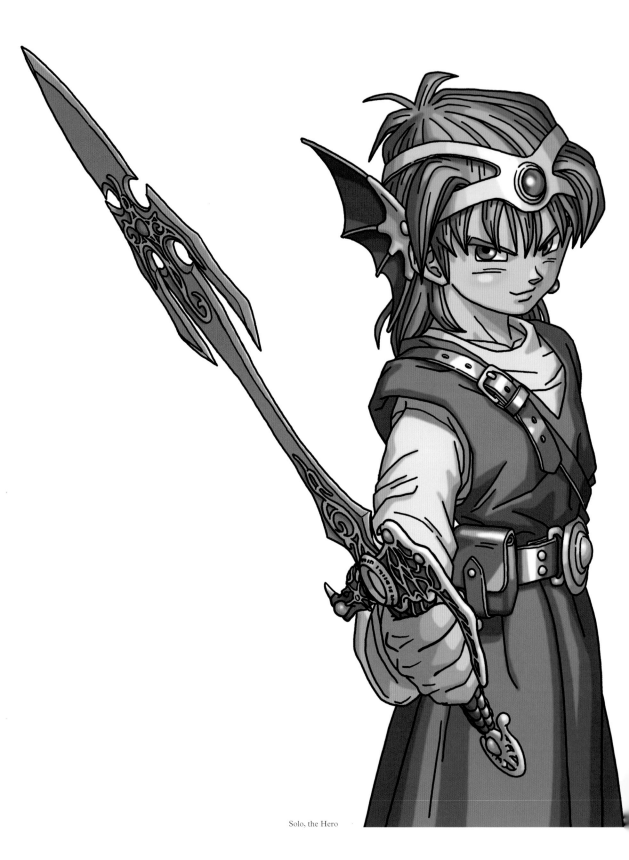

Solo, the Hero

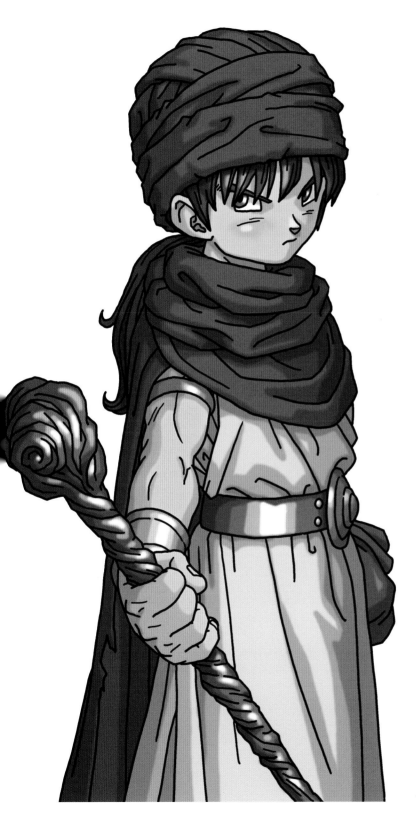

The Legendary Monster-tamer

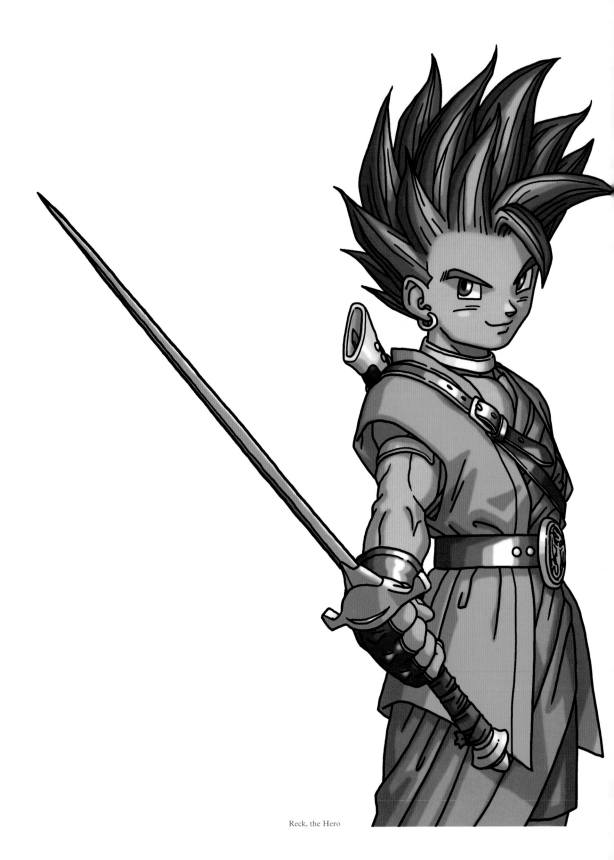

Reck, the Hero

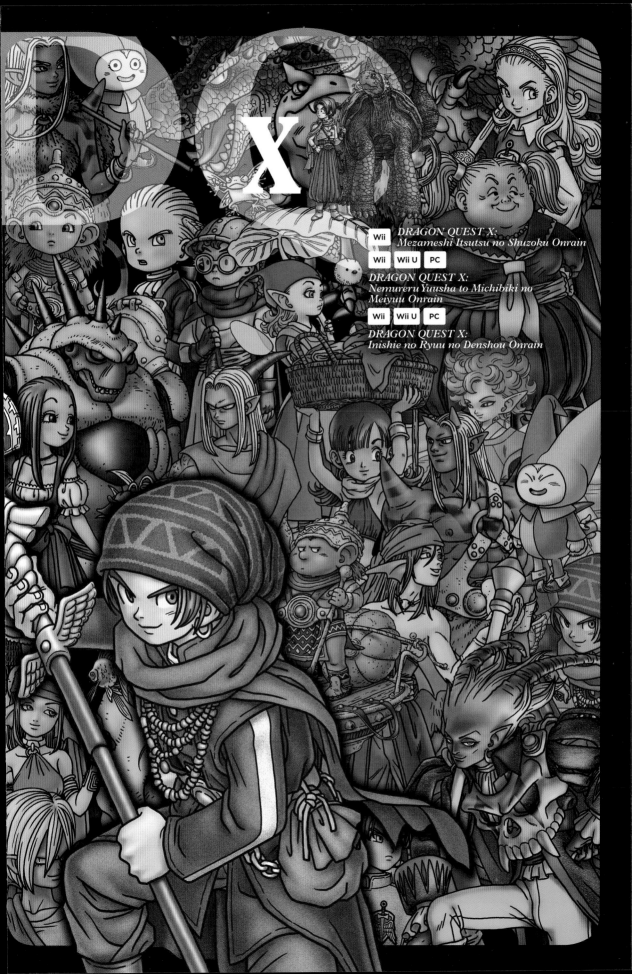

X

Wii

DRAGON QUEST X:
Mezameshi Itsutsu no Shuzoku Onrain

Wii | Wii U | PC

DRAGON QUEST X:
Nemureru Yuusha to Michibiki no
Meiyuu Onrain

Wii | Wii U | PC

DRAGON QUEST X:
Inishie no Ryuu no Denshou Onrain

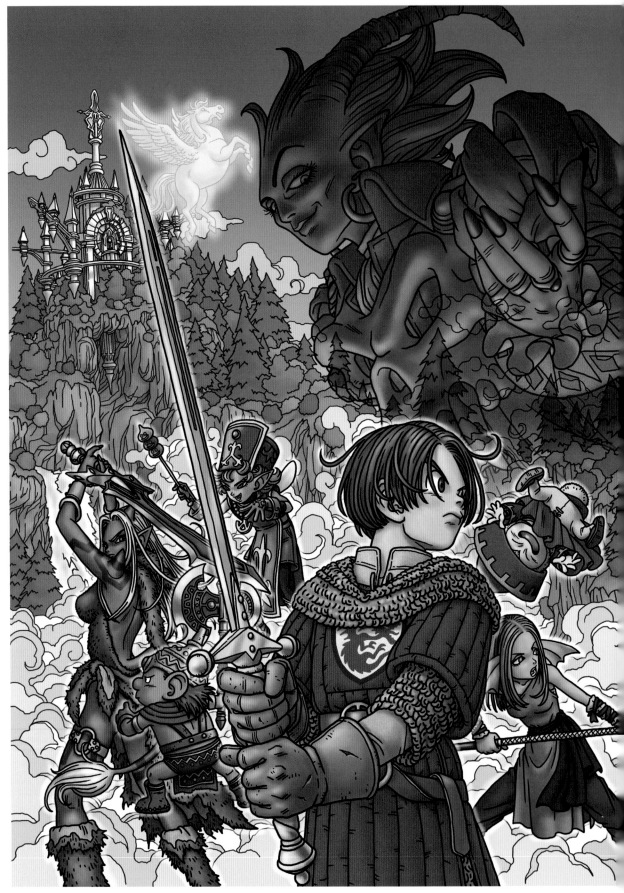

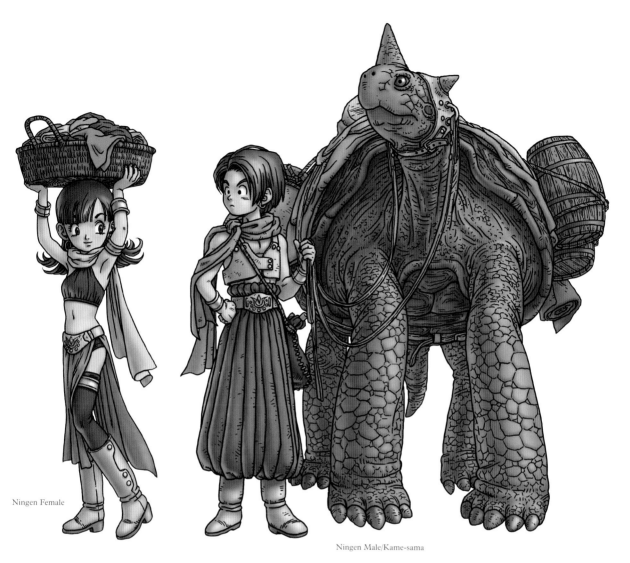

Ningen Female

Ningen Male/Kame-sama

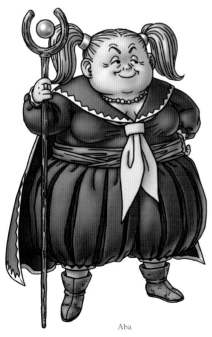

Aba

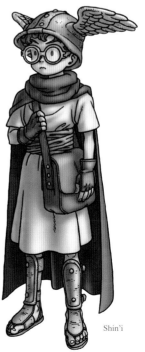

Shin'i

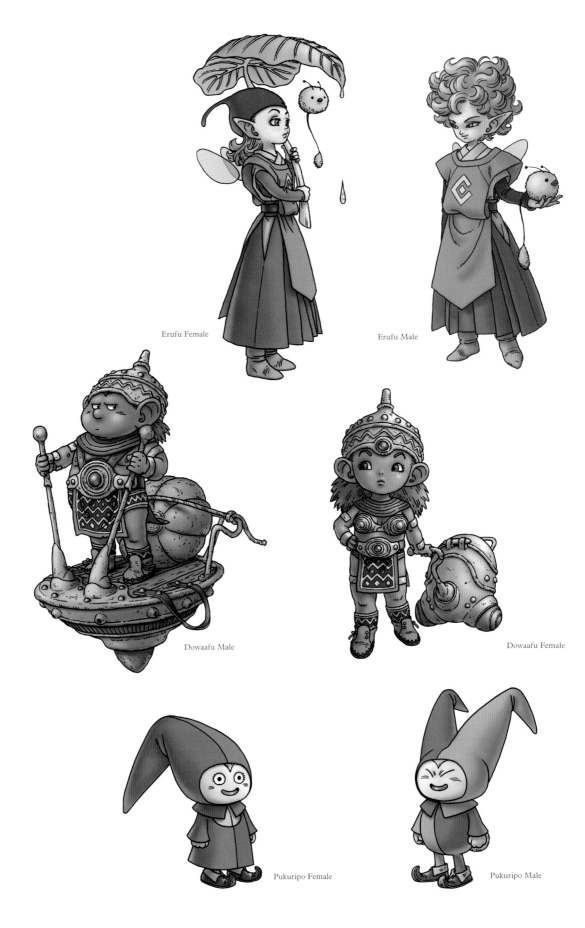

Erufu Female

Erufu Male

Dowaafu Male

Dowaafu Female

Pukuripo Female

Pukuripo Male

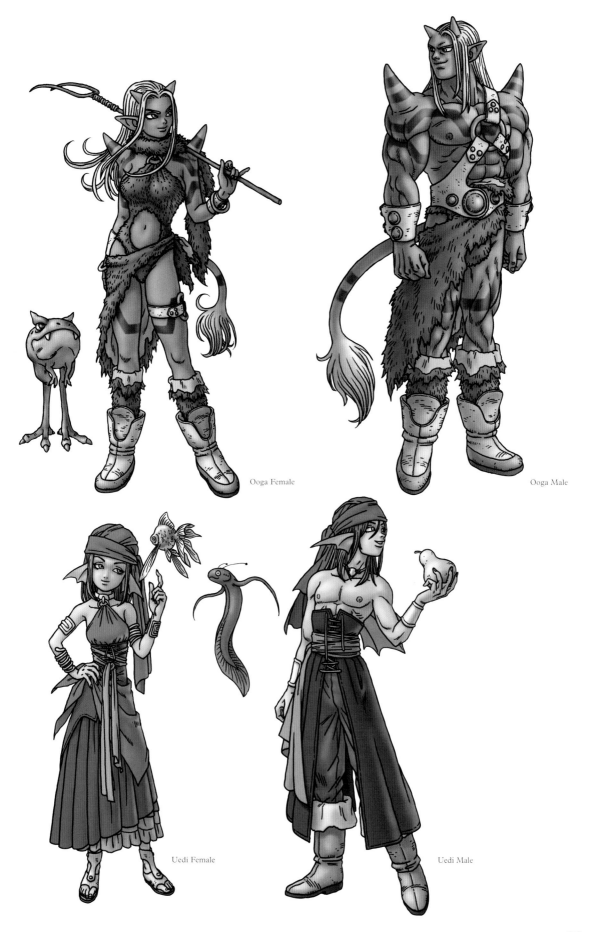

Ooga Female

Ooga Male

Uedi Female

Uedi Male

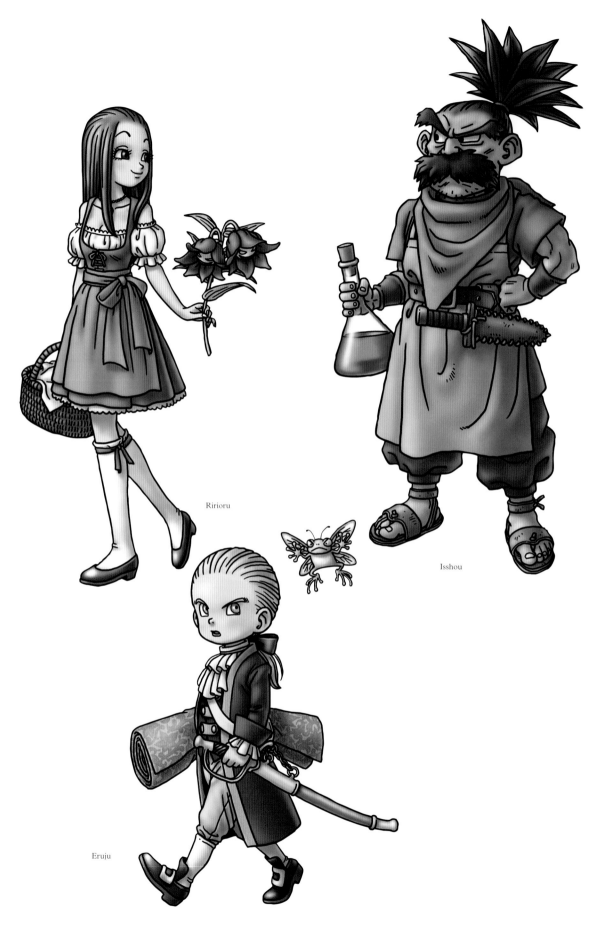

Ririoru

Isshou

Eruju

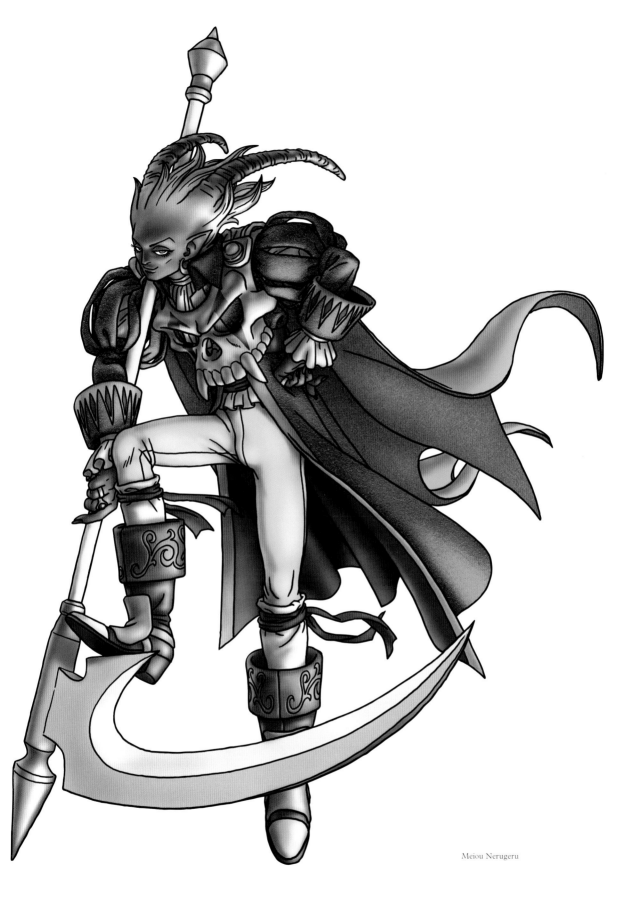

Meiou Nerugeru

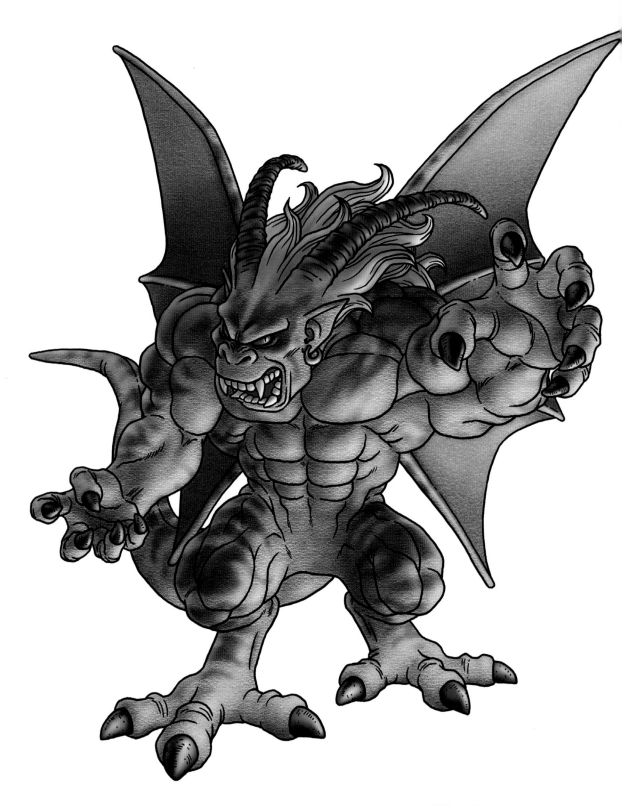

Meijuuou Nerugeru

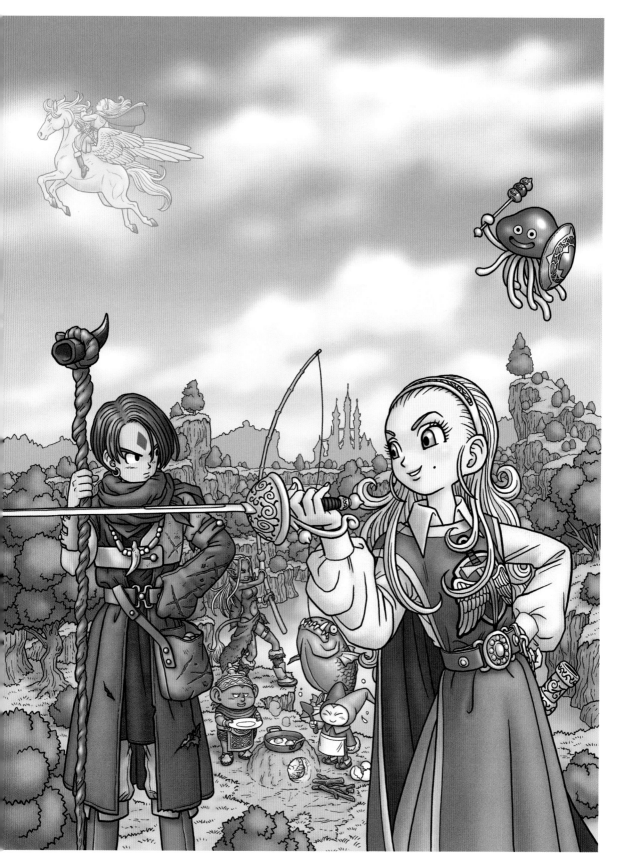

Wii/Wii U/PC • *DRAGON QUEST X: Nemureru Yuusha to Michibiki no Meiyuu Onrain* • Package Art (2013)

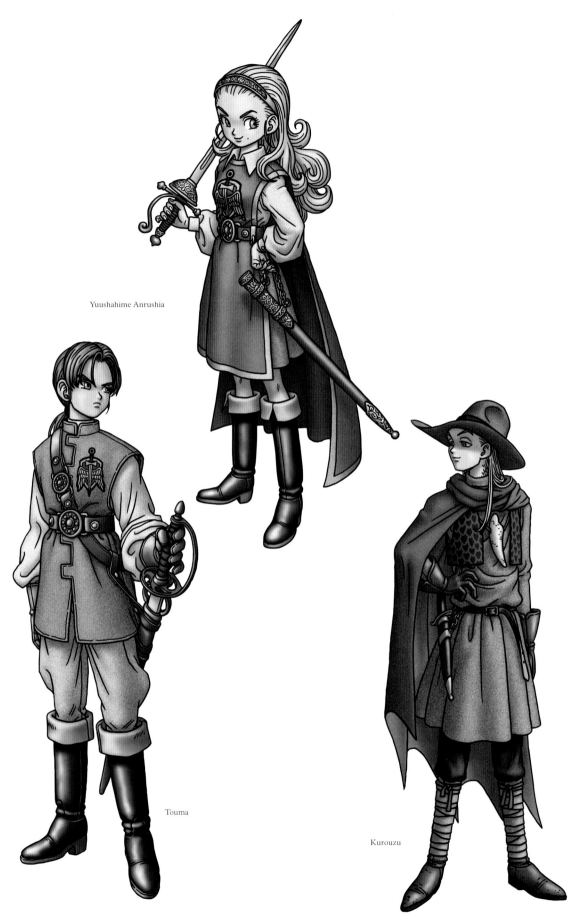

Yuushahime Anrushia

Touma

Kurouzu

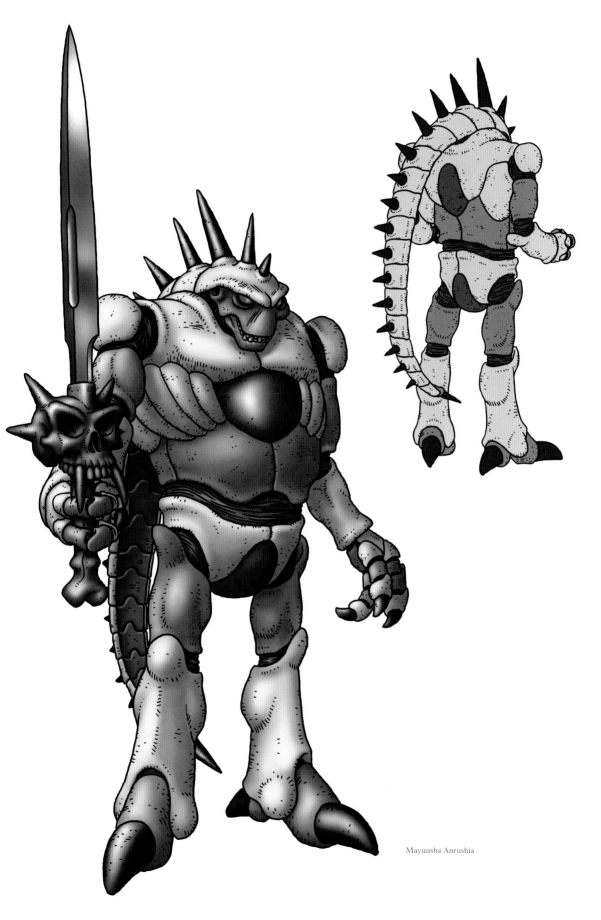

Mayuusha Anrushia

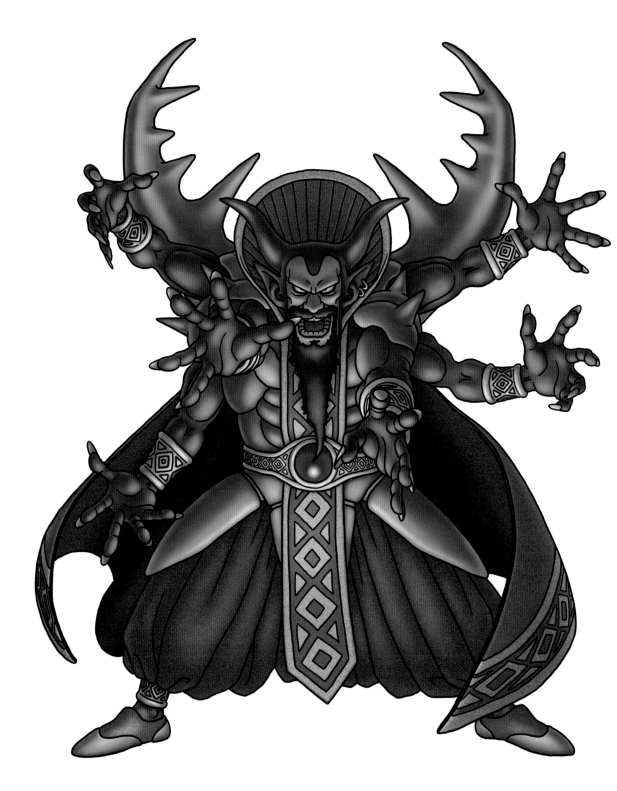

Daimaou Madesagoura

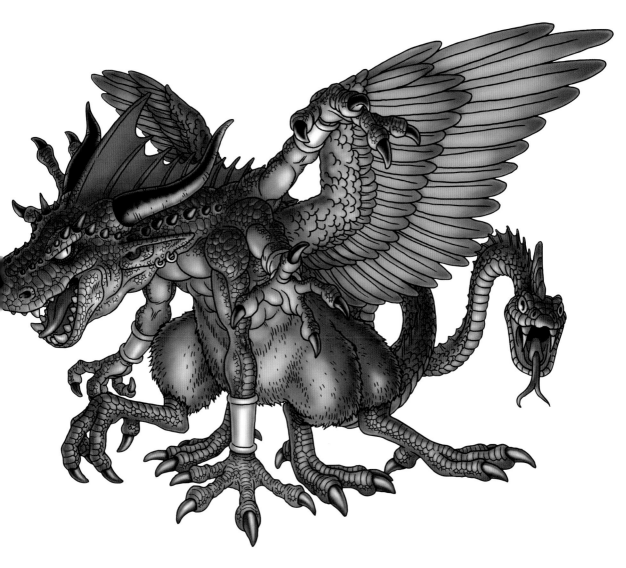

Souzoushin Madesagoura

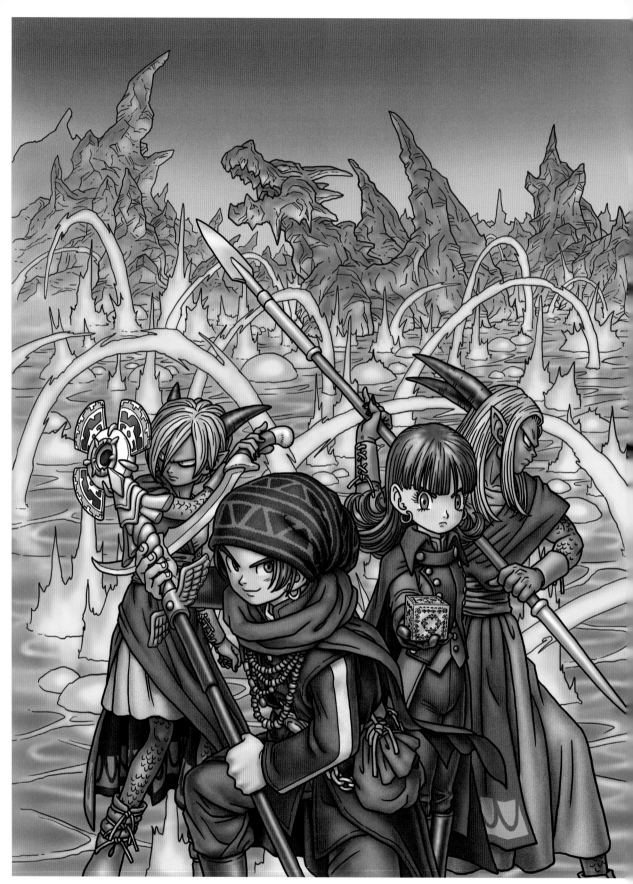

Wii/Wii U/PC • *DRAGON QUEST X: Inishie no Ryuu no Denshou Onrain* • Package Art (2015)

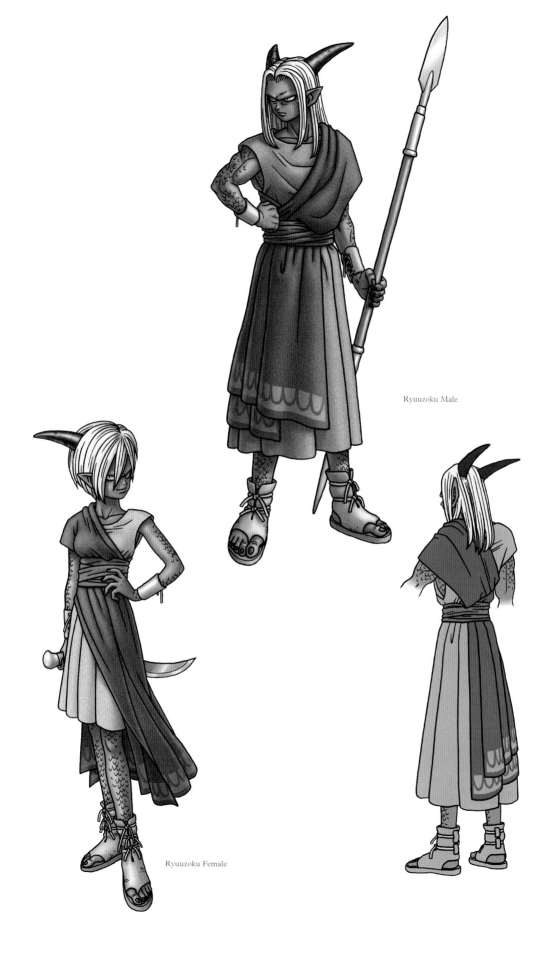

Ryuuzoku Male

Ryuuzoku Female

DRAGON QUEST
SPIN-OFF SERIES
ILLUSTRATIONS Part 5

DRAGON QUEST BUILDERS • Package art character (2016)

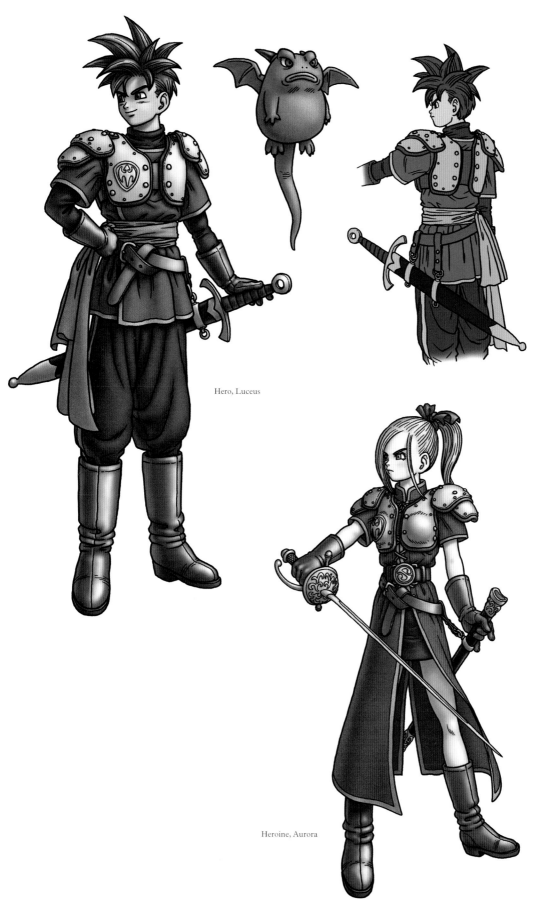

Hero, Luceus

Heroine, Aurora

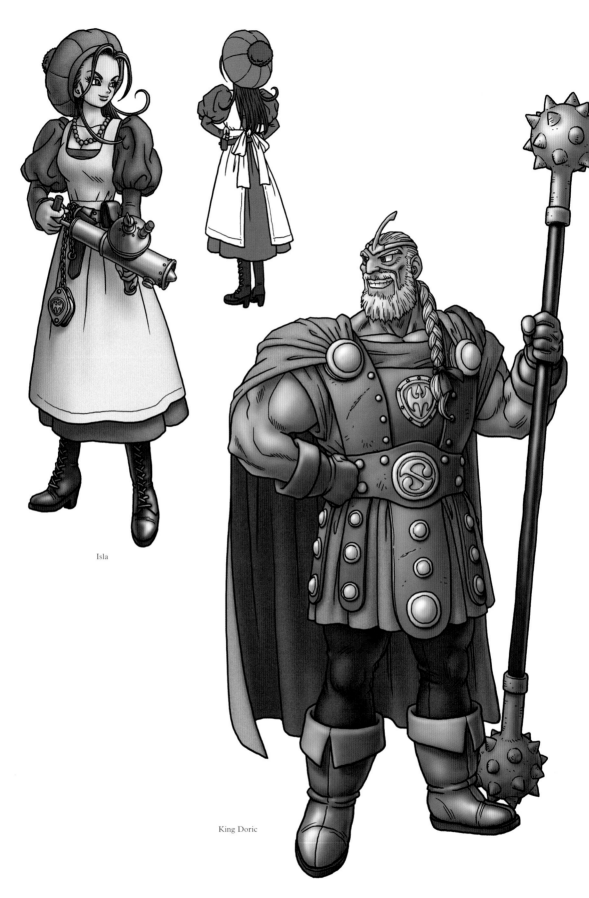

Isla

King Doric

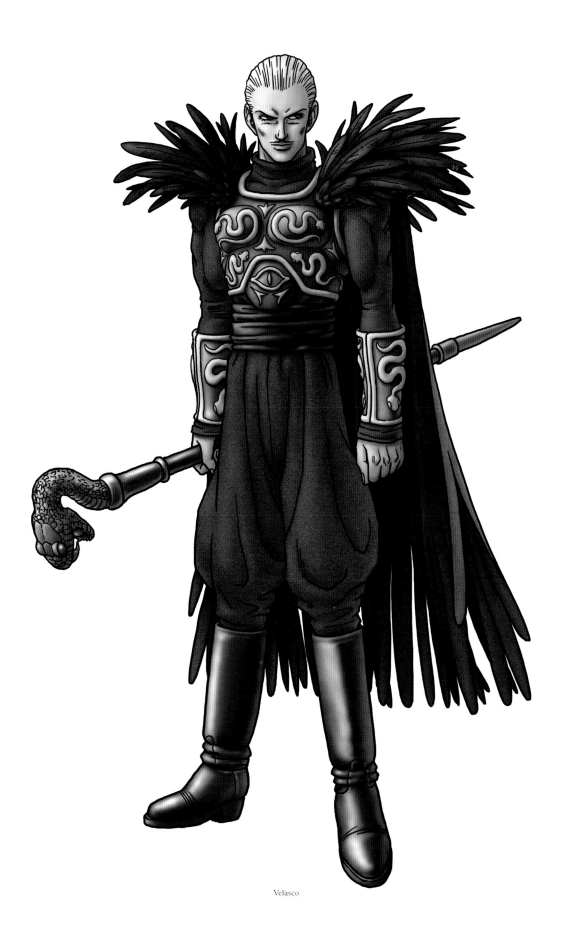

Velasco

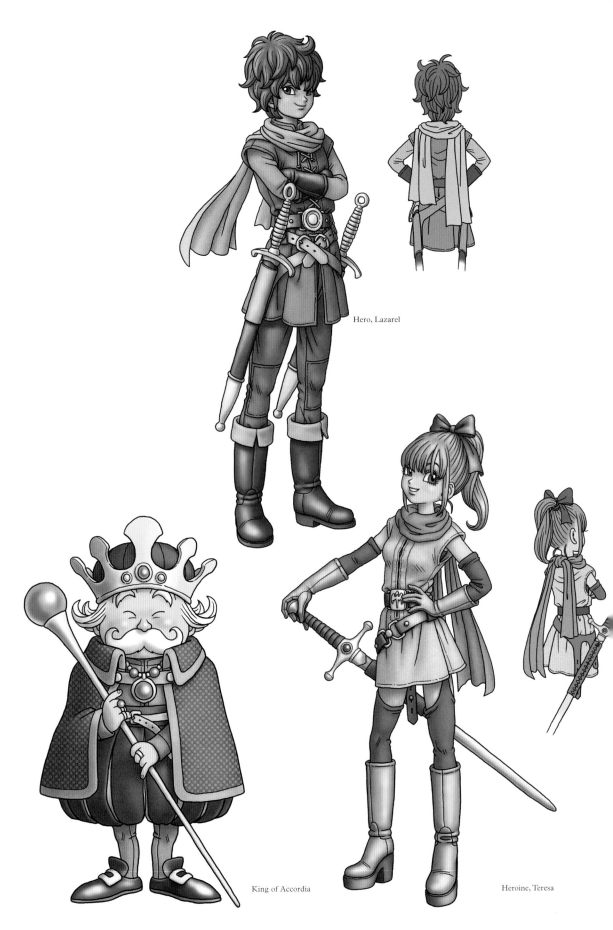

Hero, Lazarel

King of Accordia

Heroine, Teresa

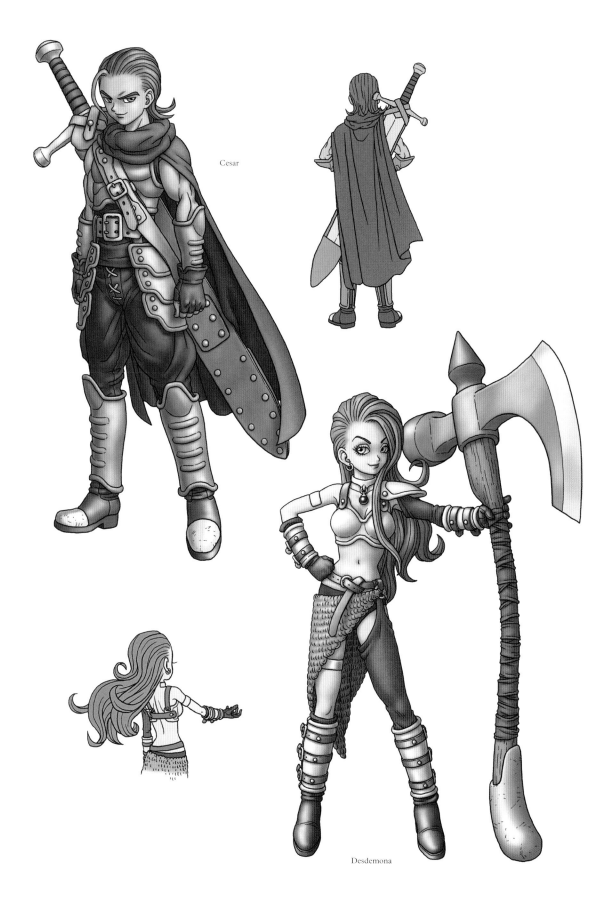

Cesar

Desdemona

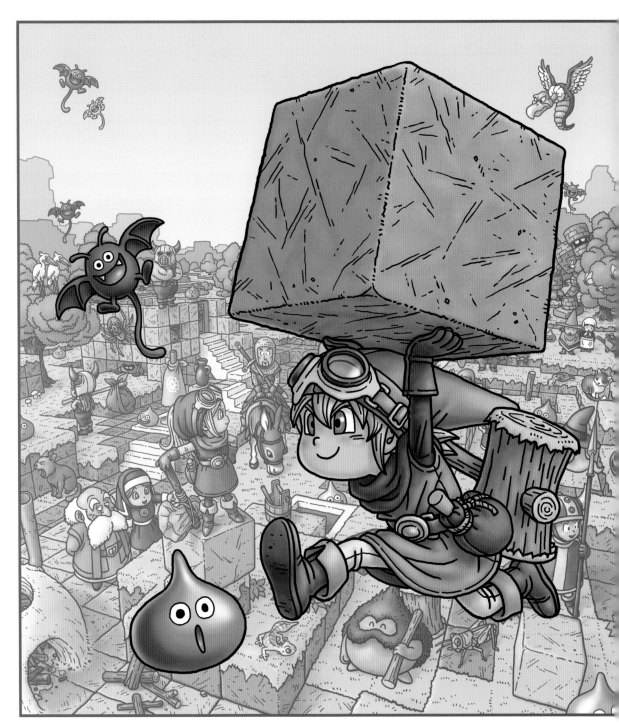

PlayStation 4/PlayStation 3/PlayStation Vita • *DRAGON QUEST BUILDERS* • Package Art (2016)

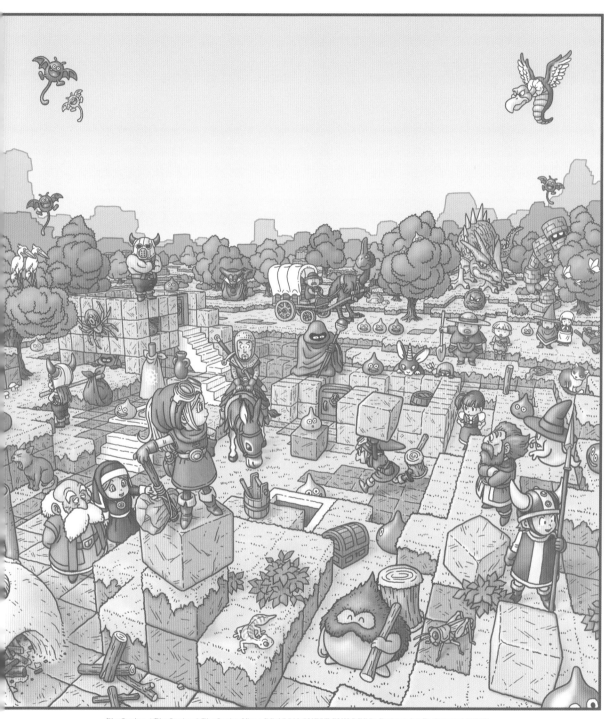

PlayStation 4/PlayStation 3/PlayStation Vita • *DRAGON QUEST BUILDERS* • Package Art Background (2016)

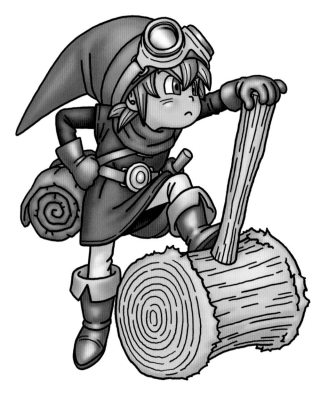

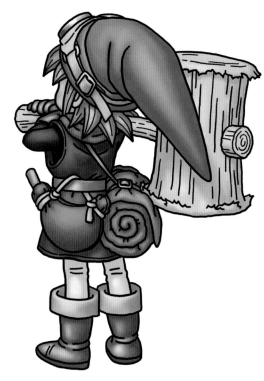

The Hero

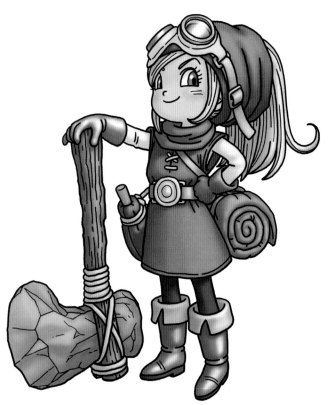

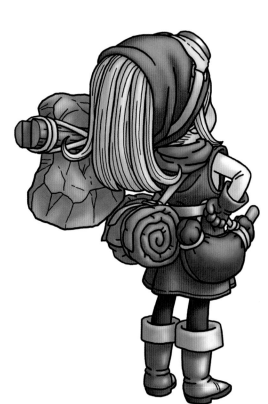

The Heroine

And on to *DRAGON QUEST XI: Echoes of an Elusive Age...*

You've just seen over 500 illustrations from the *DRAGON QUEST* series, drawn by Akira Toriyama over the course of thirty years. This enormous amount of art ties together those thirty years' worth of history and gives us a glimpse at the future. *DRAGON QUEST XI* is next, and the journey surely won't end there...

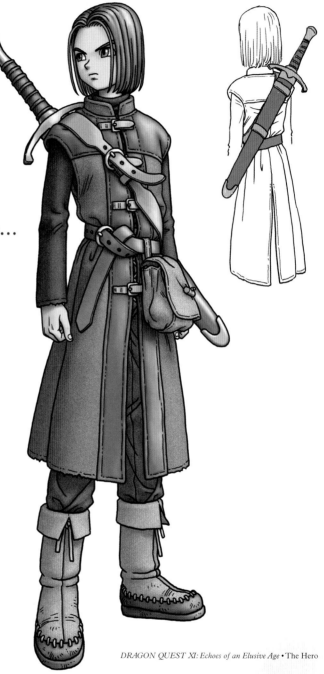

DRAGON QUEST XI: Echoes of an Elusive Age • The Hero

The adventure continues...

ANALYSIS OF DRAGON QUEST Illustrations

The editorial staff of *V Jump* took a look at the thirty years' worth of Akira Toriyama's *DRAGON QUEST* illustrations found in this book, analyzed them, and explained their thoughts game by game. Be warned that some of it may be conjecture, as much about the older games is unclear or ambiguous. In the following pages, you'll also find truths brought to light by valuable testimony from people involved with the games' development— truths revealed for the very first time right here.

DQ | *DRAGON QUEST*

DRAGON QUEST, the first game in the series, released for the Family Computer System (Famicom) on May 27, 1986. This book includes the single package art illustration and fifteen monster illustrations. While compiling the book, we discovered that an extra variation of each illustration existed besides the final version. These all appeared on a single sheet, and we've spread them out over pages 8 through 11. There are also the precolored monochrome versions, whose shadows make them distinct from the final versions. We can assume that Toriyama was told not to use those shadows, in the end.

DQ II | *DRAGON QUEST II*

Following the success of the first game, *DRAGON QUEST II: Luminaries of the Legendary Line* released eight months later for Famicom. The illustrations from that game include the package art, concept art for over forty monsters, and the three playable characters in the player's party.

The faux-pixelated versions of those three characters (found on the right side of page 15) were meant to mimic the Famicom's pixel sprites. These are likely what Toriyama was referring to in an interview when he mentioned the first time he drew "sprite-looking art" early on in the series' timeline. The base character designs for the Prince of Midenhall, the Prince of Cannock, and the Princess of Moonbrooke were modified into these pixel forms. Some monster designs also received similar treatment to make them suitable for Famicom graphics (see the top of page 18). The Bubble Slime design was the only one incorporated as such, while the rest received the standard Toriyama look.

Multiple *DQ II* monsters were found on a single page of illustrations, with many having tentative names written in pencil by Toriyama himself. Those monsters and names have been left as-is in this book. Many among them ended up unused, though some would be revived and implemented in future games, as with Cannibox (in *DQ III*) and Tortoceratops (in *DQ V*).

DQ III | *DRAGON QUEST III*

Unlike other illustrations, the package art for Famicom's *DRAGON QUEST III: The Seeds of Salvation* is remarkable in that it was drawn on light gray Color Kent paper. We can't speak to the original product packaging, but in this book, the surrounding paper's color is faithfully portrayed. This gives the art a certain gravitas.

There are also over fifty monster illustrations. The tentative names written in pen by Toriyama are unique to the monster concept art of *DQ III*. Of particular note is the one appearing next to Small Satan (Imp)—"King Satan." Did Toriyama imagine that to be the Imp's mature form?

Looking at the boss concept art, we see that "Boss #2" (beneath Baramos) and Demon Lord Zoma's second form (on page 28) also went unused. *DQ III* was already pushing the limits on data capacity to the extent that the title screen was omitted, so we can surmise that there were, at one point, grand plans for all this unused content.

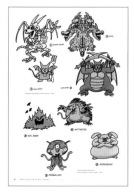

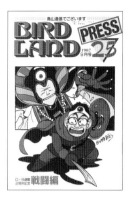

The Super Famicom remake added the new thief class, with concept art of its own. Note Toriyama's comment next to the female thief. Notes like this give us a valuable glimpse about his preferences concerning his own work. Now, we present a pair of incredibly rare images drawn for *DQ III*'s release. The first is the cover of volume 25 of *BIRD LAND PRESS*, the newsletter of the Akira Toriyama Preservation Society (Toriyama's fan club, which has since ceased operations). In keeping with Toriyama's sensibilities, it features Toriyama himself as the hero and *Weekly Shonen Jump* editor Torishima, also known as Mashirito, as Demon Lord Zoma. The September 1987 issue was likely delivered to club members in August of that year. However, *DQ III* wasn't released until February 10, 1988, meaning that any suggestion of Zoma amounted to major spoilers for the game, even if the name "Zoma" doesn't appear anywhere.

The second image is a 1988 New Year's postcard for members of the fan club. Toriyama appears to be playing *DQ III* before it was released! Perhaps he got to beta test a ROM of the game, which tells you how easygoing those days were.

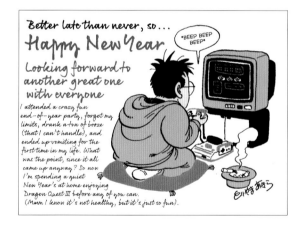

DQ IV | *DRAGON QUEST IV*

Within the illustrations from Famicom's *DRAGON QUEST IV: Chapters of the Chosen*, the highlight is without a doubt the respective heroes from parts one through five of the game. It's noteworthy that these characters have more realistic proportions than those from past games. The deeper story and richer characters of *DQ IV* supplemented the Famicom's sprites, and those realistic proportions in the concept art were a great way to stimulate the imagination.

Each of the sixty monster illustrations was done on a separate page with its own code number. We've presented them in sequential order in this book, as that's likely the order in which Toriyama drew them. The Peddler is included among these monsters.

The two illustrations on page 42 come from the strategy guide put out by *Weekly Shonen Jump*. Here, you can also see the cover of that strategy guide and the monochrome

Famicom Shinken Ougi Daizensho: DRAGON QUEST IV Guide • Chapter title art

Famicom Shinken Ougi Daizensho: DRAGON QUEST IV Guide • Cover

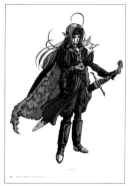

title art for each chapter of the book. The characters received new concept art for the 2001 PlayStation remake of the game. This version features fresh content where Psaro joins the party, so he received new illustrations of his own. These only appeared in print a few times, so we've given Psaro as much space as possible in this book.

DQ V | *DRAGON QUEST V*

DRAGON QUEST V: Hand of the Heavenly Bride released on the Super Famicom, and with new hardware came larger game boxes, which meant bigger package art. A second large illustration features the protagonist as a child, and many readers will recall that that one was used for the instruction manual. The Super Famicom hardware was capable of portraying assets in more detail, which might explain why Toriyama also drew the various NPCs to populate the towns and villages (see page 76). Based on testimony from the production team, however, his NPC designs were a little too distinctive and therefore aren't portrayed in the game.

The non-boss monsters are presented in Japanese alphabetical order. Each was drawn on its own page, just like those from *DQ IV*, but many of the *DQ V* monster

illustrations were even bigger yet. Grandmaster Nizmo's second form, for instance, is a particularly striking piece of art that spread to the very edges of the page. Bjorn is another one that stands out as a hazy-looking monster in the far distance. We learned that Toriyama first made a photocopy to lighten the lines of the drawing before coloring it. This section also includes a whopping twelve unused monster designs.

DQ VI | *DRAGON QUEST VI*

From Super Famicom's *DRAGON QUEST VI: Realms of Revelation*, we have the package art and character concept illustrations. It's striking how the dragon's wings poke out beyond the border of the vertically aligned Super Famicom game box. The monsters on page 106 are from *DQ VI* but were actually drawn at the time of *DQ V*'s release. Giant Moth and Stormsgate Citadel were revived after going unused, and Pudgedevil was originally meant to be Grandmaster Nizmo's first form, which is evident from the similarities between the two designs. Note that Pudgedevil is just a palette swap of Murdaw.

On page 107, we have an unused concept for the hero of the game. This character has been referenced in interviews

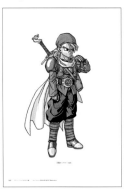

since as one who was a little too distinctive to play the hero. With appeal more befitting a side character, he was shelved in favor of the *DQ VI* hero we're familiar with. The influence on Terry's design is clear. Yuji Horii has stated, in fact, that the *DQ VI* hero was originally going to be Terry, but perhaps he was specifically referring to this unused design.

DQ VII | *DRAGON QUEST VII*

DRAGON QUEST VII: Fragments of the Forgotten Past on PlayStation was the first game in the main, numbered series whose art was colored digitally. *DRAGON QUEST MONSTERS: Terry no Wandaarando* for Game Boy, *Torneko: Last Hope* for PlayStation, and *DRAGON QUEST I+II* for PC also used digitally colored art, but compared to those designs, *DQ VII* makes greater use of shading and cloth details for added realism. What's more, there are more characters than just those in the player's party; we also have illustrations of the hero's family and Kiefer's family to round out the cast.

DQ VIII | *DRAGON QUEST VIII*

The PlayStation 2—the most advanced hardware at the time—brought the world of *DRAGON QUEST VIII:*

Journey of the Cursed King to life with 3-D graphics and cel shading. *DRAGON QUEST* never looked so real as in this ambitious project. Up until this point, Toriyama's illustrations served as mere supplementary material for the sprites in the games themselves, but with this title, his art could actually be implemented into the game world—a fact he was aware of when designing. As a result, we see much more concept art for the party characters, including multiple expressions and representations of game mechanics like the Super High Tension mode.

The sheer number of NPC characters is also astounding (see pages 157 through 164). According to those involved at the time, nobody expected Toriyama to draw quite this much. The knowledge that cel shading would allow all these character to be implemented directly must have gotten his creative juices flowing, leading to more concept art than anticipated. Playing the game reveals just how faithfully these designs were replicated. From what we've discovered, Toriyama enjoys drawing these ordinary, understated folks more than the typically "cool" hero characters. However, we learned that some of these NPCs were a little too quirky looking, and as such, they only have rough, unfinished designs. Two such rough designs (without shading, even) are presented here.

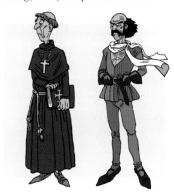

One is an elderly monk, and the other may be familiar to some readers. That's right—Morrie, the host of Monsutaa Batoru Roodo, was originally

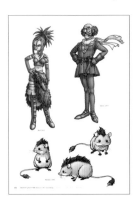

designed to be the town's rich man (Dominico)! But as previously explained, his design was a little too extravagant for a less important NPC, so the role went to Dominico's design. Later in the development process, the red and green–garbed man was brought back as the basis for Morrie, a much deeper character. Accordingly, there wasn't official concept art of Morrie from Toriyama for quite a long time. That is, until *DQ VIII* came out on the Nintendo DS, because in that version of the game, Morrie

received the spotlight as a playable party member. Beyond just the characters, Toriyama also drew a detailed schematic for the ancient ship; the developers claim that of course they didn't actually request that from him. The ship doesn't even play a large part in the game, yet the concept blossomed in Toriyama's imagination and he wound up inventing an

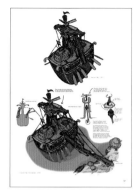

entire system of energy manipulation for this ancient civilization. It's an anecdote that demonstrates how much attention he pays to the constructions and principles of motion in his designs.

DQ VIII is notable for how faithfully Toriyama's designs were incorporated into the character graphics, and for

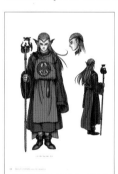

the large amount of concept art that never saw publication in magazines or strategy guides. The human form illustrations of King Trode, Princess Medea, and Lord of the Dragovians are seeing the light of day for the first time in this book because, originally, those three characters were too integral to the story to have their designs revealed in external media.

DQ IX | *DRAGON QUEST IX*

From *DRAGON QUEST IX: Sentinels of the Starry Skies* on the Nintendo DS, we have illustrations of the main characters, Corvus, the various job classes, and two monsters. *DQ IX* inherited the job system from *DQ III*,

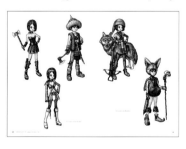

which is why we have so many illustrations showing those different jobs (see pages 194 through 201). By interviewing people from the dev team, we learned that they referenced that very same concept art while working on *DRAGON QUEST X: Mezameshi Itsutsu no Shuzoku Onrain*, since that game was in production at the same time as *DQ IX*. Most of Toriyama's art was used for the job classes in *DQ IX*, while some went on to serve as the basis for designs in *DQ X*. The Ranger and Monster Master are two such examples.

DQ X | *DRAGON QUEST X*

DRAGON QUEST X: Mezameshi Itsutsu no Shuzoku Onrain, *DRAGON QUEST X: Nemureru Yuusha to Michibiki no Meiyuu Onrain*, and *DRAGON QUEST X: Inishie no Ryuu no Denshou Onrain* are updates 1, 2, and 3 of *DQ X*, respectively, and this book contains illustrations of the package art, main characters, and bosses from each of those major updates. The package art for update 2 portrays the hero in the Monster Master class garb, though that equipment actually remained unimplemented for quite a while. Fans of Toriyama's work rejoiced when the equipment set was finally released in March of 2016.

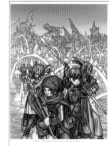

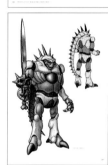

The package art for update 3 is another curious piece, as it seems to show the hero as a new class, the Dancer. Perhaps that costume will also be implemented someday?

While compiling this book, we discovered one illustration from *DQ X* that had never been made public before—that of Demon Hero Anlucea. This is a key character linked to plot secrets from update 2, so there was never

a good opportunity to introduce it in magazines or other publications.

DQ XI | *DRAGON QUEST XI*

Up to this point, the only illustration for the long-awaited *DRAGON QUEST XI: Echoes of an Elusive Age* was of the game's hero, but we're proud to include an extra rear-view image featuring the character's sword. Expect more illustrations for *DQ XI* from Toriyama in the near future. What sort of new characters will we see? What will the package art look like...? For

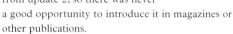

fans of Toriyama's *DRAGON QUEST* art, there's sure to be plenty more to appreciate in the years to come.

Message from
YUJI HORII

YUJI HORII

Yuji Horii was born in 1954 in Japan's Hyogo Prefecture. He
graduated from Waseda University's Department of Literature.
As a game designer, he's considered the father of the *DRAGON
QUEST* series. After dabbling in freelance writing, he found
himself moving towards game design when, in 1982, he entered
and won Enix's (now, Square Enix) game programming contest.
He's created multiple hit titles in the *DRAGON QUEST* series and
is still active in the world of game design.

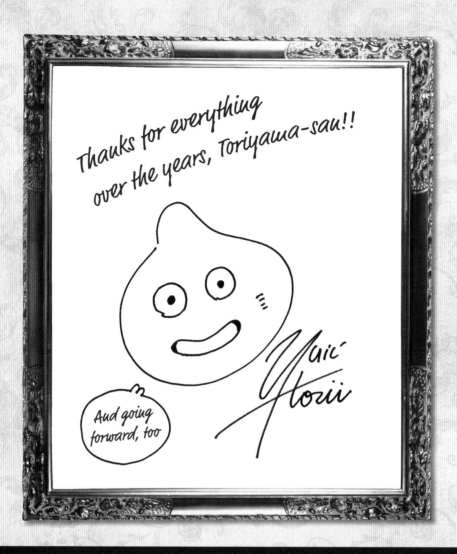

Thanks for everything over the years, Toriyama-san!!

And going forward, too

Yuji Horii

Back when *DRAGON QUEST* was first coming together, I remember being shocked and delighted when Torishima-san of *Shonen Jump*'s editorial department told me, "Akira Toriyama wants to do the art for your game." I later learned from Toriyama-san that that wasn't actually true; Torishima-san had just been trying to light a fire under one of his artists. However it happened, though, getting Toriyama-san to do the character designs couldn't have been more perfect. The monsters could've turned out scary, but instead they were charming, which made the battle screen all the more fun.

The designs of the main characters were also excellent, of course. Though they could only

appear as sprites on the screen, one look at Toriyama-san's art and those images would stick with you, forever altering how you viewed those little sprites. And now it's been thirty years. I never imagined we'd make it this long and have so much art for the series from Toriyama-san. I couldn't be happier to have it all compiled in a single book, as each piece of art brings back memories. Life itself is basically an RPG.

YUJI HORII
DRAGON QUEST Series Game Designer

Yuji Horii

AKIRA TORIYAMA
DRAGON QUEST
ILLUSTRATIONS

ENGLISH TRANSLATION **Caleb Cook**
DESIGN AND LAYOUT **Shawn Carrico**
EDITOR **David Brothers**

Printed in China

Published by VIZ Media, LLC
P.O. Box 77010
San Francisco, CA 94107

10 9 8 7 6 5 4 3 2 1
First printing, December 2018